For The Working Artist
A survival Guide for Artists

by

Judith Luther

The first edition of this book was developed for the Office of Placement and Career Development, California Institute of the Arts and was funded in part through grants from the Weingart Foundation and the Ledler Foundation.

Cover Design by	Marlitt Dellabough
Cover Illustration by	Jayme Odgers [copyright © 1991]
Book Design and Typesetting by	Steve Holt
Foreward by	Eric Vollmer
Second Edition Updated by	Eric Vollmer
Research Staff & Editorial Assistance by	Warren Christensen, Nat Dean,

Alexandra Florimonte, Judy McGinnis, Susan McWhinney, Joan Ramo, Martin Van Buren, Eric Vollmer, Margo Upham-Capen

For Additional copies, contact:

National Network for Artist Placement
935 West Avenue 37
Los Angeles, CA 90065
(213) 222-4035

Copyright © 1986 Judith Luther and
California Institute of the Arts

Copyright © 1991 Judith Luther and
National Network for Artist Placement

Library of Congress Cataloging in Publication Data.
Main entry unter title: For The Working Artist.
ISBN 0-945941-01-3 (previously ISBN 0-938683-00-4)

Printed in the United States of America.

ii

CONTENTS

Acknowledgements **vii**

Foreward **xi**

Introduction **xiii**

Dedication **xvii**

I. Getting Your Career Started **1**
Housing
Publications And Organizations Which Deal
 With Artists' Housing
Telephone Service
Getting Credit And Credit Unions
Unemployment Insurance
Health Insurance
Artists' Support Groups

II. Grantsmanship **11**
The First Time Down The Grants Trail
Terms You Should Understand Before You
 Begin Preparing Your Proposal
Sample Summaries, Budgets And Project
Descriptions
From Successful Grant Proposals
Non-Profits
Don't Talk Yourself Out Of Writing Grant
 Proposals!

iii

III. Legal Assistance For Artists **39**
Copyright
Contracts

IV. Financial Management **49**
Record Keeping
Tax Preparation
Information You WIll Need To Keep The IRS
 And Your Accountant Happy

V. Opportunities For Artists **57**
 Who Wish To Work Abroad
Organizations Which Provide Information
 About Working Overseas
European Theatres, Art Centers and Festivals
 Which Present American Artists

VI. Beginning A Career As An Actor **71**
Training And Preparation
Acting Schools: New York, California
AIP Quiz For Professional Actors
Photographs And Resumes
Sample Resumes
Finding An Agent
Talent Agencies Fact Sheet
Unions

VII. The Business Of Making Music **97**
Preparation And Goal Setting
Promotion
Demos
Management
Unions
Musicians Support Organizations
Copyright For Musicians
Composers

Record Manufacturing
Music Publications
Publishers Of American Music
Record Company List For New Music
Orchestras/Contemporary American Music

VIII. **I've Written My Novel.** **131**
 Now What Do I Do?
Finding An Agent
Publications For Writers
Small Press Publishers
Conferences And Colonies
Service Organizations

IX. **Dancers, Choreographers And** **155**
 Other Mythical Spirits
Dance And Dancers
Advice From Dancers Who Are "Not More
Than Fifty Percent Bitter"
On Training
On Auditions And Getting Into A Company
Contracts, Agents And Paperwork
Ways To Make It Work
Supporting Your Act
Survival And The Price You Pay
Parting Words

X. **Visionaries And Visual Artists** **175**
Preparing Your Resume
Sample Resume
Sample Cover Letter
Portfolios
Tips On What To Include In Your Portfolio
Tips For Approaching Galleries And Museums
Publicity

XI. In Closing..... 195

Appendices
1. Organizations Which Provide Information 199
 Related To Artists' Grants, Employment,
 Auditions, Exhibitions, Touring And
 Legal/Financial Services
2. The Foundation Center Network 209
3. Volunteer Lawyers For The Arts Network 233
4. Sample Contracts 241
5. Tax Form 1040, Schedules C And SE 261
6. List Of Equity Franchise Agents 265
7. Union Offices 289
8. Selected Theatre Publications 297
9. List Of Support Organizations For Composers 301
10. Dance Publications And Support Organizations 307
11. Publications For Visual Artists 315

Bibliography 319

Acknowledgements

In 1983 Warren Christensen, the Director of the Office of Placement and Career Development at the California Institute of the Arts (CalArts), asked me to help him and arts advocate, Stanley Fried, design an arts survival course for his division. As one of his guest lecturers later observed, the very name of the course suggested that artists were in grave danger of going under at any given moment. Nonetheless, in response to requests and recommendations from many CalArts students and alumni, we selected Arts Survival as the course title and proceeded to organize classes and workshops we hoped would prove useful to the students once they left the nurturing atmosphere of the Institute.

Classes which discussed Financial Management, How To Get An Agent, Copyright Law, and Where To Buy Low-Cost Health Insurance were all part of that initial arts survival program. Lecturers from throughout California were recruited to speak to young choreographers, composers, actors, designers, performance artists, musicians and video artists about their work and about how to get work. Other speakers were imported to teach the most basic rules for writing grant proposals and still others were persuaded to discuss the subtleties of preparing contracts, marketing art, and approaching museum curators. All things considered, that first semester provided a fairly complete blueprint for young

artists setting out to explore an urban arts jungle. In 1984 and 1985 the blueprint was refined and the territory expanded.

This book is an outgrowth of those classes and as such, owes its shape and substance to the guest lectureres who generously shared their knowledge and enthusiasm with hundreds of CalArts visaual and performing artists. A further dept is owed to the many arts administrators, managers, agents and artists whose good-humored observations supplemented the information provided in the survival workshops. CalArts also acknowledges, with deep appreciation, the financial support of the Weingart and the Ledler Foundations.

I am personally grateful to both Margo Upham-Capen and Joan Ramo. They conducted may of the interviews, organized, typed and edited much of the text, and cheered me on whenever I showed signs of discouragement. Eileen Masover typeset the manuscript on an eccentric Macintosh that-with distressing regularity-gobbled up entire chapters. For her patience with Pagemaker and with other job related irritations, I offer heartfelt thanks. Susan McWhinney gave new meaning to the word *PERSEVERANCE* and John Orders, the ever gracious Assistant to the President of CalArts, gently guided the project to its conclusion.

A special thanks goes also to the working artists who shared information about their professional experiences, to the friends and colleagues who reviewed portions of the manuscript, and to the staff members of CalArts who, in a variety of ways, contributed to FOR THE WORKING ARTIST.

I am particularly indebted to Marilyn Horne, Peter Coyote, Tennyson Schad, Beatrice Straight, David Hyry, Kira Perov, Bill Viola, Matt Bond, Richard Musgrave, Rebecca Wright, Donna Woods, Fred Strickler, Jim Ramo, Cris Capen, Deborah Slater, Judy Maltese, Bob Monaco, James Riordan, Fionna

Flanagan, Suzanne Gilert-Hoehl, Sussan Suntree, Cora Mirikitani, Carole Laidlaw, Jon Bauman, Scott Luther, Larry Harris, Carl Stone, Tim Miller, Cynthia Galles, Julie Gibson, Lindsay Shields, Jim Boerlin, Casey Childs, Danielle and Carolyn Ramo, Emmanuel Culman, Yen Lu Wong, Martin Wiviott, Virgina De Moss, Kevin Emery, Jay Perry, Linda Vallejo, And Maudette Ball for their time, patience. and courtesy. Having an opportunity to discuss arts business with artists and arts advocates of such distinction and generosity was a pleasure, an honor and in some cases, a truly delightful surprise.

Anita Bonnell and Kathleen Arias offered kind advice and production assistance, Marlitt Dellabough designed a beautiful cover under severe time constraints, and Azo provided Marlitt and FOR THE WORKING ARTIST with a charming original cover illustration.

The following agencies and offices graciously agreed to let me reprint forms, lists, and information about their organizations:

The Granstmanship Center
The Foundation Center
U.S. Office of Copyright, Library of Congress
Volunteer Lawyers for the Arts
Actors Equity, Los Angeles Office
General Telephone
California Theatre Council
Actor's Fund of America
Actor's Information Project

Finally I am deeply grateful to the two people most responsible for this book...Warren Christensen, whose energy and vision got it started, and Marc Wilder, whose patience, support, and humour ensured its completion

Foreward

"Artists move us on an irresistible course. We follow them knowing that like the ghost of Hamlet's father, they do not trouble our imaginations for nothing."
 Anton Chekov

This explanation of the role of the artist that Anton Chekhov offered to a Russian friend is a good place to start a practical survivor's guide for the artist. The compelling force that inspires artists is based on their faith and commitment in their art and discipline. This understanding can become lost at the beginning of a career. The world is comfortable and doesn't take the trouble to listen for the artist's call as closely as Chekhov.

Knowing this, Judith Luther has prepared a handbook that helps artists master the business side of their careers without losing sight of the gifts that inspire them. This is not a sealed package of "do's" and "dont's;" Judith holds a conversation with her readers. Avoiding "boiler-plate" format, Judith personalizes her approach to advice on preparing resumes, grant proposals, portfolios, performance pieces, etc.

For The Working Artist is filled with a chorus of different voices, including actor Peter Coyote, ballet dancer Rebecca Wright, and independent videomaker Bill Viola. These people

offer candid advice based on situations they faced in their struggle to do work. Strategies range from various forms of networking to work in humble and humbling settings. Their career improvisations spark one's own concept of versatility.

There are no get rich quck schemes in this book, which I find refreshing. Whether its the author speaking from her experience as an arts management counsultant and vocational counselor, or one of the many artists she consulted for this book, one has the sense that work, when adequately prepared for, does have the chance to be exposed to the designated audience. These successful artists believe that the ultimate reward is in doing the work itself, whether performing, painting, filmmaking, dancing, music, or creative writing. All of the many voices presented in this book appear to be that of people that you'd want to invite over to your house. The book is realistic, yet friendly.

In this book, you will find lists of organizations formed by people who devote their time to enabling artists to develop and findtheir audiences. Society should welcome the boundless flow of ideas and goods that artists present to the culture and to the commercial aspect of cultural life. However, society all too often appears deaf, dumb, and blind to artistic appeal. Thank the Lord for all the wonderful organizations and people mentioned in this book that enable the new artistic to gain the start of public response.

For The Working Artist doesn't lead a cavalry charge to the rescue. What Judith Luther has done is simply bring together useful information for becoming your own arts manager. It's up to you to put these insights into practice and pursue the artist's vocation which "does not come to trouble our imaginations for nothing."

Foreward by: Eric Vollmer

Introduction

When I graduated from college in 1965, most artists felt they could not function in the business world. They also felt they should not. Artists who successfully integrated business and art were at best considered exceptional and at worst suspect, as if their work must be tainted or below acceptable artistic standards. Today an artist who markets his paintings or successfully negotiates a contract is no longer viewed as an oddity or a traitor to his profession.

All artists are arts managers. Some manage better than others but every artist who pays rent, has a phone and buys food is an arts manager on a very basic level. This book is designed for those artists who wish to effectively and harmoniously manage their art and their business beyond that fundamental food-and-rent subsistence stage.

The same discipline and creativity put into writing a play or choreographing a new work will also serve an arts manager well. Preparing a grant proposal or booking a tour requires research and planning and the same organizational skills all competent artists employ on a daily basis.

When a sculptor is in the process of creation, he clearly should not be thinking about marketing his work. During that period of time, his responsibility is to be involved in the

creative process to such an extent that he gains fresh insight both into the nature of his work and himself. Once having made that attempt (and presumably having achieved something he wants to share) the artist then needs to gather the support which will allow his work to be exhibited or sold or produced. It is at this point that an artist may benefit from the advice and recommendations offered during the CalArts survival classes.

Use this book as a guide, a point of departure rather than a comprehensive answer book to every career question you'll ever have. There is clearly no one way to manage a career in any field and no tidy, sure fire solutions to every business problem an artist will confront. A few basic business skills, a little common sense, perseverance, and a good attitude will not guarantee fame and fortune but they will help you achieve the comfort and dignity most of us want and deserve.

Lawyers say that a man who defends himself has a fool for a client. On the other side of the coin, a beginning artist who does not put some effort into managing his career will probably not have paint stains on his shirt at his 25th high school reunion. Unless you are privately wealthy, have a benevolent patron, or are incredibly lucky, your arts mangement skills will have to keep pace with the progress you make as a dancer, a painter, a filmmaker or composer.

The first five chapters of this book will concentrate on information all artists should have. Financial management, proposal writing, legal information, copyrighting your work and negotiating contracts are a few subjects which most artists—visual or performing—will deal with at some point in their careers. Specialized chapters as well as resource listings, sample contracts and a bibliography will also be provided for those artists wishing specific information about their particular field or discipline. Recent art school graduates may find chapters which discuss other disciplines constructive and useful. Actors, dancers, visual artists, and writers can all

benefit from musician Bob Monacos's advice on setting goals. Fred Strickler and Deborah Slater's observations on The Price You Pay to Survive will mean just as much to composers and poets as to dancers and choreographers. Developing secondary skills to support your art applies to artists in every field (as well as to real estate brokers and self employed marketing consultants), not just to painters and sculptors.

Although I have made a concerted effort to provide accurate information, recent fees and rates, and current listings, the nature of the art world is such that agents, publications, and support organizations for artist change direction, focus and location.

I also acknowledge my sins of omission. There are hundreds of competent businesses, agencies, and individuals not listed in this guide. Their absence is a reflection of my limitations, not theirs, and must in no way be construed as a criticism of their ability or integrity. By the same token, readers should not assume that agents, recording companies, or publishers included on a list are endorsed by the publisher or this writer. I have tried to list businesses that showed some staying power and that were recommended by the artists and arts managers we interviewed. The lists are, however, by no means foolproof. You should sift through the information, see what's useful, and store or discard whatever strikes you as irrelevant to your particular objective.

When all is said and done, your career is your responsiblity and you should have fun building and shaping it. When Marilyn Horne was asked about surviving in the art world, she said "Have fun enjoy your years of struggle. Even if it doesn't seem worth it at the time, it well in the end. Anyone who can make one of the arts her life's work is blessed."

You *are* blessed. Enjoy it.

Dedication

In a speech delivered at a Los Angeles Business Committee for the Arts awards dinner, Winton M. Blount, Chairman of the Board of Blount, Inc., related a story about Edgar Degas and Vibert, the nineteenth century painter who helped found the french Watercolor Society. It seems that Vibert ran across Degas on the street one day and invited him in to see an exhibition of watercolors. Degas, who was not a pretentious man, was wearing a shabby old mackintosh. Looking him over carefully, Vibert said, "You may find our fames and rugs a little too fancy but art is always a luxury, isn't it?" Degas replied, "Yours may be but mine is an absolute necessity.

This book is dedicated to Lillian Kiesler, Jane Smith, and Maryette Charlton, three elegant survivors who have always known the difference between luxury and necessity. They are wonderful role models for actors, musicians, painters, poets and all artists who choose to live with spunk and grace.

Chapter I

Getting Your Career Started

Artists have an even greater need to do long-range planning than people who work in most other professions. Income generated from grants, acting jobs, recording contracts, and the sale of art works may be adequate to support you but the money may also come to you at irregular intervals. It's necessary to plan ahead, save money whenever you can, get and maintain good credit, and if you're in Los Angeles, maintain a fuel-efficient car in good working condition.

Your personal budget will vary according to your art form but everyone will need to budget for rent, transportation, telephone service, union dues, membership fees, postage, printing, advertising expenses, food, and health insurance. Some tips and information which may help you save money on some of these essentials:

Housing

Finding a place to live in either New York or Los Angeles can be a frustrating experience. Apartments will very likely be more expensive than you can afford, seedier than you can endure, or located in some inconvenient "bedroom community"

miles and light years from where you want to live. If you are prepared to live with other people, you can save money, upgrade your lifestyle and live in a more convenient location. You must, however, put a lot of time and research into finding reliable, compatible roommates.

Musicians who practice at night, artists who use the living room for a studio, and writers who want their home to be as quiet as a monastery may or may not be compatible with an actor preparing for a musical comedy role. On the other hand, schoolteachers with rigid schedules and routines may be too structured to live comfortably with artists whose schedules are unstructured and fluid. You must ask yourself lots of hard questions before you commit to a long lease with a friend *or* stranger. Be sure you know exactly what you're getting into, who you are and who your roommate is before you start to decorate an apartment together. Living with someone who has different goals and a different lifestyle can be murderous but just as often, relationships are enriched by diversity.

If you do decide to share housing with a roommate, post notices on the bulletin boards at your school, studio, theatre, or bookstores with a large clientele of artists. You can also contact your union for referrals or go to a commercial roommate service. Although the roommate service agencies will charge a small fee, they will offer a selection of roommates, many of whom will already have very nice homes and apartments.

Alternatives to apartment living are residence houses, hotels, and government housing projects. Residence houses are more plentiful in New York than in Los Angeles and many have long waiting lists. The New York government housing projects for artists and the one under development in Hollywood are also worth exploring. It may take several years to process your application and actually get off the waiting list and into

an apartment but rental fees for these rental units are scaled according to income. For additional information about government-subsidized projects in Los Angeles, contact:

The Actors Equity
Pam Portillo, Project Director

Offices of Councilman Michael Woo
(213) 485-3353
Offices of Councilman Joel Wachs
(213) 485-3391

In New York contact the:

Westbeth Corporation
463 West Street
New York, NY 10014
(212) 691-1500

Manhattan Plaza
400 West 43rd Street
New York, NY 10036
(212) 971-0660.

If you choose and can afford to live alone in an apartment or house, you might begin with communities which have rent control laws. You may also want to talk to the staff at the Fair Housing Council or one of the tenant associations in your city. They can advise you on the current rent laws, explain all the small print in the lease agreements, and describe what you can reasonably expect to pay in the way of annual rent increases.

Finally, you should think carefully about whether or not you want your prospective landlord to know you're an artist. Landlords are almost as enthusiastic about artists as actors are about agents. Even if you decide to come clean about your life's work, you should give your appearance some consideration and dress for an outing with your spinster aunt. If you can also get your Aunt Gladys to go apartment hunting with you, you'll be way ahead of the game. Nervous landlords have to be handled gently and protected from too many encounters with Cousin Fury, the Punk Rocker from Malibu. Unless you like being homeless, keep Fury under wraps and don't say any more than you have to about the tedium of standing in line at the Hollywood Unemployment Office.

Publications And Organizations Which Deal With Artists' Housing

Artists Live/Work Space: Changing Public Policy. Artists Equity Association, 1981. Northern California Chapter, 81 Leavenworth Street, San Francisco, CA 94102.
(415) 626-6808

Artists Foundation: The Artists Living and Working Space Program, 100 Boylston Street, Boston, MA 02116.
(617) 227-2787
Note: Provides artists and artist-groups with the architectural, legal, financial, and related technical assistance necessary to acquire and rehabilitate living and working space.

Housing For Artists: The New York Experience. New York: Volunteer Lawyers for the Arts, 1976.

Telephone Service

Performing artists live and die with a telephone permanently affixed to their ears and visual and literary artists generally maintain a closer relationship with Ma Bell than with their own families. It is therefore a very good idea to become familiar with the cost-saving services provided by the phone companies in your area, they can save you money. Ask their customer service representative to describe the specific benefits of the plan best suited to your needs. Remember that:

1) A **Business Listing** costs more than a **Residential Listing.**

2) **Frequent Caller Bonus Plans** are offered by most companies. Basically, they offer discounts for frequently called numbers. Programs and services vary, but if you call

a lot, they can save you big bucks. Some programs are a **Call Bonus** wherein points are tabulated for certain types of long distance numbers. The points convert to a discount on your total bill. Other programs focus on **Frequent Caller Service** wherein a selected area or specific number(s) are billed differently than other long distance numbers. For a set monthly fee, the particular long distance number(s) or area may be billed as if they were local, no matter how many times you call them. Variants of this plan allow a discount on the frequently called numbers, but do charge according to the volume of calls. A plan offered in Los Anageles, **ORTS** service entitles you to a 50% discount on all toll calls you make within a forty mile radius with no time limit on your calls.

3) **Call Forwarding** enables your incoming calls to be transferred to another number. This can be very important for actors who need to be constantly accessible to their agents.

4) **Call Waiting** allows you to put one call on hold and answer another incoming call.

5) **Call Waiting** and **Call Forwarding** will not take the place of an Answering Service or answering machine but they will be very helpful to actors, dancers, and musicians who depend on the efficiency of their phone system for regular employment.

6) Companies such as SPRINT and MCI will also save a lot of money if you make a lot of long-distance calls. The amount you save depends on your volume of long-distance calls but the savings can be as much as fifty percent over Bell's interstate rates.

Getting Credit And Credit Unions

It may be easier for you to get a charge card and establish credit while you're still in school and have a steady part-time job than when you're making $25,000 a year as a professional actor, musician, dancer, or video artist. Banks and credit officers take a dim view of lending money to people who work three or four months a year and rely on grants for part of their income. As a student, you may either qualify for a charge account with a low credit line or you can have your parents open a charge account authorizing you to use their card.

If you have any kind of a savings account, it's a good idea to put a portion of it in a checking account in the same bank. After a few months of building a responsible banking history, you can approach the bank's loan officer about taking out a loan. Suggest using the money in your savings account as collateral and don't tell her that you're using the money simply to establish credit. Say that you're using the money for classes, equipment, or transportation and repay the loan in a timely fashion.

Credit unions offer artists important benefits such as low-interest loans, higher rates of interest on savings, and interest checking. If you belong to one of the performing arts unions such as SAG or AFTRA, you can join the credit union by making a very small deposit. Other artists' support organizations such as The International Women's Writing Guild (IWWG) provide members access to the credit union benefits of Support Services Alliance. To participate in this credit union, members of IWWG must send an enrollment fee of $5.00 with an initial deposit of $150.00 to:

VAROH Federal Credit Union
423 East 23rd Street
New York, NY 10010

In most instances, credit unions will provide artists with more sympathetic service than banks which are not set up specifically to benefit their artist members. They may also offer their members special discounts on professional services, access/information about professional organizations, and also, discounts on entrance fees to entertainment parks, entertainments, and even car repairs.

Unemployment Insurance

Unemployment insurance is financed by employers through payroll taxes. Benefits are paid to the unemployed through an industry tax and theoretically are paid only to job seekers who **are** unemployed through no fault of their own and who are ready, willing, and able to work.

In order to qualify for unemployment benefits, you must have worked at least twenty weeks during the fifty-week period that ended with your layoff and your employer must have covered you by paying payroll taxes. The twenty weeks work need not have been consecutive or with only one employer. If you qualify, your weekly benefits will equal approximately half of your average weekly salary during the time you were working. Benefits last for twenty-six weeks although it's frequently possible to get an extension.

You are not required to take a job out of your classification. You can therefore use your time between acting jobs to study and train, thus increasing your employability. You should familiarize yourself with Unemployment Insurance regulations so that you can use the program to benefit you during those frequent periods between jobs. Pick up a handbook outlining all the Do's and Don'ts governing Unemployment Insurance at your nearest Unemployment Insurance office.

Health Insurance

Support Services Alliances also offers an opportunity to participate in a group health insurance plan. Arts service organizations such as the Los Angeles Theatre Alliance (LATA) and the IWWG as well as most artists' unions offer group health insurance plans. The IWWG and LATA both work through Support Services Alliance and offer group insurance which includes group term life insurance, dental and vision insurance, surgical and major medical insurance and short-term disability coverage. Group plans obtained through arts service organizations are ordinarily much less expensive than individual policies purchased through an insurance broker. The Artist's Equity Association provides health coverage through Mutual of Omaha for a Bluer Cross plan. Call (202) 628-9633—Washington, D.C. office or (213) 481-1176—Los Angeles office. Coverage for health and life insurance are maintained on a self-paid basis.

The best policies are offered by the unions but until you qualify for those, maintain the coverage your parents have for you or join an arts service organization which offers a group plan. Both AFTRA and SAG offer health and welfare benefits to members who have earned $5,000. or more within a period of twelve consecutive months. If you work for a minimum of three weeks under an Equity Production contract, between two to five months free health and life insurance coverage is given. Depending upon your contract and number of weeks worked, coverage may be given for longer periods. You can also pay a quarterly premium when you're unemployed and maintain the same coverage you had when you were working.

If you are unable to pay for health insurance, get information about your local free clinics *before* you have an injury or illness. Most cities provide free hospitalization and medical care for

patients who can document unemployment and a lack of resources and assets.

USC/County General Hospital and Harbor General Hospital in Los Angeles and Bellevue Hospital in New York are both teaching hospitals which offer excellent care to their patients. An inordinate amount of time is spent in waiting rooms and filling out forms but the medical care is very good. If you are really unemployed and broke, their services will be provided at no cost.

Artists' Support Group

The Actors' Fund of America, founded in 1882, is the oldest theatrical charity in the world, and is representative of many valuable organizations which provide support to artists. The Fund is a national organization with offices in New York, Los Angeles, and Chicago. Its services are not restricted to actors, but are available to all bonafide professionals in the entertainment community, working in any capacity, in the areas of ballet, opera, circus, variety, motion pictures, radio, television, and the legitimate stage.

The Actors' Fund expends over $2,500,000 a year in confidentially assisting thousands of individuals in distress. Its services include:

* Financial assistance grants for such essential living expenses as food, rent, utilities, and payment of hospital, medical and dental bills.

* Psychotherapy and counseling focusing on performance anxiety, career problems, drug and alcohol abuse and other topics.

* Educational seminars on a wide variety of subjects including money management, subletting and roommates,

the creative personality, reaching 65 as an active professional, and coping with everyday life.

* A Survival Jobs Program (New York) providing entertainment professionals with temporary employment between engagements.

* Blood drives in Chicago, Los Angeles and New York which provide hundreds of pints annually.

* Funeral Arrangements and burials throughout the United States.

* A Conrad Cantzen Shoe Fund and the Mandel Christmas Fund.

* The nationally renowned Actors' Fund Home, a retirement residence in Englewood, New Jersey.

* Nursing and nursing home care, as well as home visitations and home care for those who need special attention. When construction of The Fund's new Extended Care Facility is completed, it will offer the finest nursing care available anywhere.

* A new Career Transition Program for Dancers. Due to the incredible physical demands made on their bodies, the majority of professional dancers must retire from dance in their 30's or 40's. This new service will provide dancers with much needed assistance in setting future career goals and preparing them for productive new professions.

Headquarters	Western Office	Mid West Region
1501 Broadway	5410 Wilshire Blvd., #400	203 N. Wabash
New York, NY 10036	Los Angeles, CA 90036	Chicago, Il 60601

Chapter II

Grantsmanship

Preparing a grant proposal is a good starting point for any artist interested in exploring the business world. It compels you to deal with the concept of not-for-profit organizations, forces you to research funding agencies, prepare a budget, and begin thinking about your place in a diverse and complex community. A simple application from a small foundation will ask that you define who you are, what you want to do, and how you plan to spend the money you're asking them to give you. This may all sound like unnecessary and time-consuming "busy work" or red tape but the process of putting your thoughts and words on paper can be extremely useful. It will help you clarify and perhaps alter your objectives, stretch your imagination, and expose you to resources in your community you did not know existed.

To those of you who have managed to get through college without knowing what a grant is, congratulations! For most of us involved in arts programs or organizations, they are our life's blood. Since the days of the Medicis, artists have depended on wealthy patrons. The patrons of today are government art councils, foundations, and corporations. Simply put, a grant is a subsidy paid by an individual or

organization to another individual or organization, generally for a project or work perceived by the funder to be in the public interest.

The First Time Done The Grants Trail

There are a number of considerations you must make before you begin seeking support for your arts project. You plan it like a long-awaited vacation, but without the vacation! What's your destination, what do you hope to accomplish with your future work? Who are you taking along, what is necessary to bring about the project? Where will your work occur? when do you plan to make this happen, why is it important, and will the public benefit from your venture?

It helps to write an outline of your idea using these questions to guide you. It's a simple way to prepare to answer the questions any funding source will put to you. This initial planning step also turns up clues as you follow through concerning what sources might be appropriate to approach for assistance.

Will your project take place in the local community? Then, perhaps, there may be community sponsors and businesses in the area who would contribute to your work for the publicity.

Are you planning to give a performance? Approach companies in the area and ask their personnel office to purchase blocks of advance tickets for your event.

Are there colleges and universities nearby who would see artistic merit or some educational means of involving their students in your artwork? They may provide facilities and other resources to become a participant in your effort.

Does your project involve interests or themes that local, state, or federal agencies fund? There are limited funds set

aside to sponsor artistic and cultural activities. Your event may qualify for grant proposal submission.

Grants Research

The rough outline that you've done will help you more quickly identify likely grants sources. All the various agencies and foundations that grant moneys to artists have general guidelines which they make available on request. A list of organizations that supply this basic funding information is presented in Appendix I. You can expand on our list by consulting any arts service organizations in your area (libraries, city halls, and local arts organizations), or by contacting your state arts council offices. Foundation Directories with detailed information on funding levels, geographic areas of support, and descriptions of previously funded programs can also be found in most university libraries.

The FOUNDATION CENTER, an organization with regional affiliates in foty states, provides current information on foundation resources. Their publications Foundation Directory, and Foundation Grants To Individuals are excellent reference materials. The Center also distributes booklets such as What Makes A Good Proposal, that provides valuable information to the grantseeker. Should you decide to visit one of these Cneters, allow yourself a good amount of time to explore. The Directories take some getting used to before you can tame them to do your bidding. Keep your larger purposes carefully in mind when you go and you won't waste your trip. We have included Foundation Center addresses in key regions across the United States in Appendix II.

When you review the funding research materials, it is important to distinguish between corporate foundation and government givers. Each will have different policy procedures

and will define certain entities they will sponsor. We recommend that you refer to works like Virginia White's *Grants for the Arts* and Dance Theatre Workshop's *Poor Dancer's Almanac* which provide annotated descriptions of the specific giving priorities of each particular funding source.

It sounds like a science, doesn't it? One reference book colliding into another just like it and splashing data everywhere! The grants process is structured somewhat like a scientific experiment, but it is also an art form. There is a very important human element to it. The National Endowment for the Arts (NEA), the state arts councils and other government funding agencies have program staff to help you with your applications. These people can save you many hours of tedious research and restore the human perspective to the whole exercise. They are not mindreaders, unfortunately, so the more you and your applicant organization think things out before contacting them the better. You should keep the importance of this personal contact uppermost in mind when meeting and speaking with all the various funding staff people you approach.

Do Your Research

Be certain the agency or foundation from whom you're requesting funds supports your kind of work or project. The most common rationale funders use for rejecting a proposal is a failure to fall within their corporate or foundation guidelines.

Most government agencies and many foundations will send you an application or a guideline to follow. Follow it. Do not send a funder more than is requested. Grant panelists and foundation analysts have hundreds of applications to review and have neither the desire nor time to deal with bulk. Answer the questions in a straightforward fashion. Avoid rhetoric and when you can, stay away from jargon and acronyms designed to make 99.99% of the world feel like outsiders.

As you become involved in grants research you may discover the documentary film you were planning to make has already been made, funded, and distributed by the very agency you're approaching for support. You may also discover that the foundation from whom you're requesting funds has a long history of support to scientists engaged in research for the cure of acne and has not awarded a grant to an artist or arts organization in its twenty-five year history. Conversely, you may discover three foundations who fund exactly the kind of documentary film you're proposing.

Be gracious to the first contact you make at a funding agency

If you're calling an arts council or a foundation for information, be as gracious to the switchboard operator as you would be to the Director or Chairman of the Board.

About ten years ago I was the Cultural Services Superintendent for the city of Long Beach. As an exercise in getting to know my job, I occasionally filled in at what I considered key positions in the department. It was extremely enlightening and a little alarming to discover that the same artists who treated the superintendent with careful courtesy were demanding and abrupt with a switchboard operator.

In a CalArts seminar which covered job interviewing techniques, Robert Fitzpatrick, the President of both the California Institute of the Arts and the 1984 Olympic Arts Festival, discussed job applicants who treat secretaries in a cavalier manner. Recognizing that his secretary is the focal point of his office, he feels that applicants who fail to give her the same respect they give him will be of limited value to the Institute.

Good program officers and foundation presidents want the same respect for their assistants and secretaries. It's a grave mistake on a human level to be discourteous to clerical and lower management staff and it is also strategically foolish. The initial contacts you make within a funding agency may have a great bearing on whether or not you *ever* meet a program director or the chairman of the board. Secretaries will give you better advice and save you more time and effort than anyone else you will meet in the development business. If you sell them short, you hurt yourself, your project, your organization, and the people you hope to reach with your project.

Warren Christensen, an old hand at fundraising and development, uses "People give to people, not to projects" as a rallying cry in his grantsmanship seminars. Applicants for funding should keep that in mind from the minute they pick up a phone or walk in the door of a funding agency. An ideal proposal will describe a worthwhile project, give the funder a sense of ownership and pride, have a realistic budget, and be presented by an applicant who is well-informed, articulate, honest, and gracious to *everyone*.

Show Further Considerations

Prepare yourself to show evidence of community and peer support. this is part of an ongoing process that you and your organization should practice. Many funders will ask for some indication that your project is supported by your community. Collect support letters from the constituency your project will serve, from respected artists in your field, and if possible, from leaders within your community who recognize the value of your project. The input you get from your peers will also help you streamline and strengthen your proposal before it's

submitted. This should be augmented with prior reviews of your work, letters of support that you've previously received, and any documentation of your artistic accomplishments. You should maintain a file of all community and peer support that you receive. Agencies will ask you to append various forms of support documentation to your proposal. Be selective. Critical reviews and articles about your work give some sense of your reputation.

A resume is helpful to show how your career has developed, include letters of endorsements from people whose assistance will be needed for your project to take place. Also, present letters of recommendation from fellow artists or recognized authorities who can comment on your ability to carry out the proposed work. Finally, attach any agreement letters you may have obtained from other agencies, organizations, or individuals who may be matching or sharing the project expenses.

Prepare a Realistic Budget

Your budget should reflect your knowledge and your integrity. Unless a staff person at the funding agency has recommended you do so, do not inflate your budget on the assumption that you will receive less than you request. It is possible someone on staff will have inside information about the idiosyncracies of a particular board member but as a general principle, it is not a good idea to ask for $25,000. if you only need $12,000. Many review panels are staffed by experienced, mature artists who will understand both the direct and indirect costs of your project.

Be certain that your budget reflects the narrative portion of your proposal. You should not itemize the cost of transporting a choreographer from New York to Los Angeles unless a need for this has been established in your project description. All

elements of your proposal should clearly and accurately tell the same story.

It is usually not a good idea to request all your funding from one source. Foundations often prefer to share the responsibility of funding a project. Leveraging funding from one source to obtain funding from another is an effective strategy employed by both organizations and individual artists.

Terms You Should Understand Before You Begin Preparing Your Proposal.

Summary

Your summary should be the last part of the proposal you write and the first part of the proposal the funder reads. It should identify who you are, establish your credibility and briefly summarize all the components of your proposal, including the amount of your request and the total project cost.

Introduction

Your introduction should provide detailed information about you or your organization as well as your goals and objectives. It should establish the constituency you serve, discuss your accomplishments, document community support and describe the unique qualities of your project.

Project Description

Use this part of your proposal to clearly describe the what, how, when, where, and why of your project. Describe who will benefit from your work and why it is significant. Be as realistic as possible and try to establish your program results in measurable terms. If 45 senior citizens will benefit from your theatre workshops, say so.

Methods

This section of your proposal will give you an opportunity to prove you know what you're talking about. Your method of implementation should prove to the funder's satisfaction you can achieve your objectives through your program design. It should also be a good indication that you understand the constituency with whom you'll be working.

Evaluation

The funder will want to know that you can monitor your program as you go along and evaluate the finished project objectively. Describe who the monitors will be, how the evaluation will be done, and how the results will be used to help your organization.

Within your budget you will be expected to deal with both **Direct** and **Indirect** costs. Direct costs are those items that can be directly identified with your project. Examples of direct costs might include salaries and wages, contract fees, travel expenses, equipment rentals, supplies, and printing charges. Indirect costs such as administrative services, rent, utilities, and security are generally costs which are shared by your sponsoring organization and cannot be tied directly to your project. The amount of indirect costs you include in your budget should be cleared by the funding agency before you submit your proposal.

A simple and effective proposal model has been designed by the Grantsmanship Center, a large training center which conducts grantsmanship workshops all over the country. The Grantsmanship Center in Los Angeles is located at 650 S. Spring St., Suite 507, Los Angeles, CA 90015. They have a toll free number (1-800-424-9836) which you can call for information about seminars and workshops scheduled in your area. In Los Angeles their phone number is (213) 689-9222. Please call from 8:30 to 4:30 PST.

Samples of Summaries, Budgets, And Project Descriptions From Successful Grant Proposals

Although the following grant proposals are different in both substance and style, they share certain important characteristics. They are, first of all, very clear about what they want and why they want it. They establish the credibility of their organizations and they establish a need for the projects they wish to have funded. Their budgets are realistic and reflect matching support from other funding sources. Finally, each proposal has something to recommend it which is unique. Collectively they substantiate my contention that there is no ONE successful proposal writing style and that there is also no substitute for an honest, straightforward, human touch.

The following summaries, project descriptions and budgets represent important parts of successful grant proposals but do not represent the completed proposals which were submitted for funding consideration. Proposals II and III were all submitted by individuals and organizations which do not wish to be identified.

Sample Proposal I

Summary: The Cultural Services Division of XYZ City requests a matching grant of $17,100. from the AB Foundation for a Senior Theatre Program. This program is designed to stimulate the growth and development of Senior Citizen Theatrical workshops which have, in the past, seldom been available. A production will culminate each of two six-month training sessions.

The Cultural Services Division is composed of four separate sections: Visual Arts, Performing Arts, the XYZ Municipal

Band and the XYZ Museum of Art. Each section services special interest populations as well as the general public.

Programs/activities of each of these sections are produced in "home base" facilities, neighborhood centers, assorted community and service organizations including three senior centers and in some cases, throughout Los Angeles County and California.

The goals of the Division are to provide a creative outlet for youth and adults citywide through experience, exposure and participation in a wide variety of cultural activities and to provide opportunities for discovering individual potential and awareness thorough cultural involvement.

***Project Description:** The Cultural Services Division of XYZ City proposes to sponsor a Senior Theatre Program to be based at the XYZ Senior Center, Wightman Theatre, and the Horseshoe Theatre which is adjacent to a senior arts center. Currently there is no theatre program in XYZ designed specifically for senior performance and production. Atlhough the Recreation Department offers a wide variety of instructional activities and other special events to the community, there have only been incidental theatrical workshops designed specifically for the elderly population.*

The City of XYZ has the second largest percentage of senior citizens of any major city in the United States. With a population of more than 361,000, the City has 73,000 seniors over the age of 60. More than one-quarter of the entire population of the city is over the age of 55.

Services currently being provided in the Senior population include Protective Services and the Senior Care Action Network "Continuum of Living" targeted to the poor, the isolated, the physically frail and the emotionally vulnerable or at-risk population.

It becomes our responsibility, therefore, to not only answer this population's need for essential income and services, but to also find ways to make their lives more meaningful and personally gratifying. The challenge lies in recognizing the great diversity among the aged, and then tailoring special programs to the special needs of the diverse groups.

Among those groups are the middle socio-economic bracket who, because of reduced income or physical frailty or both, are not participating in the arts as they once did. A substantially larger group of older adults which has had neither the time, the money, or the inclination for the arts in their middle years will be offered an opportunity to participate in a new and exciting cultural activity.

The objectives of the theatre workshops and performances are:

1) *To provide the large senior citizen population with opportunities to learn and share new skills.*
2) *To develop an enriching and diverse program to fulfill not only cultural and social needs but physical and emotional needs as well .*
3) *To break down existing psychological barriers and stereotypes often associated with the aging.*

Through emphasis of the theatrical techniques of improvisation, mime, characterizations, music, dance, and story dramatization, XYZ seniors will benefit on several significant levels. Through increased creativity, imagination, concentration and communication skills, and by being entertainment providers, they will benefit artistically. By increasing an awareness of varied concepts in artistic disciplines and different social values, they will experience educational growth. They will also benefit from increased physical exercise and the emotional outlet theatre provides. Finally, this program will encourage social interaction and

aid in dealing with problems more effectively.

An estimated 120 seniors will actively participate in the theatre workshops and productions. Active community outreach will result in the presentation of informal theatre workshops to senior citizen organizations in XYZ. With a significant senior population, many of whom reside in more than 100 convalescent and nursing homes, it is anticipated that this component of the program will directly impact 6,000 seniors. In addition, workshops will go to each of the senior nutrition centers, Gold Star Mothers Homes, the main branch of the XYZ Library, and will be available to any and all other senior citizen groups, i.e., church social groups, neighborhood organizations, etc., which request per-formances.

BUDGET- Sample Proposal I

Personal Services

Project Coordinator	$ 4,000.
Fringe Benefits	400.

Outside Contractual Services

Director/Coach	$ 2,400.
Director/Coach	2,400.
Music Director/Coach	3,000.
2 Accompanists (performances and rehearsals	2,600.
2 Technical Directors	3,000.
Clerical	1,200.

Non-Personal Services

Facility Rental	$ 5,000.
Repair and Maintenance	600.
Technical Supplies	1,000.
Paint and Supplies	400.
Publicity and Promotion	2,000.
Costumes	500.
Lighting Equipment Rentals	1,500.
Sound Equipment Rentals	800.
Transportation	400.
	TOTAL $ 34,200.

Revenue

Grants (approved

MN Foundation	$ 5,000.
LJ foundation	2,000.
City of XYZ Contribution	10,000.
Request from AB Foundation	17,000.
	TOTAL $ 34,200.

Proposal I is a very straightforward request for funds which closely follows the Grantsmanship proposal model. I never had the sense that this proposal was funded on its poetic merit so much as on the strength of the need the writer established for senior citizen cultural programs. The budget also shows strong evidence of support from other foundations and from XYZ City as a stable sensitive, and effective program provider.

Sample Proposal #2

The Foundation for Cultural Arts and the Media requests a grant of $1500. from the Santa Monica Arts Commission.

Summary of Organization
The Foundation for Cultural Arts and the Media, a non-profit public benefit corporation was organized in 1979 for the primary purpose of developing educational programs in the arts and humanities, and providing film, radio, and television projects that encourage understanding and appreciation of the arts and humanites. The Foundation has been awarded two NEH grants totalling $50,000 for the planning and script development of "I Hear Tell: Storytelling in American Cultures," a proposed PBS documentary on the great living storytellers in America. The Foundation has also received $30,000 from the California Arts Council, $15,000 from the Exceptional Children's Foundation, and $15,000 from the California Department of Corrections to provide arts education and arts performance programs for developmentally disabled adults and for inmates in the five Southern California State Correctional Institutions. This project is being implemented

through a program called Artsreach. Most recently, the Foundation was awarded a grant from the UCLA Extension ($3000) and three grants from the California Council for the Humanities (totalling $38,627) to develop and produce a documentary film, Spires to the Sun: Simon Rodia's Towers in Watts. The Foundation sponsors Nierika Project: Performing the Four Changes, directed by Susan Suntree, who is developing a program to create interdisciplinary performances in collaboration with people in the process of rites of passage: death, birth, adolescence, marriage.

Description of Project

Sacred Sites/Santa Monica

The purpose of this project is to create a one-woman performance piece that explores with audiences images and history of Santa Monica's Native American sacred sites. I use "sacred" to mean places that are notably worthy of reverence or respect. These are often natural sites such as head waters, groves, places with spectacular or useful views. Inhabitants, locally the Gabrielinos, have sensed the value of certain places as enhancing their abilities to experience and honor life.

I will begin this project with a review of archeological and ethnographic materials about the natives of Santa Monica, as well as explore Santa Monica's geographical and bioligical history. (This work is a continuation of my interests in the relationships between ancient and modern life, and utilizes my background as a folklorist with a specialty in ritual and folk drama.) From my research I will create a performance made of poetry, song, movement and setting that is intended to enlarge the historical frame of cultural life in Santa Monica. I will give three one-hour performances in late July, free or low-cost ($3-5) with a map/history handout, at an outdoor or

accessible indoor location such as a Santa Monica park or building that best serves the material developed from my research. Sacred Sites/Santa Monica will give us the opportunity to be influenced by the aesthetics and intentions of the people whose culture came from intimate interaction with the landscape, the one still singing beneath our feet.

Sacred Sites/Santa Monica will appeal to a diverse audience. Santa Monicans tend to be civic minded, come from diverse ethnic and economic backgrounds, and take an interest in environmental issues, especially those concerning Santa Monica. This project engages these qualities and taps the interests of both adults and children because Sacred Sites/ Santa Monica involves homeland, history, Indians, and nuclear age interests in How to Live. Estimated attendance is about 250+ per performance. It will be publicized through flyers, mailings, postings, press releases, and radio and TV interviews. Special announcements will be made to target groups such as senior centers, schools, historical and environmental groups.

Combining poetry, song, and performance, Sacred Sites will be colorful, informative and stimulating. It will contribute to a public art that reaches beyond itself so that, as in Native culture, art as an isolated entity recedes, and more of the life of this place/Santa Monica, is revealed.

Unlike Proposal I, Proposal II is long on poetry and short on statistics. In part, this is due to the application form she uses. The proposal format influences the way a proposal is written and available space will dictate the amount of documentation an applicant provides. This artist clearly presents the sponsoring organization as one which has received recognition and financial support from other funding agencies.

The need for this project is not as well made as the need for the senior citizen theater project and this also has something to do with the proposal format. Under the best of circumstances,

individual artists will have a difficult time if their proposals are lumped together with proposals which address serious social problems.

Funding for individual artists is often available through state arts councils, the National Endowment for the Arts, and local arts commissions.

Sample Proposal III

Summary: In October 1985, the XYZ Foundation, a non-profit public benefit corporation, after almost thirty years of providing financial and artistic support for the museum, took over management from the City of XY. One of our primary missions is to expand and develop the museum exhibitions and programming in response to local and regional cultural needs by encouraging minority exposure and involvement; and by creating and strengthening the bonds between the artist, the museum and the community.

In keeping with this mission, we have recently developed an eighteen month pilot program of six one-person multicultural exhibitions showcasing the work of contemporary ethnic artists. The purpose is to recognize and promote the work of a group of talented young artists who are producing significant work in the mainstream of contemporary art and who have not yet achieved high visibility.

Enriching each exhibition will be lectures, demonstrations and workshops by the artists. All will be available at no charge to all segments of the general public.

Each exhibition will be highly publicized throughout XYZ City with emphasis on reaching minority community members as well as the general population. This will be done through print media, radio and TV.

The XYZ Foundation requests a grant of $23,9000 from the SRW Foundation to fund this worthwhile pilot project.

Project Description: *XYZ museum is a small museum which traditionally mounts 18 temporary exhibitions annually. Of these, six are shown in the galleries of the main museum building. These usually reflect the museum's focus on 20th century California and German Expressionist art. At lest one exhibiton a year has a multicultural theme, e.g. Manuel Alvarez Bravo Retrospective sponsored by the Mexican Consul General.*

Six are video exhibitons produced by the XYZ Media Arts Program shown in the upstairs galleries.

The remaining six exhibitions are mounted in the Carriage House Bookshop/Gallery; a separate gallery and sales space located on the other side of a large sculpture garden from the main museum building.

Unlike the main museum galleries which of necessity must establish a long-term formalized exhibition schedule, the Bookshop/Gallery maintains a more flexible exhibition program, reaching out into the ethnic communities by mounting such exhibitions as "Japanese paper: The Art Within" with workshops on Japanese paper making techniques.

A strong bond has developed between the large refugee community and the Bookshop/Gallery as a result of frequent shows and sales of fine Hmong jewelry, embroidery and handwork and a major exhibition "treasures of the Hmong People."

This history of past successes in addressing the needs of multicultural artists has prompted the museum to utilize this space for the NEW FACES: NEW SPACES exhibitions program.

The Bookshop/Gallery space is ideally suited for a series of small, concentrated, one-person exhibitions and has been

effectively used as such for the past 11 years. It provides an intimate, informal setting which invites the participation of the minority community members without the risk inherent in the formal, more intimidating "museum" atmosphere. No uniformed guards are apparent. Supervision is carried out by volunteers and the Bookshop/Gallery staff. Open to the sculpture gardens, it invites easy access and an ambiance which is casual and relaxed.

Most important of all, the gallery space is flexible to the programming needs of the participating artists. It lends itself to the display of both two and three-dimensional work, and can be redefined according to the requirements of the work.

The project plan is simple yet rich in all aspects:

** Six multicultural artists will be selected for six one-person exhibitions. Each exhibition will run for six weeks concurrently with the exhibitions in the main museum galleries. This will allow for maximum publicity and exposure as well as cross-fertilization between audiences. Two week intervals will enable the dismantling of one exhibition and the mounting of the next.*

** Artists have been selected by the project director and the supervising curator, with input from the XYZ Curatorial Staff and a volunteer advisory board comprised of leaders from multicultural and community arts organizations.*

** Two main criteria were used for the selection of the artists. The primary criterion (based upon the expressed desire of the artists interviewed to have their art recognized before their minority status) was the outstanding quality of the work submitted.*

** Secondly, we considered artists who were emerging into gallery spaces as well as artists who were emerging into museum spaces. Our rationale being that these were the artists who would benefit most from the exposure which we can provide through this program..*

* Each exhibiton will be initiated with an opening reception to which the museum membership, minority community leaders and the press will receive special invitations. A tremendous publicity thrust will precede each exhibition. Please refer to the section on goals and objectives for a complete breakdown of our plan.

* Plans are being made to create a poster by one of the participating artists, St. Jivago. The Bookshop/Gallery has a long string of past successes in promoting artists and the museum through this process, e.g., Harvey Edwards' "Legwarmers" and Grain Davis' "Lilies" are two of the most popular. Private funding has been obtained for the design and promoting of the poster, which would provide St. Jivago with income as well as tremendous publicity through national distribution.

* The exhibitons will have a definite educational component. each artist has committed to presenting a lecture about his or her work. Since the XYZ area has the highest percentage of first year immmigrants in the country, at least 50% of the participating artists are bi-lingual and will lecture in their own language.

The timeline for the six multicultural exhibitions follows the exhibiton schedule for the museum as a whole. A tentativew list of artist under condsideration for the project is included in the addenda.

1rst exhibition	June 22	— August 17, 1989
2nd exhibition	September 7	— November 2, 1989
3rd exhibition	January 25	— March 22, 1990
4th exhibition	April 12	— June 7, 1990
5th exhibition	June 28	— August 23, 1990
6th exhibition	September 14	— November 8, 1990

Whenever possible, we will try to schedule the multicultural artist's exhibition where the artist would benefit most from exposure to the exhibition in the main museum.

A demonstration and workshop will be organized during each exhibition to enable participants to better understand the heritage of each of the artists and the influences of Contemporary American Culture on their work. We believe that this is an important program because in working with the artists in their chosen media, workshop participants will develop a deeper understanding of the artists as individuals. In this way, we hope to break down stereotypical viewpoints and foster an awareness of the richness, diversity and interdependence that exists between cultural groups.

Hoon Kwak, a Korean watercolor artist who has committed himself to the project, expressed this concern eloquently when he said during an initial interview, "Americans categorize art as Eskimo, Indian or Jewish, as they try to approach the essence of the art work, which immediately separates them." The other artists we interviewed reiterated this and emphasized their attempts to integrate their ancestry into their American experience and to ultimately develop a universal quality to their art.

Proposal II is an example of a fairly long proposal which follows the guidelines of a particularly throrough foundation. In its completed form, with all its documentation and support letters, it runs to over 25 pages. It is unusual for a foundation to request so much information but veteran proposal writers should be prepared to switch gears with each new funding agency. Again, this proposal presents a clear picture of an organization which is stable, in touch with its community, realistic about what it can do and is serious about both its artistic and social objectives.

Sample Budget Form

Project Budget	Expenses		Revenue Source		
				In-kind contributions match (itemize and estimate value)	
			Organization's cash match*		Request from Arts Commission
I. Personnel Costs A. Artists' Fees	___ $_____ ___ $_____ ___ $_____ ___ $_____ ___ $_____ ___ $_____	Total Artists' Fees $_____	(Not Applicable) $_____		$_____
B. Technicians' Fees	___ $_____ ___ $_____ ___ $_____ ___ $_____ ___ $_____	Total Technician Fees $_____	(Not Applicable) $_____		$_____
C. Administrative Salaries	___ $_____ ___ $_____ ___ $_____ ___ $_____ ___ $_____	Total Administrative Salaries $_____	(Not Applicable) $_____		$_____
II. Production or Exhibition Costs *scenery, props, lights, hall rental, crating, storage, transportation, etc.*	___ $_____ ___ $_____ ___ $_____ ___ $_____ ___ $_____ ___ $_____ ___ $_____ ___ $_____ ___ $_____ ___ $_____	Total Production Cost $_____	$_____ $_____ $_____ $_____ $_____ $_____ $_____ $_____ $_____ $_____		$_____
III. Administrative Costs *advertising, promotion, etc.*	___ $_____ ___ $_____ ___ $_____ ___ $_____ ___ $_____ ___ $_____ ___ $_____ ___ $_____	Total Administrative Costs $_____	$_____ $_____ $_____ $_____ $_____ $_____ $_____ $_____		$_____
		Total Project Cost $_____	Total From Organization $_____	Total In-Kind Contributions $_____	Total Request From Arts Commission $_____

* Total sources from the organization - cash and in-kind contributions combined - must be greater than or equal to funds from the Arts Commission. It is not necessary that individual line items be matched dollar for dollar; rather, bottom-line totals must match. In-kind contributions may account for no more that 25% of the total match. For this program, volunteer time may not be counted as an in-kind contribution. Therefore, if personnel are donating their time, simply list "O" for the cost.

Sample Grant Application

Community-Initiated Arts Program
Application for Organizational Projects

Application Due Date:

Name of Organization_____
Address _____

Contact person_____

Summary of Organization
Please give a brief history; include statement of purpose and your objectives.

Description of Project
What are you proposing to do? How does this project correspond with
your objectives? Give date(s) and location of event(s).

Proposed Audience
Please describe the audience for whom your project is intended and the
estimated attendance. How will the event be publicized?

Attachments
In addition to this application and project budget, please make sure the following
are attached to your application:

1 Organizational budget for the fiscal year in which the project will take
place. Show expenses and sources of revenue.
2. Documents demonstrating community and critical support:
reviews (in 8 1/2" by 11" form), letters, etc.
3. Letters showing tax-exempt status from the IRS or the California State
Franchise Tax Board.
4. Audited financial statements, if available, for the organizations's last
fiscal year.

You may attach additional pages to this application if necessary.

33

Non-Profits

Since more grants are given to tax-exempt, nonprofit organizations than to individuals, you may want to apply under the "umbrella" of a compatible tax-exempt, not-for-profit corporation. A sample of arts service nonprofits is listed in Appendix IV.

The Internal Revenue Service defines a tax-exempt, not-for-profit organization as one in which no part of the earnings inures to the benefit of a private stockholder or individual and to which donations are allowed as a charitable donation.

If you wish to establish your own not-for-profit corporation, you should be prepared for weeks of painstaking work. You may wish to secure the legal services of an attorney from organizations such as the Bay Area Lawyers For the Arts in San Francisco or Volunteer Lawyers For the Arts in New York. If you live outside these cities, request information about low-cost legal services from your municipal arts department or your state arts council. It's also a good idea to consult one of the manuals or handbooks on the market which describe the basic steps involved in organizing a not-for-profit corporation. Volunteer Lawyers For the Arts (VLA) publishes many useful guides and pamphlets geared for laypersons interested in developing a non-profit. *This Way Up: Legal & Business Essentials For Artists; The Artist Tax Workbook; and To Be Or Not To Be: An Artist's Guide To Incorporation* are all published by this remarkable volunteer service organization.

If you are submitting a proposal under the aegis of an established not-for-profit corporation, be certain the organization's staff members and board of directors are involved in the development of your proposal. Projects designed in isolation from the staff and board of the sponsoring

organization are projects designed to fail. The support you will need to complete your project has to come from an organization that understands and values your vision. If your sponsoring organization is your own dance company or visual arts collective, you should still involve your colleagues and associates in the development process.

There is always a great temptation to protect your overworked board or the members of your company from chores they have neither interest in nor time to take on. Giving in to this temptation, no matter how noble your motive, is always a tactical error. If your board and the members of your company are overworked, the chances are great your workload is even more onerous. If you do manage to complete the research for your proposal by yourself, and write, type, and submit it on time, you may still be doing your organization a disservice. Requesting a financial and contractual relationship with a funding organization is serious business and your request should have the full and complete understanding and approval of your entire company. In the event your request is approved, you may discover you need the assistance of collegues who have been informed and involved in the development of your project before it can be implemented.

From time to time, I've been talked into preparing proposals for friends who were in crisis management and didn't have time to assist in development activities for their own projects. In the face of both experience and common sense, I've reluctantly gathered information from files and too-brief telephone conversations and written proposals I knew needed more research and structure. It has never worked out. Even when a proposal was funded (on the basis of the organization's history rather than the merits of the proposal), the recipients were unable to implement the project to the satisfaction of the

funders. Proposals developed in a vacuum are seldom tailored to the true capabilities of the organizations making the requests. Without exception I have found that organizations too busy to participate in the development process are too busy to spend a funder's money with care and creativity.

Don't Talk Yourself Out Of Writing Grant Proposals!

Many people avoid requesting grant support because they allow themselves to be intimidated by the mystique and razzle-dazzle of what has become almost a grantsmanship industry. The simple truth of the matter is that if you successfully prepared a cover letter and an application for admission to a college or university, you can write a perfectly acceptable grant proposal. There should be no mystery in a process which asks you merely to state your goals, prepare a budget, and describe your project. You should be able to persuasively build a case for support and if you are not prepared to do that, you probably are not prepared to spend someone else's money. Artists also frequently site a "lack of time" or "no talent for politicking" as a rationale for avoiding the grantsmanship process.

Preparing a grant proposal *does* take a lot of time to research and prepare. In an early arts survival seminar, Naj Wikoff, a sculptor who successfully manages his own business, recommended that artists interested in fundraising get up an hour earlier every day. Each artist would then have an extra seven hours a week to devote to fundraising or grantsmanship activities. Most of us are not very effective at managing our time and going through the process of applying for a grant can help us become more time-efficient.

The political aspects of the grantsmanship process are a matter of perspective. Most review panelists and foundation

staff members are people of good will and integrity. By and large they demand less attention, information, and handholding than many of the agents, directors, and gallery owners with whom you deal on a daily basis. This is not to say that artists who pander to panelists or panelists who encourage flattery and attention are impossible to find. They simply don't have much staying power. My experience has been that the average panelist or staff member is conscientous, hard-working, and encourages good communication, no more and no less. If you perceive documenting your work as "schmoozing" or "politicking", it will be tiresome. If you view it as a legitimate part of the grantsmanship process, it won't be any more stressful than calling your agent to tell her you're in a new Equity Waiver Play.

Once your proposal has been submitted, you should be prepared to do follow-up. If you have indicated in the cover letter that you will be calling to discuss your proposal, do so. Without making a nuisance of yourself, let the program officer at the funding agency know you are accessible if they need additional information. If you have not been notified about the results of the panel review within a few weeks of their posted notification date, write a short note of inquiry. If you are turned down for lack of funds, ask the program officer if he recommends that you re-submit the proposal in the next funding period. If you're turned down because of a deficiency in the proposal, discuss it with staff so that you can make adjustments before you submit again. Try to learn from the experience and maintain your contacts within the funding agency.

Most staff people are interested in their applicants and will want to be kept informed of their exhibitions, productions, or concerts in which you're involved. Writing grant proposals

is an ongoing process and whether you're approved or rejected, you'll very likely be dealing with the same staff people year after year. In many ways, they should be viewed as partners in your career, people who have a sincere interest in both your growth and the progress of the community you both serve.

Chapter III

Legal Assistance For Artists

This chapter will not offer the definitive analysis of the 1790 copyright law. Nor will it provide the answers to every question you've ever had about landlord-tenant agreements. What it will offer are answers to some very basic questions you should ask about protecting your work. I will also recommend some sources you should contact when you face more complex legal issues.

The smartest thing a young artist attending a major university can do is form a close and lasting relationship with a student from the law school. As an actor, dancer, composer, writer, or visual artist, you will confront legal problems throughout your career. At the very least, you should know where to find low-cost legal assistance, understand your rights, and be able to anticipate problems before they cost you time, anxiety, and money. Your best protection will always be knowledge but if you also happen to run into a lawyer who likes you and your work, marry her and put her on your board of directors.

The largest and best known organization involved in providing free legal assistance to artists is Volunteer Lawyers for the Arts (VLA), mentioned in Chapter I. VLA headquarters is in New York City but the organization also has affiliates in forty-two cities nationwide. (See Appendix III).

VLA offers free legal assistance only to low-income artists who meet their financial criteria. If you do not qualify for legal assistance, VLA lawyers will refer you to a non-VLA attorney who will provide assistance at a substantial discount.

If there is no VLA affiliate in your community, your state or municipal arts council should be able to refer you to other groups which provide low-cost legal assistance. There may also be qualified law students interested in providing volunteer help at some of your local law schools. Occasionally civic-minded firms, businesses, and corporations will lend legal counsel and executives to nonprofit corporations as their way of contributing to the general good of the community.

Obtaining free legal assistance may involve a good deal of "digging" and a prudent artist will find it before he needs it. As I suggested earlier, if you do find a lawyer who likes you, try to interest her in your work. It may not be judicious or ethical to try and merge your personal and professional interests with hers, but it may make perfect sense to invite her to join your board of directors. Free legal assistance is not impossible to find but if your Aunt Gladys tries to fix you up with a nice attorney, remember that the nearest VLA office may be four hundred miles away and say "Yes".

Copyright

One of the many free guides and brochures offered by the Volunteer Lawyers For the Arts is entitled *Copyright Guide For The Visual Artist*. Other brochures and pamphlets discussing copyright as it relates to artists are distributed by the U.S. Copyright Office, Library of Congress, Washington,

D.C. 20559. Ask for the latest copy of publications of the *Copyright Office, Circular R-2* and *Copyright Basics, Circular R-1*. Copyright registration procedures and application forms may be obtrained free by calling the local number listed under copyright forms under the Government Section in the telephone directory.

Since 1790 there has been a copyright law protecting creative ownership but until the Copyright Act of 1976, the law was not relevant to film, television, computer generated art, radio, or even choreography. The old laws also did not protect work previously sold or transferred. Thus, artists or their heirs were unable to benefit from the belated success or reissue of their works.

The most dramatic story I can use to illustrate the importance of copyright involves the creators of the Superman comic strip. In 1938 Jerry Siegel and Joe Schuster sold their comic strip story for $130. Although the comic strip, the television and radio series, the films and all the Superman products subsequently grossed well over a billion dollars, Siegel and Schuster received no compensation for their creativity. Eventually, in response to adverse publicity, Warner Communication Inc., the corporation which controls the rights to the Superman character, provided the two creators with pensions of $30,000 a year for life. The simple process of copyrighting their work could have protected them from such an obvious and costly injustice.

Although I urge all artists to consult the free brochures dealing with specific disciplines, I will briefly address the questions most frequently asked in the CalArts workshops on copyright law.

What Are The Rights Provided By Copyright?

Basically, copyright is a property right. Originally designed as an exclusive right to make copies of original work, copyright protection is now very wide in scope. It includes:

1. the right to reproduce a work
2. the right to prepare derivative works, such as a translation, an abridgement, or an adaptation
3. the right to distribute a work
4. the right to perform a work in public
5. the right to display a work in public

Works protected by the Copyright Act now fall in the seven following catergories:

1. literary works
2. musical works (including accompanying words)
3. dramatic works (including accompanying music)
4. pantomimes and choreographic works
5. pictorial, graphic and sculptural works
6. motion pictures and other audiovisual works
7. sound recording

Can Ideas Be Protected By Copyright?

Copyright will not protect ideas, names, titles, and short phrases. The Copyright Office states that "to be protected by copyright, a work must contain at least a certain minimum of authorship in the form of original literary, musical, or graphic expression. Names, titles, and other short phrases do not meet these requirements."

The idea of Boy Meets Girl cannot be protected but copyright will protect your *form of expression*. If you write a story about an American Boy meeting a Malayasian Girl on

the top of a Swiss mountain in the 1800's, you've put flesh on the skeleton of your idea and made it eligible for copyright protection.

In order to protect an idea, an artist should always document it before it is disclosed to others. This ensures that the *expression* of the idea is protected by copyright. If possible, the artist should describe his idea in writing, date the written description and have the date notarized or confirmed by another party (preferably a lawyer). At the very least he should mail a copy of his written description to himself or another person who will keep the envelope sealed. The idea should only be disclosed when it is understood that the idea will be kept confidential or that the creator of the idea will be compensated if it is used following disclosure. An idea is obviously very difficult to protect but an expression of an idea, whether in writing, on videotape, or in the form of artwork, can be protected.

Exactly How Do I Copyright My Work ?

It is important to understand the difference between obtaining a copyright and registering or proving your claim of ownership. To obtain your copyright, you need do nothing more than place the appropriate copy notice on your work. The United States copyright, recognized by all countries that have signed the Universal Copyright Convention, is composed of three elements:

Symbol

For copies of all works except sound recordings, the first element in the notice is the word Copyright, the abbreviation Copr., or the more commonly used symbol ©. Some artists use

both the word Copyright and the symbol ©. For sound recordings, the first element of the notice is the symbol ®.

Year

The year of the publication is the second element in the copyright notice.

Owner

The name of the owner of the copyright is the final element in the notice. The name should be the present owner rather than the original owner if ownership was transferred. By adding the words All Rights Reserved, additional international copyright protection is gained.

The copyright notice for a book or a painting should look like this:

© 1991, Judith Luther
All Rights Reserved.

The copyright notice can go on the front or back of your work. It can also be placed on any frame, mat, or base. In cases where there is no way to place notice on the work itself, the copyright notice can be placed on a label, providing the label always travels with the work. Record albums, tapes, and other sound recordings require the following form of copyright notice:

®1991 Wilder Recording
All Rights Reserved.

Although the law requires that the notice be fixed to the phonorecord or its label, it is common practice for the notice to appear on both the bottom rear of the jacket and on the album label.

Registration is not required for a work to be copyrighted but official registration is ordinarily necessary before you can file an infringement suit. Registration with the Office of Copyright will provide evidence of the validity of the copyright and your claim. It also makes you eligible for a larger award if you registered your copyright prior to the infringement. With registration you can be awarded "statutory damages", plus $200 for innocent infringement. If willfulness is proven, the award can be as much as $50,000 per infringement plus attorney's fees. Without registration, you can only be awarded actual damages.

Since registration is such a simple matter, it makes good sense to gain the added protection by filing the following with the Copyright Office:

1. An application supplied upon request from the Copyright Office, Library of Congress, Washington, D.C. 20559, 202-8700.
2. A $10 filing fee.
3. Two copies of the work (one, if unpublished). If your work is one-of-a-kind or three-dimensional, send "alternate" identifying material such as photographs or slides.

How Long Is My Work Protected By Copyright?

Under the new law, your copyright will extend through your lifetime plus fifty years. After that, the work is in the public domain.

Given the ease with which work can be protected, most professional artists choose to do so. Going through a few simple steps will serve notice to the world that you hold creativity, hard work and property in high regard and that you

expect the world to share your respect for your own work and that of others.

For more extensive information about copyright law, I recommend:

Trademark and The Arts, Center For The Law & Art, Borchard, 1988.

Business and Legal Forms For Fine Artists, Allworth Press, (Crawford), 1990.

A Writer's Guide To Copyright, Poets and Writers, Inc., 1990.

The Artists' Survival Manual, Scribner (Klayman and Steinberg), 1984.

Legal Guide For The Visual Artist, Allworth Press (Crawford), 1990.

Licensing Art and Design, Allworth (Leland), 1990.

The Rights Of Authors And Artists, The American Civil Liberties Union Handbook (Norwick, Chasen, and Kaufman), 1983. (Out of Print, but check your library).

Musician's Guide To Copyright, Bay Area Lawyers For The Arts (Erickson, Hearn, and Halloran), 1979. (Out of Print, but check your library).

Contracts

In layman's language, a contract is a binding agreement between two or more parties. It is not always written nor even always agreed to orally. Although usually set forth in writing, many valid and enforceable contacts are not written.

In the best of all possible worlds, contracts would not have to be documented. Humanity being somewhat less than

perfect and my memory being *most* imperfect, I personally prefer to clarify my business relationships with a document that at least defines my responsibilities, schedule, and compensation.

The problem with most contracts is that they need a Philadelphia lawyer to interpret them. Incomprehensible documents make most of us suspicious and since we don't like to sign contracts we don't understand, we're forced to seek legal advice. I recognize that dealing with a complex video or cable market makes it necessary to develop a far-sighted and comprehensive document which protects everyone's rights. However, I think contracts are almost always more complicated than they need to be. Contracts should be tailor-made for the individual or art form and if legal terms are necessary, they should be presented so that an average PhD can understand them.

In an article entitled "Selling Under Contract", Tennyson Schad, the founder and owner of Light Gallery in New York, advises that contracts be "short and sweet."

"If you need a lawyer to understand it," he asks, "what good is it?" This refreshingly sensible article is included in Lee Evan Caplin's excellent book, *The Business of Art*.

For a sample contract I can personally decipher, see Appendix X. It is about ten pages too long, but the language is reasonably clear and a variation of it is frequently used by artists and gallery owners. Model contracts are also available in such publications as *The Artist-Gallery Partnership* (American Council For The Arts, 1285 Avenue of the Americas, New York, New York 10019); *The Artist-Gallery Consignment Arrangement Agreement* drafted by Artists, American Artist Business Letter, Billboard Publications, New York; *Law and the Writer*, Writer's Digest Books, 9933 Alliance Road,

Cincinnati, Ohio 45242; and *Making It Legal: A Law Primer for the Craftmaker, Visual Artist, and Writer*, McGraw Hill, New York.

The Screen Actors Guild, the American Guild of Musical Artists, the American Guild of Variety Artists, the American Federation of Musicians, the Society of Stage Directors and Choreographers, as well as most of the other performing arts unions, will provide standard (and long) contracts. Since these contracts are fine examples of legalese in motion, I suggest that you review them with your agent, your manager, a lawyer and if one is handy, a Ouija Board.

In dealing with people who are contract-shy, Timothy S. Jensen, staff attorney for Volunteer Lawyers for the Arts, suggests several options:

1. A letter of agreement stating what you will do and what they will do in non-legal language.

2. A certified letter from you to the theatre or producer stating your understanding of your professional relationship between you. If their understanding is different, they must state it in writing, so that each party has a document of the agreed terms.

3. Witnesses to corroborate changes in plan, dates, number of costumes, and other details. Get names and addresses. If there is a disagreement, be sure a third party is present to observe or is informed immediately afterward.

4. A diary. If all else fails, you can turn it into a best-selling book.

Don't sign anything you don't understand or think you'll want to change a few months down the road. Contracts, like personal relationships, work only as long as all the involved parties are satisfied with what they're giving and getting. Define all the conditions of a contract before the ink dries on your signature rather than later in arbitration hearings or contract litigation proceedings.

Chapter IV

Financial Management

The training artists receive in dance, theatre, and art schools seldom includes an introduction to basic bookkeeping, tax preparation, and budgeting. For some strange reason, educators who design programs for artists seem to think their students will emerge from school fully prepared to successfully manage the business side of their careers and/or will be ready and able to hire professional account-ing/bookkeeping assistance.

It is a fatal flaw too many arts education programs do little to correct and one which encourages artists to give their accountants and bookkeepers far too much power. Although artists frequently treat it as such, bookkeeping is not a mystery only accountants and Harvard Business School graduates can unravel.

Record Keeping

The best bookkeeping system is the simplest bookkeeping system. If you can't understand your own records and if you're spending more than a few hours a week on bookkeeping, your system is too complicated. Basically, you need to remember

that you're only keeping records for two purposes:

1. So you will know how much your business is making or losing.

2. So you can account to the government for both your income and expenditures.

One of the most effective and easiest bookkeeping systems I've read about is recommended by photographer Jeanne Thwaites in *Starting And Succeeding In Your Own Photography Business*. She suggests reducing your book-keeping system to three ledgers and a Spike (a weighted base with a metal spike sticking upwards). Ledger 1 should be used to record money *paid* to you. Ledger II is used to maintain records on money *owed* to you. Ledger III is used to record your *expenses*. The Spike is used to hold receipts and other information until you have time to record it in Ledgers I, II, or III.

In order to save time, buy ledgers that are uniform in size but in different colors so that you can identify them quickly. Use an ink or ballpoint pen for all your record keeping. Black is preferable, in case you need to photocopy your records. Do not use a pencil if you wish the IRS to take you seriously. You will at least want to record the date you received income, the amount, and its source in Ledger I. Whether you do anything else will depend on what you want to accomplish with your bookkeeping. As you expand your business, you may discover a need for more information but you should always be wary of unnecessary recordkeeping or duplication. Ledger II is for your receivables. You will need to record the date of your business transaction, the person or company to whom you sold an item or provided a service, their address, the amount owed, and the billing date or status of the account (e.g. Account went to Collection on 8/14/86.)

Ledger III is used to keep track of all the money you spend. Record *when* you spend, *where* it goes, the *amount* of the expenditure and whether you paid for it by check or with cash. The Spike will simply serve as a temporary file for all the receipts and bills you don't want to immediately enter in your ledgers.

A checking account is another boon to recordkeeping. To a great extent, a checking account will duplicate your records in Ledger III. If you lose receipts, which the IRS will demand as proof of purchase, you can use your cancelled checks as back-up receipts.

Since most small businesses fail because of cash flow problems, you need to be particularly careful about monitoring your expenditures. By monitoring the cost of what you sell as art, you will also be able to determine the price you need to charge in order to make a living from your work. You may also discover you're spending too much on items that don't contribute to the service you provide or the product you create. By overspending on items which don't contribute to your art, you may deprive yourself in ways that will eventually force you out of business. Keeping good records will give you the information you need to analyze where you're going and what it's costing you to get there.

Tax Preparation

While it is both realistic and desirable for you to do your own bookkeeping, it is very important to hire an accountant to prepare your tax returns. Tax laws change so quickly you will be hard-pressed to keep abreast of the changes. If you insist on playing accountant, you may cheat yourself out of many profitable and legitimate deductions. If you can't afford to hire an accountant, you may be able to locate one who will

work free of charge or at a greatly reduced fee. Try calling Accountants for the Public Interest or the Volunteer Urban Consulting Group, Inc. (VUCG), a nonprofit organization founded by the Harvard Business School Club of Greater New York. VUCG receives volunteer support from eight business school alumni clubs scattered throughout the country, and offers nonprofits assistance in financial planning, budgeting, marketing and accounting. For additional information about VUCG programs, write Volunteer Urban Consulting Group, Inc., 300 East 42nd Street, New York, NY 10017.

Accountants for the Public Interest has a number of affiliate offices throughout the country. If there is not an office near you, call one of the affiliates and ask to be referred to an accountant who does volunteer consulting in your city. Many state branches of the Society of Certified Public Accountants also have public service committees that can provide the assistance you need.

Accountants for the Public Interest
1625 I Street, N.W.
Washington, DC 20006
(202) 659-3797

New Jersery Accountants for the Public Interest
965 West Seventh Street
Plainfield, NJ 07036
(201) 757-9313

New York Accountants for the Public Interest
36 West 44th Street, Suite 1208
New York, NY 10036
(212) 302-6940

CPA's for the Public Interest
220 South State Street, Suite 1404
Chicago, IL 60604
(312) 786-9128

Community Accountants
3508 Market Street
Philadelphia, PA 19103
(215) 662-0211

The Support Center
57 Eddy Street
Providence, RI 02903
(401) 521-0710

If you don't believe that hiring an accountant to prepare your income tax returns will save you grief and money, you should at least consult one of the several excellent guides on the market for artists who insist on doing things the hard way. *The Art Of Deduction,* prepared by the Bay Area Lawyers For The Arts; *The Art of Filing,* by Carla Messman; and *Fear of Filing: A Beginner's Guide To Tax Preparation And Record Keeping For Artists, Performers, Writers, and Freelance Professionals* by Theodore W. Striggles, are all designed to help working artists stay in the good graces of the IRS.
Simply proving they are, indeed, professional artists is a major problem for many artists whose major source of income is derived from driving a taxi or from tips they make as waitresses. Maintaining records and receipts which document meetings with gallery owners, casting agents, and publishers will not only help establish your identity as an artist but will also bring your net profit or taxable income down so that you pay the government as little as possible.
In the early years of their careers, artists often invest more in their work than they get back in income. With proper documentation, you can legitimately place yourself in a bracket that pays no taxes. It involves keeping a diary, simple ledgers, and holding onto a lot of receipts for parking, classes, postage, special clothing, and equipment. It's worth the trouble if, at the end of the year, you've saved $800 or more in taxes.

Good records from the lean years will also help you when you wish to reduce your tax rate through income averaging. When your annual income suddenly skyrockets through the sale of a piece of sculpture or the commission of a piece of music, you will want good records to document that you lived on weak coffee and gruel the preceding four years. There are certain requirements to be met in order for income averaging to be applicable but in concept, the process will level out the current year's (high) taxable income with the average (low) taxable income from the prior four years. This is very important if you're an actor or musician whose income fluctuates widely from year to year.

Some examples of expenses that, as of the date of publication, can legitimately be deducted from your income in order to reduce your taxes:

* Travel expenses
* Offices and offices in the home
* Commissions to agents and managers
* Equipment used in the trade or business
* Insurance or repairs
* Supplies and inventories
* Special clothing worn solely for your work
* Legal and accounting fees
* Studio rent
* Entertainment related to your business
* Postage
* Booking fees
* Dues and fees for business related workshops, seminars, or memberships.

These are only a few examples of expenses which can be deducted. Although tax laws may treat artists as both individual income earners and sole proprietorships, they also provide

special benefits artists are in a unique position to enjoy. Find an accountant who has worked with other artists (and one who has a reputation for being scrupulously honest) to explain what some of those benefits are. Once a qualified accountant has guided you through an encounter with the IRS, you won't want to go back to second-guessing government auditors.

Information You Will Need To Keep The IRS And Your Accountant Happy

If you receive more than $600 in any calendar year from an individual or a company, you should expect to receive a Form 1099-MISC. If you pay someone $600 or more in a calendar year, you must issue them a Form 1099-MISC indicating exactly how much you paid them. The 1099-MISC form comes in three-parts. Copies are sent to both the recipient of the money and the government. The payer keeps the third copy as proof of deductions made on his Schedule C.

As a self-employed person, you will at least need to file Form 1040, Schedules C and SE (See Appendix IV), and possibly Forms 4562 and 3468. If you purchased business equipment in the preceding year, you should indicate that on Forms 4562 and 3468. If you own your own home, you will need to itemize personal deductions on Schedule A. If you are married to a working spouse, you will also need a Schedule W and if you paid for child care while you worked, you will need Form 2441. Begin preparing your federal returns by starting with Schedule C. Schedule C consists of four sections: an introduction plus Part I (deals with income), Part ll (provides space to list your deductions) and Part III (which determines the cost of goods sold in your business).

You can obtain all the forms you need from your nearest federal building or from most post offices. If these buildings are not conveniently located, write the federal government and request a complete packet of all necessary forms.

Keep track of all reports such as interest payments, 1099-MISC forms, and statements of dividends which come to you through the mail. Set the reports aside in a manila envelope marked Record of Miscellaneous Income and turn the envelope over to your accountant at tax time.

As a self-employed person, you are required to make quarterly estimated tax payments to cover your annual tax liability. From your last tax payment, estimate the amount of tax you expect to pay in the current year. Divide that amount by four and make your first quarterly payment by April 15. The second payment is due in mid-June, the third in mid-September, and the fourth on January 15. Always pay at least as much each year as the previous year's total tax in order to avoid a costly interest charge.

Prepare for your accountant as carefully as you would prepare for a meeting with a gallery owner or a producer. Remember that the money you earn and keep is as valuable as additional earned income. A Supreme Court decision has given every taxpayer the right to arrange his affairs so that he can pay the least amount of tax. Take advantage of that and hold on to your hard-earned dollars.

Chapter V

Opportunities For Artists Who Wish To Work Abroad

In 1985 video artist Bill Viola worked in Stockholm, Geneva, and Marseille, generating, he estimates, almost forty per cent of his work and income for the year. Meredith Monk, Molissa Fenley, and Robert Wilson have also spent a large portion of the past few years abroad, enhancing not only their individual and collective reputations but the myth that gold and appreciation are offered in abundance across the seas.

The Wilsons and Violas notwithstanding, it is very difficult for artists to find work in foreign countries and for a variety of reasons, it's likely to get more difficult. Although in recent years a few American artists have worked and earned more money in Europe than they have in the United States, now even they anticipate a decline in foreign bookings. Dancer/ performance artist Tim Miller, successful in obtaining bookings in Great Britain, Austria, Italy, France and Scandinavia, feels the decline in demand for American artists may be a result of the strong impact Americans have had on the work of contemporary European artists. Inspired by their American colleagues, more European artists are producing more work

and demanding more government support than they've received in the past.

The extent to which American artists are welcome abroad depends on many factors which have little to do with artistic merit. The political climate, the currency exchange, the size of a company or production, and the level of risk and inconvenience artists can tolerate all play a part in determining whether or not they appear at the Edinburgh Fringe Festival or the Schaubühne Theater.

The political issue may be the most difficult for apolitical artists to understand. It is certainly a hard one to defend but we must recognize that, given the opportunity, most governments will use the arts for political purposes. Great Britain, which has a very active Visiting Arts program, showed Russian artists a distinctly cold shoulder following the Soviet invasion of Afghanistan. No official government pressure was brought to bear on the Visiting Arts Administration but during that period of time, they simply decided to look elsewhere for their cultural imports. In the United States, the United States Information Agency (USIA) is highly selective in the artists and programs they export through their *Arts America* program. For all practical purposes, this agency functions as a propaganda council and generally exports artists most likely to create good will for America.

One can argue that arts organizations should not be embroiled in political issues and that individual artists should decide when and how they will symbolically or actually protest human rights violations. The reality of almost all government-funded cultural exchange programs is that in varying degrees, they *are* political. Artists who accept government funding should not be surprised or shocked if their performances and exhibitions fit into some agency's

illogical (or logical) political strategy. It's interesting that since the Reagan-Gorbachev summit talks, Russian performers are more welcome in the United States that they have ever been. Timing is indeed everything.

The strength of the American dollar can also have adverse impacts on cultural exchange programs. European sponsors paid much more in the 1980's for American artists than they did when American inflation was at its peak in the late 70's. If a dance company charged $1000 for a performance in 1979 and charged exactly the same fee in the mid-eighties, the European sponsors had to dig deeper in their pockets to compensate for the unfavorable exchange rate. 1990 saw devaluation of the American dollar, and once again American contracts are comparatively inexpensive. However, European lodging and travel expenses now appear incredibly costly. If local per diem costs are not included in your contract, watch out—research all costs before you sign.

The lack of reciprocity between U.S. and foreign governments has also caught up with us. For years European arts councils have not only paid for American artists to perform and exhibit in Europe but have also paid for their artists to come to the Unites States. Today even our most generous friends in Holland, England, and France are beginning to question this inequitable cultural exchange.

In 1980 Nancy Hanks, former head of the National Endowment for the Arts, founded Arts International, a non-profit oganization dedicated to facilitating international arts exchanges. Arts International recently merged with the Institute of International Education, in New York, and now provide resource guides for funding artists seeking to perform outside of the United States.

The size of your company or project is another economic factor which will determine whether or not you are invited to work abroad. Soloists are obviously cheaper and easier to present than a large theatre company with a complicated lighting design and set. You may wish to get yourself established and recognized overseas before you try to find jobs for your friends and colleagues. This, in itself, can be a huge undertaking and may initially involve paying for your own exploratory tour of the international arts market.

Veterans who work the foreign circuit suggest a variety of ways to get established but they all seem to agree that the tapes, resumes, and marketing materials which are so important in America have limited impact in Europe. According to Tim Miller, "almost no sponsor will book artists he hasn't actually seen or heard." If necessary, he suggests performing on the street outside important festivals in order to be seen. "Word of mouth," he says, "is very effective in getting your name around. If one sponsor sees you and likes you, he'll tell other sponsors and you'll get more work."

In most European countries, private sponsors and donors receive no tax benefits. As a result, many arts activities are subsidized by government grants. According to Frans van Rossum, former director of the Holland Festival and now Dean of the Music School at the California Institute of the Arts, this frees sponsors to present work which might be considered experimental or risk-taking. Without the burden of having to sell tickets to underwrite a performance or exhibition, presenters can nurture experimental work. Avant-garde choreographers, composers, video and performance artists like Robert Wilson, Philip Glass, and Meredith Monk were supported by European sponsors long before they gained wide recognition and acceptance in the United States.

Van Rossum suggests that Americans on their way to Europe collect addresses of sponsors, presentors, and artists before they leave the country. Once there they can follow up with one-on-one visits. While such informality might not be effective in America, he feels it is appropriate for Europeans accustomed to a much more straightforward, personal approach. In addition to the well-known museums and festivals, he urges artists to contact the many underground organizations which support contemporary work. Rather than slick press packets he specifically advises musicians to prepare a realistic repertoire list which shows consistency, originality, and an approach to music which is different from the traditional repertoire sponsors have heard a thousand times. Van Rossum also cautions Americans not to get caught up in "hype". "Sponsors are looking for content and quality," he says. "Slick, glamorous press kits are not only worthless, but counter-productive."

Kira Perov, an arts photographer and independent curator with extensive experience in producing video exhibitions and installations around the world, also feels that direct contact is essential for video artists who wish to do international work. "It's better for a video maker to go to one festival in Europe than to write a hundred letters to museums and sponsors," she says. She also suggests that artists may have to subsidize their own initial foray out of the country. "Given talent and seriousness of purpose," she says, "the contacts artists make, the experience they gain, and the exposure to fresh ideas they receive will be worth the money they invest in travel."

Short of going to Europe, artists are advised to go to New York or some other city regularly visited by European sponsors and presenters. Many international sponsors and festival directors make annual visits to New York to view work at sites

such as La Mama, the Brooklyn Academy of Music Opera House, Dance Theatre Workshop, the Kitchen, and Danspace. During the past ten years the network of presenters in Europe and the U.S. has expanded and strengthened. European sponsors now rely heavily on recommendations from trusted colleagues and will make a point of going to a particular gallery or performance space if referred by the Executive Directors of Dance Theatre Workshop or the Brooklyn Academy of Music.

Negotiating contracts is a dicey business in any country and is a subject I cover at more length in Chapter III. Many presenters have a standard contract which you should have translated before you sign it. The method of payment can be very tricky and you should clearly understand whether you will receive your fee in the currency of your foreign sponsor or in American dollars. As a general rule you should not accept more foreign currency than you expect to spend during your visit in the country. You should also request an advance payment of at least 25% of your total fee one month prior to the time you leave the U.S. Technical riders attached to your contract should be translated before you send them so that you and your sponsors have a clear and accurate understanding of your technical requirements. If at all possible, consult an attorney (see Chapter III on Volunteer Lawyers for the Arts) before you sign a contract with an overseas sponsor. If legal advice is unavailable, ask artists, curators, managers, or arts administrators who have worked abroad to review your contract before you put your name on the dotted line.

Three organizations which will provide artists with information about working overseas are the International Theatre Institute/US; the United States Information Agency (USIA) "Arts America" Program; and the Canada Council

Touring Program. Their current phone numbers and addresses are as follows:

Arts International
Institute of International Education
809 United Nations Plaza
New York, NY 10017
(212) 883-8200

International Theatre Institute/US
220 West 42nd Street, Suite 1710
New York, NY 10036
(212) 944-1490

United States Information Agency "Arts America"
301 Fourth Street, S.W.
Washington, DC 20547
(202) 619-4779

Canada Council Touring Office
P.O. Box 1047
99 Met Calfe
Ottawa, Ontario K1P-5V8, Canada
(613) 598-4342.

Some embassy and consular staff will also provide good information about their cultural and international touring programs.

There are a limited amount of fellowships and scholarships made available here for artists who wish to perform and study abroad. These stipends can make up for certain expenses for travel and housing, and in lucky instances, pay the way for the entire venture.

Fulbright grants for creative and performing artists offer funding for a year of study and training throughout the world. A more regional organization, Partners of the Americas, develops exchange opportunities for artists to trade places with fellow artists in Latin America and the Caribbean basin

for stays of one month and longer. The National Endowment for the Arts has fellowship applications for those artists who may wish to visit Japan and France.

The prospects for touring for individual artists and troupes is difficult, as we've already mentioned. The issue of artistic merit tends to take a backseat to considerations like the political climate, level of risk, money rates, and inconvenience one will encounter on sojourns abroad. You're very unlikely to receive bookings from foreign producers who've neverencountered your work, so a good deal depends on your prior visibility in the States. There is an Artistic Ambassador Program of the United States Information Agency that funds trips for non-professional musicians to many countries.

The Fund for U. S. Artists at International Festivals and Exhibitions is a joint sponsorship created to garner more international attention to American visual and performing artists. The U.S.I.A. distributes funds to qualifying visual artists and the N.E.A. provides this service to performing through their International Office. Performing groups also contact International Festival offices themselves and receive performing space, often gratis. A San Fernando Valley acting troupe took their offbeat comedy called THE STEVEN WEED SHOW to the Edinburgh Festival on a lark two years ago. They were given a tent to perform in off Edinburgh's Royal Mile and met with bewildered, but modest success from the European theatregoers. Resourcefulness is still the key to this kind of enterprise.

As has been widely suggested, the best information sources are other artists who have worked abroad. Artists like Eric Bogosian, Tim Miller, Bill Viola, Terry Allen, and Meredith Monk are extremely approachable and knowledgeable about the festivals, museums, and theatres which welcome American

artists. The International Theatre Institute also publishes The International Directory of Theatre, Dance and Folklore Festivals, a very useful guide which maintains current information on presentors and sponsors.

The following theaters, arts centers, festivals, and individuals may also provide useful information for artists with few personal contacts outside the United States:

Berlin Festival
Budapesterstrasse 50
D-1000 Berlin 30
Federal Republic of Germany
(30) 25489

Centre for the Arts
John MacFarlane, Assist. Director
Simon Fraser University
Burnaby, British Columbia V5A-1S6
Canada
(604) 291-4267

City of Longon festival
City Arts Trust, LTD
230 Bishops Gate Hall
London, EC 2M 4QH
United Kingdom
(01) 377-0540

Copenhagen Summer Festival
Trevor Davies, Director
Johnstrupsalle 3
1923 Copenhagen
2200 Denmark
(01) 39-60-33

Dance Umbrella
Riverside Studios
Crisp Road
London W6 9RL
England
(071) 741-4040

Edinburgh Festival Fringe Society, Ltd.
M'Naire MacKenzie-Robinson, Director
Royal Mile Centre
180 High Street
Edinburgh EH1-1QS
Scotland/UK
(31) 226-5257

Edinburgh International Festival
Edinburgh Festival Society, Ltd.
Frank Dunlop, Director
21 Market Street
Edinburgh EH1-1BW
Scotland/UK
(31) 226-4001

Festival d'Automne
("The Autumn Festival")
Michel Guy, Director
156, rue de Rivoli
75001 Paris
France
(42) 96-12-27

Festival d'Avignon
Alain Crombecque, Director
66, rue de la Chaussée d'Antin
75009 Paris
France
(48) 74-59-88

Festival D'Ete International De Quebec
26 Rue Saint-Pierre
Case Postale 24
Montreal, Québec PQ G1K 7A1
Canada
(418) 692-4384

Festival International de France de Paris
15, Avenue Montaigne
75008 Paris
France
(47) 20-36-37

Festival of Two Worlds
("Spoleto Festival")
Via Cesare Beccaria 18
00196 Rome
Italy
(39-743) 28-120-36-14-041

Festival Van Vlaanderen
E. Flageypleih 18
B - 1050 Brussels
Belgium
02 / 648-14-84

Helsinki Festival
Karsten Bo, Director
Unioninkatu 28
SF 00100 Helsinki
Finland
(358-0) 659-688

Holland Festival
Ad 'Sgravensanke, Director
Kleinagartmanplantsoen 21
NL 1071 RP, Amsterdam
The Netherlands
(31-20) 27-65-66

International Film Festspiele Berlin
Moritz de Hadeln, Ulrich Eckhardt; Directors
Budapesterstrasse 50
1000 Berlin 30
Federal Republic of Germany
(30) 254-890

London International Festival (LIFT)
Unit 33
44 Earlham Street
Covent Gardens
London WC2H 9LA
England
(071) 836-7433

Munich Biennale
Hans Werner Henze, Director
Rindermarkt 3-4
8000 Munich 2
West Germany

Opernsfestspeile
Professor WolfgangSawallisch
Maax-Josefs-Platz 2
8000 Munich 22
Federal Republic of Germany
(089) 21-851

Visby Festival
Tranhusgatan 47
S - 62155 Visby
Sweden
(031) 0498 -11068

Zurich International Festival
Verkehrsverein
P.O. Box 8023
CH - 8023 Zurich
Switzerland

The Center for Arts Information in New York publishes an organizational guide called INTERNATIONAL CULTURAL EXCHANGE. Its a comprehensive guide to institutions and groups that help foster international cultural exchange programs and may be purchased at an affordable cost from them (see APPENDIX). The administrators at Arts International, a program of New York's Institute of International Education, offer a computer data base service to the public. They have information on many fellowships and arts exchange programs, worldwide, that they provide artists for an hourly fee or membership costs. There are some real hurdles that you'll

encounter in seeking to take your artwork abroad, but enormous rewards await you in terms of experience, if you make the leap.

It's unrealistic to expect a fortune from the concerts and exhibitions you schedule overseas. It *is* reasonable to expect travel costs, per diems, small fees, and experiences that will more than compensate for any reduction you might take in income. Getting reviews from Europe, Japan, or Canada can also be very helpful in getting engagements in the United States. As in all artistic ventures, there's an element of risk involved in saving up your tips to finance an exploration of Europe but the opportunity to do challenging work for new and appreciative audiences should never be discounted.

Chapter VI

Beginning A Career As An Actor

*"Everyone will think you' re crazy and everyone will be right.
There's no other profession that requires so much hard work
and dedication and pays off in poverty and rejection. It's a
tough business and you have to be tough, talented, and damn
lucky to survive even ten years as an actor in New York or
Hollywood."*

Cris Capen
Actor

There are hundreds of theatre How To books on the
market. Two of the best, *Your Film Acting Career* by M.K.
Lewis and Rosemary Lewis, and *Your Acting Career* by
Rebecca Nahas, provide excellent information and counsel
for beginning actors. Their advice is sensible, authoritative,
straightforward, and encouraging to actors who have made a
commitment to work hard, sacrifice, and endure. This chapter
will briefly focus on issues and problems most new actors face
and it will also offer answers to a few questions many actors

think cannot be answered. For more comprehensive career information, I recommend the Nahas and Lewis books.

The financial plight of actors is well-known but some of the statistics bear repeating. In 1985 only 600 members of the Screen Actors Guild earned over $10,000. With 55,000 members making poverty wages and 75 percent of Equity members unemployed at any given time, actors who envision a life of comfort might be well-advised to consider other careers. The actors' struggle is long and hard and only those who are tough, talented, tenacious, and extraordinarily lucky are likely to survive for the count. The Lana Turner overnight success stories are more the stuff of myth than reality and more representative of an era when careers were made and broken by powerful and whimsical studio bosses.

Actor Peter Coyote views the sad financial state of his profession philosophically. "I made no money as an actor until I was thirty-eight," he says, "and I think that's okay. It's a great gig and it should be difficult. One of the ways to keep people who are not serious about acting out of the profession is to make it hard." Coyote, whose vision and energy contributed to the shape and substance of the California Arts Council, a state agency which provides grant support to theatres and theatre people throughout California, has had considerable experience reviewing requests for support from talented actors willing to work in schools, prisons, and community centers. "Young actors who want instant fame and success are too greedy;" he says,"they're concerned about the wrong things. I don't suggest that the cream necessarily rises to the top but if they're good and stick to it, they'll make it."

His views were echoed by Fionnula Flanagan at the 1986 California Theatre Conference. "When I was younger I would have walked barefoot across the Sahara Desert at high noon to

get a part in a play. Money was not an issue. To a great extent, this is still true although now I would probably wait until sundown and steal a camel." This chapter is written for the Flanagans and Coyotes of the future, and for all actors who value their art enough to work under the most horrendous conditions for very little pay and no recognition. No book can make you an actor but I hope the information provided in this chapter will be helpful to those who steadfastly refuse to be anything else.

Training and Preparation

When you decide to make the transition from amateur to professional actor, you should realize you will be competing with an almost limitless number of actors for a limited number of jobs. Many of those actors will be veterans who have been in the business for five, ten, even fifteen years. In your first auditions you must establish your credibility as an actor and present skills and tools which will make it reasonable for a stranger to give you a job. If you are not prepared, you are in the wrong place at the wrong time. There's no point in searching for an agent if you are not ready to do a terrific cold reading. If you can't audition like a professional, don't spend your time and money trying to get a card from Equity or SAG. Before you invest in photographs and the tools of your trade, invest in training. Prepare yourself for a business that is both tough and overrun with serious, talented, hardworking professionals.

Training can be obtained at any number of places. Colleges, universities, professional schools and workshops all offer classes which can be invaluable as you pursue your professional career. Actors get jobs through leads from other actors more often than from producers and directors. The friends you

make in acting school will not only be immediately helpful to you by giving you encouragement, criticism, and advice, but they will often remember you after they have become successful.

Actors clearly must exercize caution in selecting classes and workshops. A lot of unemployed actors offer classes in order to make a little money. You may or may not learn what you need to learn from them. Most reputable acting schools and teachers will let you audit classes and you should take advantage of that opportunity.

The need for good training was also discussed at the 1986 California Theatre Conference. In a workshop for actors, Barbara Bain, a veteran of both stage and televison, cautioned "If you go to an acting class and they're working from a television script, walk out. You may never do Shaw or Ibsen or Shakespeare but working from these kinds of scripts will prepare you for anything you do. The technical aspects of film or television can be learned in four or five hours but you have to have the experience of working with wonderful material in order to gain the solid foundation you'll need to perform on a sound stage."

Before choosing an acting teacher or school, discuss the ones you're considering with other actors or call Equity to see if they have information about the teachers and schools on the top of your list. You might also want to answer the following questions before you turn over your hard-earned money for tuition:

1. What is the cost and method of payment? Can you pay by the week, the month, the session or do you have to pay the full fee in advance?
2. Who is the teacher? What training and experience does she have?
3. Where does the class training lead?
4. In what method of acting are you interested? Should you be studying musical-theatre, mime, impovisation, Method acting, or Grotowski-based physical theatre? Will the class you're considering provide the experience you want?

Some of the best acting schools offer two-year programs which provide students with opportunities to perform before audiences of directors, agents, producers, casting directors, and other professionals who work in film and theatre. Admission for second year training is usually based on the work you've done the first year. Almost all good schools will require an interview and audition prior to approval of registration.

Tuition fees and terms of payment vary but you should plan to budget at least $1800. a year for schools which offer a full-time program. While you're "in training", save whatever money you can. The basic tools of your trade (phone service, photographs, resumes) can be quite costly Union fees are very high, and your food, rent, and transportation invariably cost much more than you expect to pay.

There are thousands of acting schools around the country. Several in New York and California which come highly recommended are:

New York

Stella Adler Conservatory Of Acting
130 West 56th Street
New York, N.Y. 10019
212/246-1195

American Academy of Dramatic Arts
George Cuttingham, President
120 Madison Avenue
New York, N.Y. 10016
212/686-9244

The American Mime Theatre
Director: Paul J. Curtis
61 Fourth Avenue
New York, N.Y. 10003
212/777-1710

American Musical and Dramatic Academy
Karen Entwhistle, Director of Admissions
2109 Broadway
New York, N.Y.10023
212/787-5300 *or* 800/367-7908

Circle in the Square Theatre School
E. Colin O'Leary, Executive Director
1633 Broadway
New York, N.Y. 10019
212/581-3270

Herbert Berghof Studio
122 Bank Street
New York, N.Y. 10014
212/675-2370

Juilliard School
Michael Langham, Director
Drama Division-Office of Admissions
144 West 66th Street
New York, N.Y. 10023
212/799-5000

Sonia Moore Studio of the Theatre
485 Park Avenue
New York, N.Y. 10022
212/755-5120

George Morrison Studio
Director: George Morrison
212 West 29th Street
New York, N.Y. 10001
212/242-7706

Neighborhood Playhouse School of theTheatre
340 East 54th Street
New York, N.Y.10022
212/688-3770

New York Academy of Arts
Director: Dr. Gregory Headburg
419 LaFayette Street
New York, N.Y. 10003
212/505-5300

Warren Robertson Theatre Workshop
235 West 4th Street
New York, N.Y. 10001
212/627-5332

Lee Strasberg Theatrical Institute
Artistic Director: Anna Strasberg
115 East 15th Street
New York, N.Y. 10003
212/533-5500

California

American Conservatory Theatre
450 Geary Street
San Francisco, CA 94102
415/649-2350

Estelle Harmon Workshop
Executive Director: Estelle Harmon
522 North La Brea Avenue
Los Angeles, CA 90036
213/931-8137

Film Actors Workshop
Director: Anthony Barr
Burbank Studios
Vineland
North Hollywood, CA 91505
818/766-5108

Film Industry Workshop, Inc.
Directors: Tony Miller and Patricia George
4047 N. Radner
Studio City, CA 91604
818/769-4146

Lee Strasberg Theatrical Institute
7936 Santa Monica Boulevard
Hollywood, CA 90028
213/650-7777

Playhouse West
Director: Robert Carnegie
4250 Lankershim Boulevard
N. Hollywood, CA 91602
818/506-6345

The Stella Adler Conservatory
1651 Argyle Avenue
Hollywood, CA 90028
213/465-4446

Theatre of Arts
4128 Wilshire Boulevard
Los Angeles, CA 90010
213/380-0511

Actor's Information Project (AIP), an organization that teaches the business side of show business, has designed a short quiz for actors who wish to assess their commitment and ability to handle their own business.

A Quiz For Professional Actors Who Suspect They Could Be Getting More Work

You need two things to be a successful actor - talent is only one of them. In a business where only 6% of all actors work consistently, it's essential you know how to run your business. Take a few moments to fill out the following quiz to see how you're doing.

Answer each question yes or no. Score 1 point for each yes.

1. I have a clear, comprehensive business plan for the upcoming year.
2. My apartment works effectively as my office space.
3. I have current head shots that work for me.
4. I have a clear, concise, updated resume.
5. I have an up-to-date personal mailing list.
6. I mail pictures or postcards to industry professionals at least once a month.
7. I send a cover letter with every picture/resume I mail.
8. I follow up my mailings with phone calls and try to obtain appointments.
9. I have access to all the current business information I need.
10. I show my work to agents or casting directors at least once a week.
11. I am effective in the way I present myself at interviews.
12. I have a clear personal image that makes it easy for people to know how to cast me.
13. I have established working relationships with at least 5 casting directors.
14. I have someone to go to for objective business advice.

Score 2 points for each yes.

15. I average 3 or more auditions a week.
16. I can clearly, and with assurance, communicate my career goals to anyone.
17. I have at least 3 friends who hold me accountable for getting my work done as an actor.
18. I do not let it stop me when people tell me "no".
19. I am satisfied with the progress I am making in my career.

BONUS - 10 points.

21. I have made my living exclusively from acting for at least 2 years.

Total your score. Now check yourself to see how you're doing.

0-6 pts You have either just begun your career or you are not committed to the business side of show business.

7-12 There are still may areas not receiving the attention they need. You need to focus your energies.

13-18 You have begun to create momentum in your career but your efforts are scattered.

19 & up Congratulations! If you'd like to meet other actors as committed and motivated as you are, call AIP.

Reprinted courtesy of Jay Perry, President, Actor's Information Project.

Photographs and Resumes

When you are finally ready to audition for roles, you will need to prepare your resume and have your pictures made. These two items will be your most important tools in getting through the door to audition for stage, film, and television roles. Even before you try to find an agent, you should have about a hundred pictures and resumes printed.

Ask other actors whose pictures you like for information about their photographers and shop around until you find one whose prices you can afford. Trade publications such as "Backstage" and "Drama-logue" will have ads and listings of photographers but personal referrals are always best. Professional pictures are so important to your career that you should place finding a good photographer at the top of your agenda. If you are really broke and can't afford to pay anything for photographs, you might offer to exchange modelling time for a couple of good head shots. Photography schools and classes occcasionally need models and well exchange time for pictures. As a last resort you can buy a roll of film and ask a photographer to shoot it as a test roll. However, this is matter of such importance that you should try to save enough money to hire a good, professional photographer who will take good, professional pictures.

If you're paying for the photo session, the photgrapher should use at least four rolls of film in order to give you a good selection. You should check in advance of the session to be certain his fee includes enlargements. Make a point of discussing your choice of clothing, make-up, the backgrounds he plans to use and ask if he will schedule a second session at no cost if you don't find useable shots from the first session. Advance planning and clarification will work to his advantage as well as yours.

Although many beginning actors have expensive composites made before they get an agent, this is an unnecessary expense. (A composite is a group of photo-graphs arranged on one sheet of paper showing different poses, clothes and backgrounds.) Most agents will want to advise you on having a composite made up. Basically, all you need to get started are two head shots, preferably taken from the shoulders up, each with different expressions. The photos should be eight by ten glossies, black and white on a light background, and they should look like you. Don't overdo the make up and clothes and don't have the photographer take glamour shots if you don't normally look glamorous. If you are clean shaven and have a two-inch scar on your forehead, don't have the scar airbrushed out and grow a beard. All the photographs you use should be up to date and reflect something true and basic about your personality. Casting directors dislike being misled and your two-inch scar will not hurt your chances nearly as much as deception.

When your proofs are ready, go over them carefully with a magnifying glass. When they are blown up, you will always find something that didn't show up on the proof sheet. Have your photographer and objective friends (preferably those involved in theatre) help you select the final two pictures and be absolutely certain they really represent the way you will look when you walk into an agent's office.

There are numerous film labs which specialize in quantity duplication of actors' photographs and most will be listed in the trades. When you order your copies, have your name printed on the bottom of the picture. Some actors will also have an agent's name printed on the bottom of the picture opposite their own but since actors change agents frequently, I recommend against this. Be sure to check the copies you

receive to make certain they are as bright and clear as the original eight by ten you received from the photographer. If they are fuzzy or dull, ask the lab to re-order. Your pictures are your most important selling tool and you should insist on a good quality product.

Update your photos any time your appearance changes significantly and stay in touch with reality enough to recognize you've aged ten years and your pictures haven't. No casting director will appreciate making an appointment to see a perky nineteen-year-old who turns out to be an over-percolated thirty-year-old. Remember there are roles for all ages and all types and make the most of being who you truly are.

Your resume should also reflect integrity and good sense as well as your experience. Don't list all your high school credits nor pretend you were featured in a Spielberg film if you were an extra. Don't lie about your age, your weight, or your training. Beginning actors are not expected to have impressive resumes and you should be heartened by the belief that your hard work will make your list of credits grow. Since your resume will be stapled to the back of your picture, it should be no longer than one page. It should be a record of only your acting experience so one page will be more than adequate for most actors at the beginning of their professional careers.

The resume you prepare can be modelled after any one of several different formats but you should observe a few basic do's and don'ts:

DO prepare your resume on a good typewriter.

DO leave a telephone number where you can be reached during the day or night. An answering service or machine is preferable to your own phone number until you get an agent. At that point, your agent's number should be listed directly below your name.

DO leave enough space after each listing of film, stage, and televison credits so that you can update your resume without starting from scratch.

DON'T let your resume be printed with typos, misspelled words or coffee stains. Remember that your resume will reflect your professionalism and your seriousness of purpose.

DON'T list skills you don't have. If you say you are an accomplished flamenco guitarist, you should be able to do better than plunk out "Proud Mary ".

A standard format for a theatrical resume will include the following items:

Name

Your name should be prominently placed at the top of the page. If you can't afford to have it typeset in bold type, you might consider "bootlegging" your name from one of your pictures. You could also purchase press-on letters at almost any art supply store and "set" your name yourself.

Agency Name

Include their address, zip code and their telephone number with and area code.

Height
Weight
Hair Color
Color of Eyes

Union Affiliations Use abbreviations.

Credits In Los Angeles, television and film credits are listed first. In New York, list theatre credits first. Use discretion and select an order that best represents what you want the reader to know about you.

Credits should include:

 (TV) Name of Show
Production Company
Special Billing

 (Film) Name of Film
Production Company
Role/Billing

 (Stage) Name of Play Theatre
Role

Commercials List available on request
(if you have one).

Special Skills Anything you do really well.

Training List if you have studied with a highly regarded teacher or studio.

Education List if you are a graduate of a highly respected institution or university.

Sample Resume

NANCY BUFFUM

Messages: (213) 542-8676

Height: 5'9"
Weight: 135
Hair: Red
Eyes: Green
Unions: SAG, AEA, AFTRA

Chandler Talent Agency
Agent: Sam Suddenly
204 Wilshire Blvd., #123
Los Angeles, CA 90017
(213) 632-3456

Television:

Cheers, Jeers and Leer	Zavala Productions	Frankie & Johnny
Bondage, Burden or Right	ABL Productions	Narrator/Host
Lizard and Other Reptiles	Found, Inc.	Co-starred as the Other Reptile

Film:

Los Angeles, A Sincere Town	Iron Will Documentaries	Biker-Girl
Los Angeles, Part II	Iron Eyes Documentaries	Biker-Girl
Chuck Norrisy Story	Kal Kannon Films	Black Belt Seamstress

Stage:

Tempestuous	Center Theatre	Calibanella
Chuck Norrisy Musical	Long Beach Civic	Chuckett II
Biography	Light Opera	

Commericals:

List available on request

Special Skills:

Blue belt in karate. Macrame champ of Ohio. Eastern European Dialects. Jazz, tap and clogging (Cunningham method)

Training:

Studied Dialects with Wayne Newton, acting with John Dereck, voice with Dai Dai Galiciano.

Education:

M.F.A. , University of West Georgia, School of Fine Arts.

Finding An Agent

As a group, agents are much-maligned. There is an old joke that compares changing agents with changing chairs on the Titanic and whether they deserve it or not, agents are often portrayed as unsympathetic, shallow fly-by-nighters whose primary goal in life is to exploit hardworking but naive actors. A picture of agents and agencies which is much closer to the truth is painted in detail in *Your Film Acting Career* by M.K. Lewis and Rosemary Lewis. They explain not only why and when you need to contact agents but how to get, motivate, and change them. I recommend that every youg actor interested in finding professional stage, film, or television work read chapters 10-14 of their book without delay.

A much briefer information sheet on talent agencies is distributed by the Los Angeles Consumer Protection Division of the Federal Trade Commission:

Talent Agencies Fact Sheet

Question:
What is the difference between a legitimate talent agency and one whose purpose is to separate you from your money?

Answer:
The legitimate talent agency does not charge a fee payable in advance for registering you, for resumes, for public relations services, for screen tests, for photographs, for acting lessons, or for many other devices used to separate you from you money. If you are signed as a client by a legitimate talent agency, you will pay such agency nothing until you work. From then on you will pay them 10 percent of your earnings as a performer-but nothing in advance. Most legitimate talent

agencies normally do not advertise for clients in newspaper classified columns nor fo they solicit through the mail.

Question:
Are legitimate talent agencies licensed by the State of California?

Answer:
Yes. Such talent agencies are licensed by the State as Artists' Managers and most established agencies in the motion picture and television film field are also franchised by the Screen Actors Guild. You should be extremely careful of any talent agency not licensed by the state.

Question:
What about personal managers and business managers?

Answer:
There are well established firms in the business of personal management and business management but such firms in the main handle established artists and they do not advertise for newcomers, nor promise employment.

Question:
What about photographers?

Answer:
If a purported talent agent seeks to send you to a particular photographer for pictures, what should you do? Hold your wallet tight and run for the nearest exit. Chances are he's a phoney and he makes his money by splitting the photographer's fee. If you need photographs, choose your own photographer. Better still, try another agent. Under no circumstances should you pay anything in advance.

Once you have an agent interested in seeing you, set up a general interview and handle it in as relaxed a manner as you can. Dress casually and use the interview as an opportunity to find out something about the agent as well as an opportunity to let him know you. Prepare to do cold readings, have one or two short monologues you can present (one should be light and funny) and try to let the agent see something of the real you. There is no need to be devastatingly funny, dynamic, or wonderful throughtout the interview. Actor Ed Harris warns about trying too hard. "Five minutes of wonderfulness is about three minutes too much for most agents", he says.

In New York, it is permissible to have more than one agent representing you in each field without a signed contract. In Los Angeles an exclusivity rule stipulates that you may have only one agent working for you in each field. Remember that agents receive a standard ten percent of your income only after you've been employed. If an agent askes for advance money, head for the hills.

The amount of personal attention you get from agents will vary. Basically, you can expect a reliable agent to:

* Check his daily copy of Breakdown service (a listing of current casting opportunities and roles) and submit your picture and resume to the appropriate casting directors.

* Negotiate billings, fees, and business arrangements.

* Read and check contracts for you.

* Return your phone calls and take an active interest in your work.

* Represent your interests in good faith.

You must view your relationship with an agent as a two-way affair and be conscious of your responsibilities to him. It is important to establish a relationship which is business-like and professional but it never hurts to also take a personal interest in people with whom you have a lot of contact. Too many actors treat agents like a necessary evil and take no interest in them aside from their ability to get jobs. In addition to offering personal interest and courtesy, you should:

* Keep your agent supplied with pictures and resumes.

* Provide a composite if he requests one.

* Be available on short notice. Casting can happen very quickly and your agent should be able to find you at all times.

* Be a real professional. Prepare for a good audition, be on time, and be informed about the business.

* Keep your listing in the Academy Players Directory currrent.

* Pay his commission.

Investigate new projects on your own and let your agent know about any new developments in your career. If you are appearing in an Equity Waiver production or studying with a new teacher, let your agent know.

Try not to be a pest. You must have a certain amount of faith that he's working for you and will not have time for daily phone calls inquiring "So, what's new?"

When you ask agents to represent you they will either say "Yes" or "No". "Yes" is not a guarantee of success and "No" does not mean your career in theatre is hopeless. Try not to blow their responses out of proportion. They are important to

your success but you're not going to succeed or fail on the work of one or ten agents. Remember that, relax and keep trying.

If you plan to work professionally, agents are important to your success. Although reputable agents will never promise you work, it's difficult to do without them. They are your connection to the casting directors and producers who do the hiring for all union television, film, and stage productions. It is their job to get your pictures and resumé in the hands of the people who can give you jobs. They will also do the follow up necessary to secure an audition for you and will negotiate your contract once you gain employment.

The various kinds of agents available are:

Theatrical - Agents who handle talent for television and motion pictures.

Commercial - Agents who handle on-camera talent for television commercials.

Legitimate - Agents who handle radio and off-camera elevision work, announcing, cartoons, etc.

There are also agents for modeling (printwork and advertising) and Variety agents for nightclub work.

Most actors will want to be represented by Theatrical and Commercial agents and if you plan to work on the East Coast, you should have a Legitimate agent as well. You can find out which agents are franchised from the local union offices. Lists are free to union members and are available to non-members for a small charge. A recent 1990 list distributed by Equity is in Appendix VI.

The easiest way to get an agent to see you is to have a fellow actor, a producer, or a casting director put in a good

word for you. If those contacts are established, send the agent your picture, resume, and a cover letter indicating you've been referred by a mutual friend. If that option is not available, you must try the time-consuming and frustrating method that most actors employ:

After first removing any impossible or unlikely agencies, take the list of franchised agents that you've received and do a mailing. Send them your pictures, resume, and a brief cover letter. Record each agent's name, address, phone number, and the date of your mailing on a file card and follow up with a phone call within a week to see if anyone is interested in representing you. This is a very frustrating process and will often elicit responses indicating no current interest in new talent or a glut of clients with your look. All their remarks should be written down before you proceed to the next ten agents on your list. Although this can be very discouraging and tedious, you must perservere for weeks, months, years or as long as it takes to break through the barrier of excuses they have for not seeing you. If you're persistent, eventually someone will see you, like you, and send you out to audition. The important thing is not to give up if you know you're good and have something special to offer.

Unions

Performing artists just getting into the business are advised NOT to join unions until they're certain they're finished with community theatre, tours, nightclubs, and dinner houses which prefer to hire non-union artists. It's very difficult to work in Hollywood without a SAG card but it's also difficult to turn down non-union work when you haven't had a job in six months. Once you join any union, you may not do outside work unless you have been granted an exception or are

working in an Equity Waiver theatre. Unions provide their members many wonderful benefits but guaranteed employment is not one of them. Unless you are ready to compete with experienced professionals for professional jobs, don't go without food and shelter to pay your union initiation fees.

Once you decide you are ready, you should learn about the many paths that lead to the pot of brass in which your coveted union card is hidden. You should also have plenty of background information on all the unions in order to intelligently decide which ones you need to join.

Six performing arts unions are grouped under one national organization called the Associated Actors and Artists of America (4A's), Actors Equity Association (AEA), Screen Actors Guild (SAG), American Guild of Musical Artists (AGMA), American Guild of Variety Artists (AGVA), and the Screen Extras Guild (SEG) make up the six unions which may determine how long and how comfortably you survive as a working artist. List of 4A's offices are in Appendix VII. The myth that you can't get into a union without a union job and that you can't get a union job without your union card is widely told and almost universally accepted. While it is difficult and expensive to get a SAG or Equity card, it's not as hopeless as the actors' favorite allegory would have us believe.

There are actually several ways to obtain your membership card in Equity:

1) You might consider apprenticing with a summerstock theatre or working as a nonunion performer in an Equity League of Resident Theatres (LORT) production. If the producer or director decides to hire you under a union contract, your contract and initiation fee will establish your eligibility to join Equity. Once you persuade a

producer to employ you in an Equity show, Equity will be happy to exchange a temporary AEA card for your signed Equity contract and fees. Your permanent card involves the approval of the Council but if your contract is valid and your check doesn't bounce, you should not have a problem.

2) You can join the Equity Membership Candidate Program through any of the participating Equity theatres around the country. (Write Equity for a current list.) The Membership Candidate program requires fifty weeks of work (not necessarily consecutive) in an Equity theatre. You'll probably be paid substantially less than the other Equity actors working at the theatre, but after you've completed your fifty weeks, you will be eligible to join Actors Equity Association.

3) Members of 4A's Unions may join Actors' Equity Association by virtue of both membership and employment under any other 4A's Union. In order to be eligible you must be a member in good standing for at least one year. In addition, the applicant must have performed, under contract, work which is comparable to that of a principal or three days of work comparable to that of an extra performer (on a non-waiver basis). A current paid-up membership card for SAG, AGMA, or the Hebrew Actors' Union will be accepted as proof of membership. If your Parent Union (the first union under which you work is called your Parent Union) is AFTRA, SEG, or AGVA, you must supply additional proof of employment within the jurisdiction of these Unions. Copies of employment contracts or a letter from the Union certifying the type of contract worked, as well as your paid-up membership card, will serve as proof of your eligibility to join Equity.

4) If you have technical skills, you may want to try signing on with the crew of an Equity Production. If you can eventually work yourself into an Assistant Stage Manager's job, you'll be covered by Equity and will automatically be eligible to join the union.

The easiest union to join is AFTRA. Basically, anyone with $842.50 can walk into an AFTRA office, fill out an application form, and become a member. You can then use your AFTRA membership as an entree to other unions as well as to jobs in television and radio.

Although it is difficult to get into SAG, there wouldn't be over 73,000 SAG members if it were impossible. A few paths you may wish to explore:

1) Develop a good working relationship with a producer or director. If a producer decides to hire you, a nonunion member, in a union film, she can file a Taft-Hartley report justifying her reasons for hiring you rather than a guild member. If you are seven feet tall, have red hair and red eyes, it may be easier to justify than if you look exactly like the other 3000 Robert Redford lookalikes in SAG.

2) Ask a director or producer for an "unscripted line." The line cannot appear in the original script because the producer will be expected to hire a SAG actor to read it. However, if you are hired on the spot to read a throwaway line, you are immediately eligible to take your Day Player contract and initiation fee to the nearest SAG office and apply for membership. So if your third aunt on your mother's side is producing the fifth sequel to *Rocky*, ask her to set you up with an unscripted line.

3) Join SAG through the other unions. Eligibility for SAG involves waiting one year after you first become a member of AFTRA and finding one AFTRA job during the course of that year. You can also use SEG, AGMA and AGVA as "parents" into SAG. The waiting period is the same (one year) as for AFTRA and the initiation fee will vary according to your parent union. However, you are required to pay full dues and an initiation fee of $904.50 to SAG. [Some of the other unions give discount rates up to forty percent of the standard initiation fees, making it more economical to obtain multiple union membership; however, SAG has discontinued this policy.]

The performing unions provide artists many benefits and guarantee decent working conditions. Their pension plan, welfare funds, and health and dental insurance are all vitally important to struggling performing artists. More that that, union membership symbolizes to others and to yourself that you are serious about your work, you consider it your profession, and that you expect all the protection and respect your union demands and you deserve.

See Appendix VIII for a list of Selected Theatre Publications.

Chapter VII

The Business of Making Music

Without music, life would be a mistake."
 Nietzche

Anyone who has ever applied for a bank loan recognizes that the ability to qualify is in reverse proportion to the need of the applicant. If you're unemployed, if your children are hungry and if your house has just burned to the ground, Hell *will* freeze over before a bank officer approves your loan request. If, on the other hand, you're a multimillionaire with at least three unmortgaged houses and a Rolls Royce parked in one of your six garages, you can probably have your chauffeur fill the trunk of the Rolls with the bank's cash reserves.

The music business operates on the same principle. When young musicians and composers are starting out and most need the sage counsel of agents, managers, publicists, engineers

and writers, no one will give them a free ten minutes. In the unlikely event that an unknown band comes up with a smash hit and sells two million records, agents, managers and promoters will come crawling out of the Beverly Hills woodwork.

Preparation

Since the likelihood of an unknown band selling two million records is analagous to hitting a Las Vegas jackpot, young composers and musicians need to learn to be their own agents, managers and publicists. Although the experience may be painful, and will almost certainly be tiresome, the knowledge gained will serve you well as you become successful. The music industry is not distinguished by great humanitarians who trade on candor and trust and you will be far ahead of the game if you can at least evaluate the skills of the people you hire to represent you.

The music industry is not unlike the theatre or dance world in that its survivors are required to have thick skins, talent, and a lot of friends in the business. Just as actors get jobs through other actors, musicians get jobs from other musicians. Conductor/composer Henry Mancini says "One of the best ways for an instrumentalist to crack through the job barrier is to find other people who do the same thing he does. A trumpet player should know every trumpet player in town because that's the only way he's going to break in. That's how I was able to start composing film music and it's a technique others have used successfully. I met everyone I could who composed film music and, little by little, they got to know me and started to recommend me for one thing and another. I would say this is the best way to break in unless someone brings you in from outside."

In cities like Los Angeles, New York and Chicago, your chance for success is completely dependent on your ability to perform. Henry Mancini says that in Los Angeles "You have to be an excellent musician if you plan to do studio work. There is simply no time to practice at home. Studio instrumentalists must be first-rate readers and extremely flexible. A sax man might have to play a musical comedy score in the morning and switch to a 'big dance' sound in the afternoon."

In order to gain experience, many young musicians take their instruments and haunt nightclubs, waiting for a chance to "sit in". They work dances, bars, organization dinners and church picnics. Blues pianist Bob Riedy advises young musicians to "study and play along with recordings of favorite artists to learn their techniques." He also suggests that musicians "be prepared to give up *everything* for music."

If you're very lucky, you'll be able to support yourself through your music ten or twelve years after you get out of school. If you're willing to handle your career in a businesslike way and if you perfect your craft with practice and lots of jobs in places that would make your Mother and John Cage blush, you can probably make a respectable living in half that time. You must remember that there's no such thing as an overnight success. You have to prove your talent with good, solid performances and banal as it sounds, you have to prove your commitment with persistence and hard work.

Warren Christensen, the artistic director of the Garden Theatre Festival, an event that grew in three years from a $60 backyard party to a $1.5 million month-long arts festival, says "When preparation meets opportunity, people call it luck. That's misleading because opportunities are always out there. You can't control that. The only part of the equation you can

control is the preparation. So long as you put yourself out there, continually study and prepare, believe in yourself, and even when you feel terrible, get yourself out to be seen and heard, an opportunity will eventually come along."

Bob Monaco and James Riordan have written a book entitled *The Platinum Rainbow* (subtitled How to Succeed in the Music Business Without Selling Your Soul) which should be required reading for every music school graduate and/or everyone hoping to sell millions of records. It is to musicians what *Poor Dancers Almanac* is to dancers and choreographers. Their comments about goal-setting are particularly apt for young musicians in a hurry to make a hit. "Before you do anything, you must formulate that plan for success. Use the one I've given you in this book or make up your own, but haveone. And follow it.

"Once you have your primary goal set, you need to break it down into four or five secondary goals. Then you're ready for your working goals, which in some ways are the most importantof all. Let's say that you decide the best way to work on your live show is by playing clubs, so your first working goal is learning twenty songs by other artists. Your second working goal might be to write or discover ten original songs. Before you can pursue other secondary goals, you must master thesetwo working goals.

"You've got to discipline yourself, and one of the best ways to do it is by having a schedule based upon achieving a working goal. After you achieve one working goal, immediately set another. If your time limit runs out, immediately figure a new one. Goal setting is one of the only ways to keep an artist working effectively toward his dream. Take it one rung at a time. Make sure you do it right before you move on, and you won't have to go backwards. Remember

that the more things you do well in the beginning, the easier it will be in the home stretch. TAKE YOUR TIME."

When you're certain your performance skills are as good or better than other musicians you know are recording, performing, and bringing in a regular paycheck, and after you've set realistic goals for at least one year, you need to consider the following issues:

Promotion

Unless you are lucky enough to be engaged to a publicist, you should begin documenting all your performances. Make a list of all the clubs you've played and the concerts and tours you've done. Get someone in your family or circle of friends to take black and white pictures you can use in a promotional package and have the best writer in your band write a promotional letter you can use when you contact A & R people, club owners, and booking agents.

Make sure your mailing list is up-to-date and includes everyone you want to inform about your performances. Send your press materials well in advance of your performance and flood the community in which you're performing with fliers, window displays, and newspaper announcements.

All this has to be done weeks before your performance in order to accomodate newspaper deadlines. Involve local record stores and university music departments in promoting your concerts.

While you're still in school, ask some of your distinguished professors and teachers to write general letters of recommendation. Don't wait ten years or let another two hundred students pass through their doors before you make your request. Larry Stein, the National Program Director of Young Audiences and a producer of the Olympic Arts Festival,

emphasizes the wisdom of this strategy. "You always need to build up your portfolio," he says. "It's a lot of little things that say to other people you have it all together."

Demos

A demo represents your talent and demonstrates the kind of work you do. It can be made for you to evaluate your own performance or to send to a record company. Larry Harris, the co-founder of Casablanca Records and Filmworks, says "You should do three songs on a demo tape, ten-fifteen minutes long, just enough to let someone know you have the capability of cutting a hit record. You have to make the tape sound as professional as you can. If it sounds muddy or scratchy, the record company is not going to get past the first song. If you don't have good original material, take old songs and revamp them. Bring them up to date. The tape should show what the group can do, especially their vocal ability. Be creative when you send in the tape. Do some creative packaging and grab somebody's eye. Don't just send it in a little brown wrapper because it will go in the pile with the hundreds of other brown wrappers. Try sending it in a gift box."

Larry Stein suggests sending tapes to booking agents and producers whether they ask for it or not. "I'm really big on excerpt tapes," he says. "I send short tapes, no more than seven minutes long, thirty seconds to a minute of different kinds of things. I also include a page that says what it is, what instruments they're hearing and when it was recorded."

Finally, Bob Monaco and James Riordan caution musicians about investing a lot of money in producing demo-masters: "A master is just what the term implies. It is the best you can do at a given point in time and space. A master is a forever situation. If you don't like what you did, you're going to cringe

every time the needle hits the groove. Perfection is unattainable, but a master should represent the best you feel you can do.

"Any tape that you do on your own, without the backing of a record label, should be considered a demo. You can, of course, do master quality demos, but since the release of the record still depends upon interesting a label, you are in a sense making a demo for record companies to hear.

"If you have nine or ten dynamite original tunes, if you're playing five nights a week to a crowd that goes nuts for you, and if your band is as tight as a gnat's ass, then you're probably ready to do a master. But if you've been together for three months and you think you're the next Rolling Stones, you'd better read *The Platinum Rainbow* before you waste a lot of time and money trying to cut a great album when you should be concentrating on cutting your musical teeth.

"The answer to demo or master for a new group is demo. Demo, demo, demo! When your demos start sounding like records, then it's time to consider a master, but not before. Don't press records out of demos and don't take anything other than your best to a record label."

Management

Larry Harris (Casablanca Records) says "It's managers who have relationships with record companies. They've dealt with them in the past so they can get their tapes to the A & R people. Booking agents can also do it and music lawyers can do it. They get people signed because they've dealt with the record companies for a long period of time (as have certain people at radio stations.) Record companies do not want to deal with artists directly. There are too many times when the record company has been accused of ripping off unrepresented artists. It's also very awkward to listen to an artist's tape with

the artist sitting in front of you. Record company people don't like to put themselves in that position. A manager will take care of all the business with the record company and will make sure that the record company is behind the group. A good manager will also make sure the group has an agent, the correct lawyers and accountants, and will monitor the airplay a record gets. When a record company has hundreds of artists, a group can get lost in the shuffle if a manager doesn't stay on top of his group's progress."

Musicians and performing artists pay their managers as little as ten percent and as much as fifty percent of their earnings. If your manager is someone who has been in the business for a long time and has the knowledge and access you need to get your career off the ground, it may be smarter (and more profitable) to give away a large percentage than to hold onto ninety percent of nothing. If you've already tried to manage and promote your own career for a few years, you'll have a sense of what you're buying with your twenty or thirty percent.

Jon Bauman, formerly with ShaNaNa, says "ShaNaNa was very fortunate because they found an honest manager at the beginning, a law student who really fought for the needs of the group. Word of our act was put into the William Morris Agency and all these Morris agents started coming up to Columbia University to see the show. Big management agencies are characteristically the best or the worst place to be. If things are going well, they're the best place to be. When things cool off, they're the worst place in the world to be. You get put on the back burner and can be totally lost. What the big agencies are about is writing business. Their jobs depend on how much business they write. Consequently, the building of careers and doing things that are difficult and time consuming won't

happen in a big agency. If you're a small fish in a big pond, it can be dangerous."

Most managers and agencies aren't going to take on musicians at the beginning of their careers. Until you're ready to sign with a record company or book a national tour, you really don't need high-powered management. This is just one more chore that you and your long-suffering friends will have to learn to handle. And five years down the road, you'll be glad you did because you'll know whether or not that big-time manager deserves thirty percent of your earnings for the next five-year period.

Unions

When you make more money as a union member than as a non-union member, **you** should hike to your nearest American Federation of Musicians' (AFM) office and apply for membership. Application must be made in person and fees ($249.50 plus one year's dues. Minimum down payment is $150.50) must be paid in cash or with a Cashier's Check. Attendance at one orientation meeting and an audition is also required.

Union membership not only guarantees wage scales but provides numerous benefits and services. Many branches offer low-cost rehearsal space, free published help wanted and audition notices, contract preparation and consulting services, job referrals, and listings on agents, managers, record companies, and nightclubs. The AFM insurance program includes coverage for health, retirement, disability and death benefit group insurance. Low-cost instrument insurance, credit union membership and notary public service are also part of the generous benefit package provided through the American Federation of Musicians.

AFM is a national organization with over 250,000 members. Their addresses in New York and Los Angeles are:

> 817 North Vine Street
> Los Angeles, CA 90038
> (213) 462-2161
>
> 1501 Broadway, Suite 600
> New York, NY 10036
> (800) 762-3444

Other musicians' support organizations throughout the country:

> **American Composers Alliance & Edition**
> 170 W. 74th Street
> New York, NY 10023
> (212) 362-8900
>
> **ASAC (American Society of Authors and Composers)**
> 1 Lincoln Plaza
> New York, NY 10023
> (212) 595-3050

ASAC/The Songwriter's Society is a 50-year-old national organization run by and for songwriters for the purpose of furthering and protecting their rights in the music business.

> **AFTRA**
> (American Federation of Television and Radio Artists)
> 260 Madison Avenue
> New York, NY 10016
> (212) 532-0800
>
> **American Music Center**
> 250 West 54th Street, Room 300
> New York, NY 10019
> (212) 247-3121

AMC sponsors the American Music Week and has a large resource library on American music.

L.A. Songwriters Showcase
P.O. Box 93759
Hollywood, CA 90028
(213) 654-1665

A non-profit songwriter service organization that includes an annual songwriter expo, educational programs and showcasing to the music industry through both live and taped mediums.

AGVA (American Guild of Variety Artists)
4741 Laurel Canyon Boulevard, Suite 201
North Hollywood, CA 91607
(818) 508-9984

Musicians Contact Service
6605 Sunset Boulevard
Hollywood, CA 90028
(213) 463-5573

Music Critics Association, Inc.
6201 Tuckerman Lane
Rockville, MD 20852
(301) 530-9527

The Music Library Association, Inc.
P.O. Box 487
Canton, MA 02021
(617) 828-8450

National Academy of Recording Arts & Sciences
303 N. Glenoaks Boulevard, Suite 140
Burbank, CA 91502
(818) 843-8233

National Association for Music Therapy, Inc.
505 11th Street
Washington, DC 20003
(202) 543-6864

National Music Publishers Association, Inc.
205 East 42nd Street, 18th Floor
New York, NY 10017
(212) 370-5330

Professional Musicians Career Academy
1312 SE Fifth Street
Minneapolis, MN 55414
(612) 379-0290

Provides workshops for professional musicians, including step-by-step career direction, methods for development and assembly of musical material, training and preparation for recording, and training and opportunities to develop careers in music related areas other than performance.

PMR (Professional Musicians Referral)
1312 SE Fifth Street
Minneapolis, MN 55414
(612) 379-0290

Maintains a large listing of individual musicians seeking groups and groups seeking new members.

RIAA
(Recording Industry Association of America, Inc.)
1020 19th Street, NW, Suite 200
Washington, DC 20036
(202) 775-0101

Recording Musicians Association
1765 N. Highland Avenue, Suite 495
Hollywood, CA 90078
(818) 985-5715 *or* 364-1899

Society for Ethnomusicology
Indiana University, Morrison Hall 5
Bloomington, IN 47405-2501
(812) 855-6672

Songwriters Guild of America (LA)
6430 West Sunset
Hollywood, CA 90028
(213) 462-1108

Songwriters Guild of America (NY)
276 Fifth Avenue
New York, NY 10001
(212) 686-6820

Dedicated to the education and protection of songwriters and fosters the art and craft of American song writing.

The American Society of Composers, Authors and Publishers (ASCAP), Broadcast Music Inc. (BMI) and SESAC, Inc.

There are three performing rights societies in the United States which collect fees and distribute income from radio and TV stations, performing groups, colleges and other users of music to their composer/publisher members. The three societies are ASCAP, BMI and SESAC, Inc. and most composers in the country belong to one of the three societies.

All public performances must be licensed. If a perfoming group does not have a blanket license from one of the three societies, an individual license should be secured directly from the composer.

ASCAP

(American Society of Composers, Authors and Publishers)
1 Lincoln Plaza
New York, NY 10023

350 West Hubbard Street
Chicago, IL 60610
(213) 462-1108

6430 Sunset Boulevard, Suite 1002
Hollywood, CA 90028

66 Music Square West
Nashville, TN 37203

ASCAP (Offices—Continued)

Office 505, First Federal Savings Condominium
1519 Ponce de Leon Avenue
Santurce, Puerto Rico 00909

52 Haymarket, Suite 10 / 11
London, SW1Y 4RP
England

BMI (Broadcast Music, Inc.)

320 W. 57th Street
New York, NY 10019

10 Music Square East
Nashville, TN 37203

8730 Sunset Boulevard, Third Floor
Hollywood, CA 90069

SESAC

156 W. 56th Street
New York, NY 10019
(212) 586-3450

55 Music Square East
Nashville, TN 37203
(800) 826-9996

Copyright

Application forms are available from The Information
and Publications Section, Copyright Office, Library of
Congress, Washington, D.C. 20559. There are five new
application forms corresponding to the five new registration
categories.

Form PA for works for the performing arts (published and unpublished works prepared for the purpose of being performed directly before an audience or indirectly "by means of any device or process"). Examples of this class are musical works, including any accompanying works; dramatic works, including any accompanying music; pantomimes and choreographic works; and motion pictures and other audiovisual works.

Form SA for sound recordings (published and unpublished works for which the copyright claim is limited to the sound recording itself, and for which the same copyright claimant is seeking to register not only the sound recording but also the musical, dramatic or literary work embodied in the sound recording).

Registration fees: $10 for each registration; $6 for each renewal. You may maintain a Deposit Account in the Copyright Office, or send the fee with each new application.

Deposit of copies: The new statute regards deposit of copies or phonorecords for the Library of Congress, and deposit of copies or phonorecords for purposes of making a copyright registration, as two separate acts. With respect to works published in the United States, the new law contains a special provision under which a single deposit can be made to satisfy both the deposit requirements for the Library and the registration requirements. Copyright registration is generally voluntary rather than mandatory, although copyright owners are required to register their claims in order to obtain certain rights and remedies. One copy of the unpublished full scores is required for copyright registration; two copies of published works with notice of copyright in the United States are required for deposit for the Library of Congress.

Also see Chapter III on Copyright.

Composers

Within the difficult music field, no one has a more difficult time than the composer. Young composers fortunate enough to sign with a publisher soon realize that represents only the beginning of a long struggle to let the world know about them and their music. Carl Stone, the founding director of the Independent Composers Association in Los Angeles, says "When I graduated, I figured I would sit around Hollywood and wait for the commissions and performances to come rolling in. After about a year it hit me in a blinding flash that it wasn't working out. Basically, nothing happened. When you're composing tape music, you have a particularly difficult performance problem. It's even harder to get a ten-minute tape composition performed out there in the real world than it is to get your ten-minute composition for a string quartet performed (and that's difficult.) In this day and age, the marketplace is such that if you want to have your music performed and you want to have it performed reasonably well, you have to be intimately involved in the production. A lot of people don't want to be bothered with that. They think their job is to compose the music and someone else's to produce. That's perfectly fine but if you feel that way, you're going to sit around waiting for the performances, the commissions, and the record company to call. It might happen but you have just as much chance of winning the Irish Sweepstakes. I don't think the rela-tionship between talent and success is really there. If you want to succeed as a composer, and if it's as important to you as actually making music, you have to put energy into all aspects of getting the music out. That ranges from entering competitions, joining ASCAP, calling up radio stations and bugging them to get on their shows, and joining

up with friends to put on concerts of your own music. You have to do everything you can possibly think of to get your music out there. If it happens without you, it's right up there with the burning bush and walking on water."

While no one will look out for a composer as well as a composer will look out for herself, support organizations have sprung up around the country which offer many important services as well as information on funding and performance opportunities. The American Music Center also maintains libraries and resource files designed to help composers stay abreast of the most current information on publishing, recording and commissions.

I neither endorse nor guarantee the quality of service provided by organizations on the following lists but offer them simply as a point of departure. Ultimately, you must find your own way and build your own support systems but one or two of these companies may be helpful in getting you started.

Record Manufacturing

These companies will make 1000 records complete with black and white cover, mastering and pressing, everything from soup to nuts, for about $2,500.

Location Recording Service
2201 W. Burbank Blvd.
Burbank, CA 91506
(213) 849-1321

Music Publications

Bulletin: *Council For research in Music Education*
c/o University of Illinois
1205 W. California Street
Urbana, IL 61801
(217) 333-1027

Central Opera Service Bulletin
Metropolitan Opera
Lincoln Center
New York, NY 10023
(212) 799-3467

Guitar Player
20085 Steven Creek Boulevard
Cupertino, CA 95014
(408) 446-1105

Music Journal
60 East 42nd Street
New York, NY 10017
(212) 682-7320

Musical America
825 Seventh Avenue
New York, NY 10019
(212) 265-8360

Symphony Magazine
American Symphony Orchestra League
777 14th Street, NW, Suite 500
Washington, DC 20005
(202) 628-0099

Publishers Of American Music

Abingdon Press
201 Eight Avenue South
Nashville, TN 37202
(615) 749-6403

Boosey & Hawkes Inc.
24 West 57th Street
New York, NY 10019-3977
(212) 757-33323

CPP/Belwin, Inc.
15800 NW 48th Avenue
Miami, FL 33014
(800) 327-7643

European American Music Distributors Corp.
P.O. Box 850
Valley Forge, PA 19482
(215) 648-0506

Carl Fischer Inc.
62 Cooper Square
New York, NY 10003
(212) 777-0900

Galaxy Music Corporation
138 Ipswich Street
Boston, MA 02215
(617) 236-1935

Jerona Music Corporation
P.O. Box 5010
Hackensack, NJ 07606-4210
(201) 488-0550

Margun Music Inc./Gunmar Music
167 Dudley Road
Newton Centre, MA 02159
(617) 332-6398

New York Women Composers, Inc.
114 Kelburne Avenue
North Tarrytown, NY 10591
(914) 631-6444

Peer-Southern Organization
Presser Place
Bryn Mawr, PA 19010
(215) 525-3636

C. F. Peters Corporation
373 Park Avenue South
New York, NY 10016
(212) 686-4147

Theodore Presser Corporation
Presser Place
Bryn Mawr, PA 19010
9215) 525-3636

E. C. Schirmer Music Corporation
225 Park Avenue South
New York, NY 10003
(212) 254-2100

Seesaw Music Corporation
2067 Broadway
New York, NY 10023
(212) 874-1200

Transcontinental Music Publishers
838 Fifth Avenue
New York, NY 10021
(212) 734-2857

Record Company List For New Music

Allegro Imports
3434 S.E. Milwaukee Avenue
Portland, OR 97202

Arabesque Recordings
60 East 42nd Street
New York, NY 10165

Arista
6 West 57th Street
New York, NY 10019

Cambria Records & Publishing
Box 374
Lomita, CA 90717

CP2 Recordings, Classical Music, Inc.
Box 355
Albany, NY 12201

CRI (Composers Recordings, Inc.)
73 Spring Street, Room 506
New York, NY 10012

Crystal Record Company, Inc.
2235 Willida Lane
Sedro Woolley, WA 98284

Delos Recordings, Inc.
1032 N. Sycamore
Los Angeles, CA 90064

Earwig Music Co., Inc.
1818 West Pratt Boulevard
Chicago, IL 60626

Fifth Continent Music
1200 Newell Hill Place, Suite 302
Walnut Creek, CA 94596

Folklore Productions, Inc.
1671 Appian Way
Santa Monica, CA 90401

Folkways Records
C/o Rounder Records
One Camp Street
Cambridge, MA 02140

Global Pacific Records, Inc.
180 East Nappa Street
Sonoma, CA 95476

Gramavision, Inc.
260 West Broadway
New York, NY 10013

Grenadilla Productions
52 Kohring Circle South
Harrington Park, NJ 07640

Gwenda Ledbetter
55 Beaverbrook Road
Asheville, NC 28804

Leonarda Productions, Inc.
P.O. Box 1736 Cathedral Station
New York, NY 10025

Library of Congress (distr. Allegro Imports)
Recording Lab
Washington, DC 20540

Louisville Orchestra / First Edition Records
609 West Main Street
Louisville, KY 40202

Lovely Music, Ltd.
105 Hudson Street
New York, NY 10013

Moss Music Group (MMG)
c/o Essex Entertainment
75 Essex Street
Hackensack, NJ 07601

Musical Masters
1710 Highway 35
Ocean, NJ 07712

New Albion Records, Inc.
584 Castro Street
San Francisco, CA 94114

New Music Circle
6912 Wise Avenue
St. Louis, MO 63139

New World Records
701 Seventh Avenue
New York, NY 10036

Nonesuch Records (Elektra)
75 Rockefeller Plaza
New York, NY 10019

Northeastern Records
P.O. Box 3589
Saxonville, MA 01701

One World Records
26 Chapin Road
Pine Brook, NJ 07058

Opus One
Box 604
Greenville, Maine 04441

Orion Master Recordings, Inc.
c/o Record Technology
486 Dawson Drive
Camarillo, CA 93010

Owl Recordings, Inc.
P.O. Box 4536
Boulder, CO 80306

Serenus: Boston Music Co.
9 Airport Drive
Hopedale, MA 01747

Smithsonian Institute (distr. One World Records)
Performing Arts Division
Washington, DC 20560

Meet The Composer Regional Offices

Meet the Composer/Arizona
Arizona Commission on the Arts
417 West Roosevelt
Phoenix, AZ 85003

Meet the Composer/California
849 S. Broadway, Suite 419
Los Angeles, CA 90014

Meet the Composer/Great Lakes
Great Lakes Arts Alliance
ll424 Bellflower Road
Cleveland, OH 44106

Meet the Composer/Mid America
*(Arkansas, Kansas, Missouri, Nebraska,
Oklahoma, Texas)*
Mid America Arts Alliance
912 Baltimore Avenue, No. 310
Kansas City, MO 64105

Meet the Composer/New England
*(Connecticut, Maine, Vermont, Massa-
chusettes, New Hampshire, Rhode Island)*
New England Foundation for the Arts
678 Massachusetts Avenue
Cambridge, MA 02139

Meet the Composer/Southeast
*(Alabama, Florida, Georgia, Kentucky, Louisiana,
North & South Carolina, Mississippi, Tennessee)*
1293 Peachtree Street, N.E., Suite 500
Atlanta, GA 30309

Meet the Composer/Midwest
*(Illinois, Indiana, Iowa, Minnesota, Michigan,
North Dakota, Ohio, South Dakota, Wisconsin)*
Arts Midwest
528 Hennepin Avenue, #310
Minneapolis, MN 55403

Meet The Composer/West
*(Alaska, Colorado, Hawaii, Idaho, Montana,
Nevada, New Mexico, Oregon, Utah Washington)*
Western States Arts Federation
236 Montezuma Avenue
Santa Fe, New Mexico 87501

Meet the Composer, Inc.
(All other states)
John Duffy, President
2112 Broadway, Suite 505
New York, NY 10023

Orchestras/Contemporary American Music

Albany Symphony Orchestra
Palace Theatre 2807
19 Clinton Avenue
Albany, NY 12207
ois Jordan, Executive Director

Chamber Orchestra of Albuquerque
St. John's Methodist Church
P.O. Box 35081
Albuquerque, NM 87176-5081
David Oberg, Music Director

American Composers Orchestra
Carnegie Hall 2800
170 West 74th Street
New York, NY 10023
Dennis Russell Davies, Conductor
Laura Ames, General Manager

American Symphony Orchestra
Carnegie Hall 2800
170 West 74th Street
New York, NY 10023
Raymond t. Grant, General Manager

Atlanta Symphony Orchestra
1293 Peachtree Street, NE, Suite 300
Atlanta, GA 30309
Yoel Levi, Music Director
Nancy Bankoff Chalifour, Orchestra Manger

Augustana College Symphony Orchestra
Augustana College
Office of Cultural Affairs
Rock Island, IL 61201
Dr. Daniel Culver, Musical Director

Baton Rouge Symphony Orchestra
Centroplex Theatre
P.O. Box 103
Baton Rouge, LA 70821
Daniel J. Hart, Music Director

Bay Area Women's Philharmonic
934 Brannan Street
San Francisco, CA 94103
JoAnn Falletta, Music Director
Miriam Abrams, Executive Director
Nan Washburn, Artistic Director

Binghamton Symphony
Forum Theatrer 1519
99 Collier Street, Suite 200
Binghamton, NY 13901
John T. Covelli, Music Director
Nan Washburn, Artistic Director

Brooklyn Philharmonic
Opera Hous, Brooklyn Academy of Music
30 Lafayette Street
Brooklyn, NY 11217
Lucas Foss, Director/Conductor
Maurice Edwards, Art Director

Catskill Symphony Orchestra
P. O. Box 14
Oneonta, NY 13820
Charles Schneider, Music Director

Chapman Symphony Orchestra
c/o Chapman College
33 N. Glassell
Orange, CA 92666
John Koshak, Music Director

Chattanooga Symphony Orchestra
Tivoli Theatre 1760
630 Chestnut Street
Chattanooga, TN 37402
Donald L. Andrews, Manager

Cincinnati Symphony Orchestra
Music Hall
1241 Elm Street
Cincinnati, OH 45210
Michael Gielen, Music Director
Steven I. Mondor, General Manager
Jonathan Kramer, New Music Advisor

Cincinnati Youth Symphony
Music Hall
1241 Elm Street
Cincinnati, OH 45210
Teri Murai, Music Director, Conductor

Chicago Symphony Orchestra
220 S. Michigan Avenue
Chicago, IL 60604
Sir Georg Solti, Music Director

Minneapolis Civic Orchestra
624 Morgan Avenue, South
Minneapolis, MN 554405
Betty Braunstein, Manager
Robert Bobzin, Music Director

Claremont Symphony Orchestra
840 N. Indiana Hill Boulevard
Claremont, CA 91711
James Fahringer, Conductor
Sidney Orlov, Business Manager

Cleveland Orchestra
Severence Hall
Cleveland, OH 44106
Thomas W. Morris, General Manager
Christoph von Dohnanyi, Music Director

Dallas Symphony Orchestra
P. O. Box 780
Dallas, TX 75221
Leonard David Stone, Executive Director
Jamers Rives-Jones, Composer-in-Residence

Dayton Philharmonic Orchestra
Montgomery County's Memorial Hall
125 East First Street
Dayton, OH 45422
John Bauser, Executive Director
Isaiah Jackson, Music Director

Drake University Symphony Orchestra
Drake University, Music Department
Des Moines, IA 50311
John Canarina, Orchestra Director

Fairbanks Symphony Orchestra
P.O. Box 82104
Fairbanks, AK 99708
Gordon B. Wright, Music Director
Jane Aspnes, Executive Director
Fargo-Moorhead Symphony Orchestra
429 East Main
West Fargo, ND 58078
David Martin, Artistic Director

Haddonfield Symphony
P. O. Box 212
Haddonfield, NJ 08033
Arthur Cohn, Music Director
Dorothy W. Rivers, Executive Director

Hartford Symphony Orchestra
228 Farmington Avenue
Hartford, CT 06105
Michael Lankester, Music Director
Tibor Pusztai, Associate Conductor

Houston Youth Symphony
P.O. Box 56104
Houston, TXC 77256
Manuel Prestamo, Music Director

Hudson Valley Philharmonic
P. O. Box 191
Poughkeepsie, NY 12602
Imre Pallo, Music Director
Roland Valleire, Executive Director

Interlochen Arts Academy Orchestra
Corson Auditorium
Interlocken Center for the Arts
Interlochen, MI 49643
Byron Hanson, Resident Conductor

Kalamazoo Symphony Orchestra
426 South Park Street
Kalamazoo, MI 49007
Yoshimi Takeda, Music Director, Conductor
Karen Litterer, General Manager

Los Angeles Philharmonic Orchestra
135 North Grand Avenue
Los Angeles, CA 90012
Esa Pekka Salonen, Conductor
Nancy Bell Coe, General Manager

Louisville Orchestra
609 West Main Street
Louisville, KY 40202
Lawrence Leighton Smith, Music Director

Mesa Symphony Orchestra
Mountain View High School Auditorium
136 West Main Street, Suite 102
Mesa, AZ 85201
Eric Black, Music Director

Minnesota Orchestra
1111 Nicollet Mall
Minneapolis, MN 55403
Edo De Waart Music Director
Robert P. Jones, General Mgr.
Libby Larsen and Stephen Paulus,
Composers-in-Residence

New American Orchestra
Foundation for New American Music
10208 Culver Boulevard
Culver City, CA 90232
Jack Elliott, Musical Director

New Hampshire Music Festival Orchestra
P. O. Box 147
Center Harbor, NH 03226
Thomas Nee, Conductor
David Graham, Executive Director

New Hampshire Symphony Orchestra
Palace Theatre, Box 243
Manchester, NH 03105
James Bolle, Music Director
John Macukas, General Manager

New Haven Symphony Orchestra
Woolsey Hall 2695
33 Whitney Avenue
New Haven, CT 06510
Catherine Weiskel, General Manager
Michael Palmer, Music Director

New York Youth Symphony
Carnegie Hall 2800, Room 504
881 Seventh Avenue
New York, NY 10019
David Alan Miller, Music Director

Northwood Orchestra
c/o Northwood Institute
Midland, MI 48640
Don Jaeger, Music Director
Christine Goedert, Special Events Director

Pasadena Symphony Orchestra
117 East Colorado Boulevard, Suite 375
Pasadena, CA 91105

Peabody Symphony Orchestra
One East Mt. Vernon Place
Baltimore, MD 21202
Frederik Prausnitz, Conductor
Linda G. Goodwin, Manager

Philadelphia Orchestra
1420 Locust Street
Philadelphia, PA 19102
SJoesph Kluger, Executive Director
Riccardo Muti, Music Director

ProMusica Chamber Orchestra
1870 Madison Road
Cincinnati, OH 45206
Thomas Widler, Music Director

Rochester Philharmonic Orchestra
108 East Avenue
Rochester, NY 14604
Mark Elder, Musical Director

Saint Louis Symphony Orchestra
718 North Grand Boulevard
St. Louis, MO 63103
Leonard Slatkin, Music Director

St. Paul Chamber Orchestra
318 Landmark Center
75 W. 5th Street
St. Paul, Minn. 55102
Hugh Wolf, Conductor
William Vickery, Managing Director

San Francisco Symphony
Davies Symphony Hall 3063
San Francisco, CA 94102
Edo de Waart, Conductor
Peter Pastreich, Executive Director

Santa Cruz County Symphony
6500 Soquel Drive
Aptos, CA 95003
JoAnn Falletta, Music Director/Conductor

Springfield Symphony Orchestra
1391 Main Street, SUite 1006
Springfield, MA 01103
Raymond Harvey, Music Director
Robert Stiles, Executive Director

Toledo Symphony Orchestra
One Stranahan Square, Suite 354
Toledo, OH 43604-1496
Dr. Melvin Harsh, Artistic Adviser
Robert Bell, Managing Director

Tuscon Symphony Orchestra
433 S. Stone Avenue
Tuscon, AZ 85701
Robert Bernhardt, Music Director
Eric G. Meyer, Executive Director

Wichita Symphony Orchestra
Century II Concert Hall 2200
225 W. Douglas, Suite 207
Wichita, KS 67202
Michael Palmer, Music Director
Mitchell A. Berman, General Manager

Chapter VIII

I've Written My Novel.
Now What Do I Do?

It would be presumptuous and foolhardy to tell writers how to write. Each writer is different and will follow his own path. The information provided in this chapter is not meant to establish directions but is simply meant to make it easier to reach the destination you've already chosen. While writing is, of necessity, a lonely profession, it's helpful to know there are well-established support systems to provide advice, legal assistance, health insurance and even emergency funds if you're ill or about to be evicted. Most important, there are organizations and guilds and publications which provide contact with other writers and offer valuable insight into the problems you'll face as you try to turn your writing profession into a paying business.

The information in this chapter will enable you to identify agents, small press publishers and distributors, explore sources of funding and awards, and connect with writers and organizations whose problems and concerns are similar to yours. The next move is up to you.

Finding An Agent

It's not absolutely necessary to have an agent. Many successful writers find publishers and negotiate contracts without assistance. However, unless you want to spend a large portion of your time contacting publishers, reading rejection letters, and if you're very lucky, negotiating contracts, you'll be well advised to find a reputable agent to assume those responsibilities for you. It also does not necessarily follow that a good writer will be a good agent. Professionalism is valuable in every field.

It is important to clearly understand what a literary agent can do for you before you go knocking on the doors at the William Morris Agency. Certainly before you establish a formal professional relationship, you should understand that besides filing rejection letters, good literary agents will:

1. Try to sell an author's work to appropriate publishers (there's little point in sending a romance novel to a textbook publisher).

2. Negotiate the terms of an author's contract with a publisher.

3. Collect all payments due the author from a publisher.

4. Ensure that the publisher is complying with all contractual agreements

5. Conduct auctions (an auction means that a manuscript is submitted to publishers and subsidiary buyers with a deadline by which they must bid on it).

6. Explore other markets such as films, television, and foreign sales for an author's work.

These duties as well as the amount of compensation to the agent, reimbursable expenses, and the duration and scope of the contract should be reflected in any written agreement you make with an agent.

Having absorbed this, your next step should be toward the door of an agent's office, preferably one recommended by another writer. If you can't find another writer to refer you, a less desirable but frequently used option involves writing "cold" letters of inquiry. You will be able to find lists of agents in the various reference books and literary publications listed in this chapter. According to Debby Mayer, the author of *Literary Agents, A Writer's Guide*, many agents will respond to unreferred queries. Of the 164 agents who participated in a survey she conducted, 102 said they read "cold" letters. Since very few read unsolicited manuscripts, you may as well save your postage money and concentrate on writing an interesting letter of inquiry.

Your inquiry should include a short sample or description of your work, a description of your education and training as a writer, and your publication history. Make your letter clear and to the point, and always type it neatly. Agents who respond to your letter will probably ask you to submit sample chapters for review. Other agents will indicate that they're not accepting new clients and still others will not respond at all. You'll improve your chances for a positive reply if your letter is well-written and enclosed with a self-addressed, stamped envelope. Try to do enough research so that you can direct your letters to specific agents and don't be discouraged by the first half-dozen rejections. It could be much worse. If you were a beginning actor, you'd receive a half-dozen rejections between breakfast and dinner.

Once an agent does express an interest in reading your manuscript, or some portion of it, be certain you submit it in its most polished form. Present your manuscript professionally and ask for an initial response within two weeks. When the manuscript is returned, thank the agent, particularly if she's offered comments and criticism, and repeat this routine until

you find a capable representative for your work.

The following reference books and organizations maintain up-to-date lists of literary agents and agencies:

Guide to Literary Agents
and Arts / Photos Representatives
 Edited By Robin Gee, 1992
Writer's Market Publications
1507 Dana Avenue
Cincinnati, OH 45207

Independent Literary Agents Association,
Inc. (ILAA)
15 East 26th Street, Suite 2801
New York, NY 10010

Founded in 1977, the ILAA is a national organization of over 100 literary agents located in cities such as New York, Boston, San Francisco and Washington, D.C. Membership is open to full-time agents who fulfill the organization's requirements concerning experience in the profession. ILAA does not recommend agents or give information about its members' areas of interest or specialization. Upon request with a self-addressed envelope, ILAA will provide a list of members who are willing to receive query letters (not manuscripts) from writers.

Literary Market Place (LMP)
R.R. Bowker Company
245 West 17th Street
New York, NY 10011

LMP is the "phone book" of the trade publishing industry. It includes a comprehensive listing of book agents: all reputable commission agents and some "mixed" agencies (commission and fee-charging.) The minimum requirement for an agent's inclusion is three books sold to established publishing houses in the previous year.

Novel & Short Story Writer's Market
1507 Dana Avenue
Cincinnati, OH 45207

A thorough listing of agencies which represent fiction writers. They note which agents do and do not charge fees.

Society of Authors' Representatives, Inc.
(SAR)
10 Astor Place
New York, NY 10113

SAR was founded in 1928 by a group of literary and dramatic agents. A voluntary organization, its 54 members "subscribe to the ethical practices" outlined in its brochure. The brochure, which lists member agents and offers advice on finding and working with an agent, will be sent to those requesting it if they enclose a stamped, self-addressed envelope. SAR has drawn up three model forms: a contract for U. S. book publication, a contract for foreign publication, and a permissions form, all available for a small fee. They are helpful in acquainting a writer with rights that can be negotiated with a publisher.

Writers Guild of America, East, Inc.
555 West 57th Street
New York, NY 10019

Writers Guild of America, West, Inc.
8955 Beverly Boulevard
Los Angeles, CA 90048

The Writers Guild offers a comprehensive and reliable list of screenplay agents for radio, TV, and screenwriters only. All agencies on the list have signed the Guild's Basic Agreement or its Manager Basic Agreement.

The Writer's Handbook
The Writer, Inc.
120 Boylston Street
Boston, MA 02118

Annual lists agencies in New York City.

Writer's Market
Writer's Digest
1507 Dana Avenue
Cincinnati, OH 45207

Lists 62 agencies, none of which charges a fee. Information is often more thorough than that of Literary Market Place, but since this is an incomplete list of working agents, it should be used in conjunction with LMP.

Publications for Writers

The following publications provide comprehensive information on grants, unions, conferences, contracts, health-insurance, self-publishing and other issues which concern beginning writers:

AHA Funding Directory
Association of Hispanic Arts, Inc.
173 East 116th Street
New York, NY 10029

Lists foundations, corporations and public arts-funding opportunities for individual artists and arts organizations.

Catalogue of Literary Magazines
Coordinating Council of Literary Magazines
666 Broadway, Eleventh Floor
New York, NY 10012

Includes descriptive entries for over 340 literary magazines.

AWP Newsletter
Associated Writing Programs
c/o Old Dominion University
Norfolk, VA 23509

Prints manuscript requests from small presses and announcements of awards, contests, etc.

Careers in the Arts: A Resource Guide
Center for Arts Information
1285 Avenue of the Americas
New York, NY 10019

A guide to professional unions, associations, internships, apprenticeships and training programs to help individuals make the necessary and proper choices about arts careers.

Coordinating Council of Literary Magazines Newsletter
Coordinating Council of Literary Magazines
666 Broadway, Eleventh Floor
New York, NY 10012

Reports workshops, conferences, contests, grants, and prizes.

Dramatists Guild Quarterly
The Dramatists Guild, Inc
234 West 44th Street
New York, NY 10036

This quarterly contains transcripts of symposia, commentaries, letters, and notices of productions. Fre-quently lists information about professional opportunities.

Dramatists Sourcebook
Theatre Communications Group
335 Lexington Avenue
New York, NY 10023

Dramatists Sourcebook is probably the most comprehensive guidebook to playwriting opportunities published in the United

States. It lists 130 American non-profit theatres and their guidelines for submission, as well as grants, contests and residencies. It also itemizes artist colonies, sources for emergency loans, useful publications, script publishers, agents, and academic programs. In the back, an invaluable index organizes all appropriate information into a month-by-month submission calendar "so that the reader can easily determine which deadlines are fast-approaching and which remain at a comfortable distance. A new edition is issued each September.

Grants and Awards Available to American Writers
PEN American Center
568 Broadway
New York, NY 10012

Lists nearly 500 American and international grants programs for all kinds of writers, including guidelines, deadlines and application procedures.

Hollywood Scriptletter
1626 North Wilcox, #385
Hollywood, CA 90028

This monthly newsletter features interviews with people in the film and television industries. Both the business and the art of writing for the electronic media are explored. Markets and contests are listed in the back of each issue, including stage possibilities.

Jobs in the Arts and Arts Administration
Center for Arts Information
1285 Avenue of the Americas
New York, NY 10019

A guide to placement and referral services, career counseling and publications that feature arts-employment listings.

Money for Artists
Center for Arts Information
1285 Avenue of the Americas
New York, NY 10019

A guide to grants, awards, fellowships and artists-in-residence programs primarily for the New York State artist.

Network
International Women's Writing Guild
Box 810, Gracie Station
New York, NY 10028

Monographs.

Poets & Writers, Inc.
72 Spring Street Street
New York, NY 10012

Poets & Writers is an information center and service organization for nationwide literary activities. They publish the following:

Poets & Writers Magazine
72 Spring Street Street
New York, NY 10012

News and commentary on publishing, jobs, grants, taxes, arts programs, legislation, and other practical topics.

Reprints include: "How to Give an Unsolicited Manuscript the Best Chance" (a complete guide to manuscript preparation and marketing), "The Quest for a Publisher" (capsule reviews of 14 writers' market reference books), "12 National Groups Offering Services to Writers" (details on the services and membership requirements of the nation's major literary organizations), "Book Contracts" (how to negotiate a fair one by yourself) and "A Guide to Writers' Resources" (where to find information on everything: emergency grants, print centers, vanity presses, writing programs, translators, self-publishing, health insurance and more).

Literary Bookstores: A List in Progress
72 Spring Street Street
New York, NY 10012

344 stores which specialize in contemporary fiction and poetry; appendix lists 34 literary bars and coffeehouses.

Sponsors List.
72 Spring Street Street
New York, NY 10012

641 organizations across the nation that sponsor readings and workshops involving poets and fiction writers. Entries include names of contact persons, number of writers hired annually, and fee budgets if available.

A Writer's Guide to Copyright
(available thru Volunteer Lawyers For Artists, New York)

A summary of the 1990 copyright law for writers, editors and teachers.

Publishers Weekly
R. R. Bowker Company
249 West 17th Street
New York, NY 10011

The trade magazine of the publishing industry, *Publishers Weekly* covers more than most writers and the average reader needs to know. Single copies or subscriptions are available from the Bowker office.

A Quick Guide to Loans and Emergency Funds
Center for Arts Information
1285 Avenue of the Americas
New York, NY 10019

Describes 6 free or arts-loan funds for organizations in New York and two special bank programs, as well as 14 loan funds or emergency funds for artists.

The Writer
The Writer, Inc.
120 Bolyston Street
Boston, MA 02118

News for writers in all fields, with emphasis on marketing and writing techniques.

Writer's Digest
1507 Dana Avenue
Cincinnati, OH 45207

The world's leading magazine for writers. Monthly issues include timely interviews, columns, and tips to keep writers informed on where and how to sell their work.

Other helpful Writer's Digest publications:

Law and the Writer
Edited by Kirk Polking and Leonard S. Meranus. Tells how to avoid letting legal hassles slow down your progress as a writer, how you can find good counsel on libel, invasion of privacy, fair use, plagiarism, taxes, contracts, social security, and more - all in one volume.

A Treasury of Tips for Writers
Edited by Marvin Weisboord. Everything from Vance Packard's system of organizing notes to tips on how to get research done free, by 86 magazine writers.

The Writer's Digest Diary
Plan your year in it, note appointments, log manuscript sales, and be prepared for the IRS with this permanent, annual record of writing activity.

Writer's Market
Edited by Bruce Joel Hillman. The freelancer's bible, containing 4,500 places to sell what you write, including the

name, address and phone number of the buyer, a description of material wanted, and rates of payment.

Writer's Yearbook

Edited by John Brady. This large annual magazine contains how-to articles, interviews and special features along with analyses of 500 major markets for writers.

Writing and Selling Non-Fiction

By Hayes B. Jacobs. Explores with style and know-how the book market, organization and research, finding new markets, interviewing, humor, agents, writer's fatigue and more.

Small Press Publishers

Beginning writers should pay particular attention to the small-press movement in the United States. With the major publishers increasingly concerned about profit, small presses and unknown writers have formed a marriage of necessity. It will be worth your time to consult the *International Directory of Little Magazines and Small Presses* (Lem Fullam, editor, Dustbooks, Inc.) to determine the kind of work each press publishes. Most publishers will also be happy to send you catalogues and submission guidelines if you send them self-addressed, stamped envelopes.

Antaeus

Ecco Press
26 West 17th Street
New York, NY 10011

Antaeus is a quarterly that publishes poetry, fiction, interviews, novel excerpts and long poems.

Book Forum

P.O. Box 585
Niantic, CT 06357

Accepts articles, interviews, criticisms, and reviews.

Book Notes: Resources for Small & Self-Publishers
P.O. B0x 3877
Rochester, NY 14607

Bottom Dog Press
c/o Firelands College
Huron, OH 44839
Poetry,fiction and personal essay.

Chelsea Magazine
Box 5880, Grand Central Station
New York, NY 10163
Chelsea purports to have no special biases and deliberately
maintains an eclectic editorial policy.

Directroy of Women's Media
47 East 65th Street
New York, NY 10021
NCRW is a non-profit that provides resources for research in
their area of interest.

Hanging Loose Press, & *Hanging Loose* (Journal)
231 Wyckoff Street
Brooklyn, NY 11217
Unsolicited manuscripts welcome; Hanging Loose takes an
active interest in new writers.

News Notes
Box 2633
Lakewood, OH 44107
Accepts poetry, fiction, articles, interviews and reviews.

St. Croix Review
Box 244
Stillwater, MN 55082
Publishes quality non-fiction. Please send application letter
first.

Sang Froid Press
P.O. Box 272
Excelsior, MN 56331

100% literary small press. Non-fiction, photo essays, and art features. Distributed nationwide.

SEZ, A Multi-Racial Journal of Poetry & People's Culture
Shadow Press, U.S.A.
P.O. Box 8803
Minneapolis, MN 55408

Poetry, fiction, articles, art, photos, cartoons and interviews. *SEZ* is interested in publishing writers who are dealing with social issues and working for a more humane society.

Small Press Internaional
P.O. Box 61
Lumby, B.C.
VOE 2 G0, Canada

100 % literary small press. Accepts poetry, fiction, essays, and reviews.

Sun Magazine
107 North Roberson Street
Chapel Hill, NC 27516

Publishes short books of poetry, fiction, art and critical theory. Style and language theory are stressed.

Union Street Review
P.O. Box 19078
Alexandria, VA 22320

Articles, cartoons, interviews, satire, criticism, reviews, letters, collages, art and nonfiction. Unicorn publishes offbeat and humorous aspects of popular culture and folklore.

Conferences & Colonies

The Poets & Writers, Inc. resource library and the Center for Arts Information offer current information on conferences and artists' colonies which accept writers for short residencies. Participants from other art forms as well as scientists, scholars and distinguished writers from foreign countries are also welcomed at many retreats. Some of the best known writers in America have worked in the creative and exciting atmosphere of colonies like Yaddo. Writers' workshops and conferences also provide opportunities to discuss your work and meet with other writers as well as agents, editors and publishers.

The conferences and colonies on the following list are well-established and have enjoyed the support and participation of writers such as John Irving, Carson McCullars, Katherine Anne Porter, Joyce Carol Oates and John Gardner.

Authors Resource CTR (TARC Inc.)
4001 E. Fort Lowell Road
Tucson, AZ 85712
(602) 325-4733

Breadloaf Writers' Conferences
Box 500
Middlebury College
Middlebury, VT 05753
(802) 388-3711

Chautauqua Writer's Workshop
Box 1098
Chautaugua, NY 144722
(716) 357-6232

Sandhills Writers' Workshop
Augusta College
2500 Walton Way
Savannah, GA 31406
(404) 737-1636

Santa Fe Writers Conference
Recursos de Santa Fe
826 Comos de Monte Rey
Santa Fe, NM 87501
(505) 982-9301

Southampton Writers' Conference
c/o English Department
LIU Southampton Campus
Southampton, NY 11968
(516) 283-4000

Wesleyan Writers' Conference
Wesleyan University
Middletown, CT 06457
(203) 347-9411

Women's Writing Conference & Retreats
International Women's Writing Guild
Box 810, Gracie Station
New York, NY 10028
(212) 737-7536

Writer's Conference
Randall House Publishing
Box 17306
114 Bush Road
Nashville, TN 37217
(615) 361-1221

Writer's Haven Workshops
3341 Adams Avenue
San Diego, CA 92116
(619) 282-3363

Service Organizations

There are many service organizations throughout the country which, through information, professional assistance, and financial aid programs, support writers. The following organizations have, over the years, promoted the writing profession with important and badly needed grants, awards, and internships. They have also helped writers establish relationships with agents, editors, and publishers. Most important, they have encouraged writers to spend as much time as it takes to develop the skill and professionalism they need to survive as productive, working artists.

Academy Of American Poets
177 E. 87th St.
NY, NY 10128
(212) 427-5665

The Academy awards an annual fellowship of $10,000, three awards of $1,000 to American poets, and more than one hundred $100 poetry prizes at colleges and universities.

American Society Of Journalists & Authors (ASJA)
1501 Broadway, Suite 1907
New York, NY 10036
(212) 997-0947

The ASJA is a national organization of independent nonfiction writers whose goal is to promote high standards of nonfiction writing. They offer a myriad of services, including employer-member referral service, an annual nonfiction writers conference focusing on marketing trends, financial assistance for incapacitated writers and a monthly newsletter.

Associated Writing Programs
c/o Old Dominion University
Norfolk, VA 23529
(212) 997-0947

AWP assists its members in their professional development, helps them find jobs and encourages their survival through publications, advocacy and information.

Center For Arts Information
1285 Avenue of the Americas
New York, NY 10019

The Center is a major clearinghouse for information useful to nonprofit organizations and artists in all disciplines, including writers.

Change, Inc.
381 LaFayette Street
New York, NY 10274
(212) 473-3742

Founded by Robert Rauschenberg, Change provides emergency grants to artists of every discipline. Grants range from $100. - $500. Free medical treatment is also available through hospitals affiliated with Change.

Coodinating Council Of Literary Magazines
666 Broadway, Eleventh Floor
New York, NY 10012

CCLM provides grants and services to noncommercial literary magazines. They offer internships in publicity, editing and library work. Their library is open to the public. They hold regional conferences on the technical and editorial aspects of publishing as well as literary topics.

The Dramatists Guild, Inc.
234 W. 44th St.
New York, NY 10036
(212) 398-9366
 and
The Dramatists Guild, Inc.
P.O. Box 480092
 Los Angeles, CA 90064
(213) 935-2686

The Guild's primary service is the securing of Minimum Basic Contracts for its members. The Guild gives members advice on legal matters and provides information on contests, theaters, grants, conferences and residencies. Guild members are entitled to a Blue Cross/Blue Shield Health Plan.

Foundation For The Creative Community
122 Amsterdam Avenue
New York, NY 10011
(212) 496-8861

The FCA is a nonprofit membership service directed to improving the social and economic situation of artists. A discount Blue Cross/Blue Shield Health Plan is available to its members.

International Women's Writing Guild
PO Box 810, Gracie Station
New York, NY 10028

The IWWG is open to all women expressing themselves through writing and provides its members with professional supports as well as a supportive networking system. Health insurance, financial and legal advice and technical assistance can be obtained through the IWWG network.

National Play Award
National Repertory Theatre
P.O. Box 71011
Los Angeles, CA 90071
(213) 626-5944

This award gives $7,500. to the winning playwright and $5,000. to a theatre producing the script.

National Playwrights Conference
Eugene O'Neill Theater Center
234 West 44th Street, Suite 901
New York, NY 10036
(212) 382-2790

Center offers a non-competitive atmosphere for new playwrights. The conference allows 12-14 playwrights to rewrite and develop their scripts while working with theatre professionals. Send S.A.S.E., prior to Dec. 1rst, for guidelines and application.

National Writers Union
13 Astor Place
New York, NY 10003
(212) 254-0279

Organization seeks better treatment of freelance writers from publishers.

PEN American Center
568 Broadway, Fourth Floor
New York, NY 10012
(212) 334-1660

PEN American Center is one of 101 PEN International Centers dedicated to promoting international understanding, fellowship and cooperation among world writers. Their broad range of services include the PEN Writers Fund (emergency grants of

approximately $500 or less to writers who are ill, unemployed or have urgent financial needs) and awards for translators and new American writers ($550 - $6,000) Both PEN members and new writers are presented in various readings; internships are offered regularly and PEN publications are available on several subjects.

James D. Phelan Award In Literature
The San Francisco Foundation
685 Market Street
San Francisco, CA 94105
(415) 543-0223

This $2,000 award is specifically for a work-in-progress in any work of literature. Only native Californians between the ages of 20 and 35 are eligible.

Playwrights Award
The Beverly Hills Theatre Guild
2851 North Beachwood Drive
Los Angeles, CA 90068
(213) 273-3033

Annual award of $3,000 to the playwright and $2,000 to a Los Angeles based theatre producing the winning script.

The Poetry Center Of The 92nd Street Y
1395 Lexington Avenue
New York, NY 10028
(212) 427-6000

Each year the Poetry Center schedules writers to read their works, ranging from poetry and plays to novels. The Center offers a series of lectures, seminars and writing workshops and gives four poets who have never published a book a $200 "Discovery"/The Nation Contest prize and publication in *The Nation* journal.

Poetry Society Of America
15 Gramercy Park
New York, NY 10003
(212) 254-9628

Dedicated to the promotion of poets and poetry, the Poetry Society of America sponsors readings, lectures and workshops, publishes a newsletter and supports a book distribution program. Awards ranging from $100. to $2,425. are presented each year to students and established poets.

Poets & Writers, Inc.
201 W. 54th St.
New York, NY 10019
(212) 757-1766

Poets & Writers is an information center and service organization for nationwide literary activities. They sponsor and support readings and workshops in New York State by providing supplemental artists' fees (range $75 - $300) to organizations that sponsor literary events. Their Information Center provides writers with help, advice and information on general professional questions.

Sergel Drama Prize
Court Theatre
5536 E. Ellis Avenue
Chicago, IL 60637
(312) 753-4472

Affiliated with the University of Chicago, the Sergel Drama Prize is a prize of $500 - $1,500 awarded to three winners.

Support Services Alliance (SSA)
c/o IWWG
Box 810, Gracie Station
New York, NY 10028

An independent organization affiliated with groups such as the Committee of Small Magazine Editors and Publishers (COSMEP) and The International Women's Writing Guild (IWWG,) offers group-rate insurance.On the West coast contace COSMEP at 2421 Buchanan Street, San Francisco, CA 94101, (415) 922-9490.

Theatre Communications Group
355 Lexington Avenue
New York, NY 10017
(212) 697-5230

LCG's Literary Services department provides a clearinghouse and acts as a liaison for artists involved in creating and producing new works for the stage.

Writers Guild Of America, East, Inc.
555 W. 57th St.
New York, NY 10019
 and
Writers Guild Of America, West, Inc.
8955 Beverly Blvd.
Los Angeles, CA 90048

Writers Guild of America is a labor union representing writers in movies, television and other media. The Guild offers members an insurance and health plan.

These lists were taken from *CODA, the Poets & Writers Newsletter*; *The New York Writer's Source Book*; the *Theatre Directory of San Francisco*; and *Callboard*.

Super Conscious Living Press,
a part of TWG Press,
1270 Fifth Avenue, Suite 505
New York, NY 10029

At one point a correspondent affiliated with groups such as
the Committee to Abolish Legalized Radical Prisons and Property
(CARP), and The International Workers' Welfare Guild
(IWWG) offers from the pregnant marriage. One press. Write or contact:
contact O. MPP at 2431 Blvd., San Francisco, San Francisco,
CA 94101, (415) 673-9300

Positive Communications Group
2901 Street, Avenue
Ste.
(800) 673-7300

(CG?) Heart Association's legal action to develop, sell, purchase,
reproduce and transmit its materials involved in creating and
producing new goods in the store.

Positive Publications, Inc.
Avenue B
New York, NY 10009

Positive Health Guidance Group, Inc.
1255 Revention Ave.
Rancho, CA, CA 90254
We at Quality Assurance seek a calling program that promotes
initiatives, relationships, and other needs. The Guild offers
exclusive opportunities and solutions.

There may not be any necessary way. These teach them.
Wondering? One way to know for sure is a book. Here we are
Directory of San Francisco, and of Blue Bird.

Chapter IX.

Dancers, Choreographers, and Other Mythical Spirits

This chapter will follow a different format than other chapters in *For The Working Artist*. The choreographers and dancers we interviewed provided such clear and eloquent answers to our questions that elaboration would have been both unnecessary and presumptuous. I am particularly indebted to Fred Strickler, a founding member of the Jazz Tap Ensemble, who could and should write his own (more comprehensive) Dancer's Survival Guide. With his permission, I have reprinted almost his entire interview. I am also grateful to Deborah Slater. She valiantly tried to convince me that dancers face greater problems than aging and aimed my questions to other choreographers in directions I would otherwise have overlooked.

I would also like to offer special thanks to Donna Wood, Rebecca Wright, Yen Lu Wong, Deborah Oliver, Michael Higgins, and the many dancers whose knowledge and generosity helped me scratch the surface of an artform I have enjoyed and loved since I was five years old.

The hills and the sea and the earth dance.
The world of man dances in laughter and tears.

Kabir

Dance and Dancers

The language dancers speak is a difficult language to learn but one that is commonly spoken. People who speak it well use words, expression, feelings, and remarkable physical movement. They also pay a heavy price for their fluency. From the beginning of their careers to the end, dancers struggle with fatigue, pain, injuries, and a clock that can be merciless. While actors, composers, sculptors, and filmmakers are enriched by maturity, the gift of age is a bittersweet one for

155

dancers to accept. Forty-year-old dancers may be more insightful, expressive, and disciplined than twenty-year-olds but their bodies also require more rest, more care, and more inspirational peptalks.

Like music, dance is an artform which is universal. It is enjoyed by all cultures and has the power to instantly give people a sense of community and a sense of themselves. Although dance can reveal the dark side of man's nature, it more often illustrates our vigor and joy, our creative spirit, and our links to other nationalities and generations. For many dancers it is a satisfying and rewarding profession and the short time they have to perfect and practice their craft makes them place a special value on each healthy, working day.

Bruce Beasely, a sculptor whose work is in the perm-anent collections of the Museum of Modern Art and the Guggenheim, says in Lee Evan Caplin's book *The Business Of Art,* that a successful artist is one who "continues to make his art and is not more than fifty percent bitter about the rest of his life." When you realize that dance companies are considered successful if they can give their members twenty weeks of employment in order to qualify them for unemployment insurance the rest of the year, you begin to get a sense of how difficult it is to hold the bitterness down to fifty per cent.

Advice From Dancers Who Are "Not More Than Fifty Percent Bitter"

On Training

Fred Strickler is a concert dancer, a choreographer and one of the founding members of the Jazz Tap Ensemble. His observations:

"Having a dance degree makes a big difference. I don't know that it's necessary but you get a broader education than if you just go to the studios. You get some contact with dance

history. It gave me some perspective. Versatility is the essence. You need to be able to do a lot of things in order to make your living through dance. If you just want to be a dancer, if you know that's your real strength and you know you're not going to be a choreographer and you're not interested in how dance works in the whole scheme of things, then perhaps college isn't absolutely necessary. But it will always be helpful and if you've got the ability and the means to get a college education, you *should* get it. If you're serious about getting a good technical dance education, hook yourself onto experienced dancers who are already working in the field. This is an artform that is still passed on, person to person. There are no texts on dancing that are really going to do the job. There is not a dance literature the way there is a music literature, so it's important to find somebody who is somehow in tune with you, with whom you feel in tune. You must be willing to give yourself over to this person as a student and be willing to listen, work hard, have patience and determination and be willing to grow.

"The first week I came out to California, I met Bella Lewitzky. Here was this person who had already developed and matured in whole areas that were just beginning to appear to me as directions in which I might want to move. In those days, she was involved in the evolution of CalArts and everyone working around her was in a super creative mode and I was fortunate to be in on that process as one of her company members."

Rebecca Wright was a ballerina soloist with both the Joffrey and American Ballet Theatre. She is currently on the faculty of the California Institute of the Arts. Her experience and views of college are very different from Fred's:

"By the time I was out of high school, I was in a company. As a ballet dancer, that's what you have to do. You can't go to college for four years and join a ballet company. At twenty-

one, you're too old. The ballet companies want you when you're sixteen to ninteen. A ballet dancer should know by the time she's eight-years-old that she wants to be a professional ballet dancer.

"If you don't have your training, you don't have anything. Training gives you the freedom to then be able to express yourself and go out of your art form if you want to make it something more, create something new. If you don't have a solid background, you don't have enough information about the classic part of it to go on. If dance students don't want to go to an art institute or college and they plan to go to New York to study, I would suggest that they try to get into a company school. They should do all the studying they need to do and then hope to be good enough to get into the company school. Young dancers need to be aware that there is not only one place and one way to dance. You have to go to the place that nurtures you so that you can become as good as you can possibly be."

Donna Wood is also on the faculty of the California Institute of the Arts. Until last year she was the lead dancer with Alvin Ailey:

"I was raised in Dayton, Ohio, and studied with Jeraldyne Blunden and Josephine Schwarz, my mentor, until I left for New York at the age of sixteen. When I was fifteen, I took a very intensive six-week course with the Dance Theatre of Harlem. There was a lot of exposure to New York dance in Dayton beause so many companies and guest artists travelled near the area to perform and teach. I went to New York at the beginning of the summer when I was sixteen and tried out with four companies. I was determined not to go to New York without a job. Ailey did call and asked me to join him in the fall as a member of the company (with a three-month probationary period).

"You need to work with teachers and mentors who are as enthusiastic about dance as you are. It's very important to instill the joy of movement and the joy of dance. Training with respected teachers tells everybody else what your training is. I'm not saying it's going to get you a job but it will mean to others that you have an understanding of a certain kind of movement. There are very few teachers who really give you a well-rounded perspective of movement and I would suggest that you study with a series of teachers as opposed to just one teacher. You'll need different perspectives and different techniques to become an overall, whole dancer. When you're studying with three different teachers at one time, the information you get from Teacher A is going to feed into Teacher B and Teacher C so that you'll connect in a different way and develop several approaches.

"At CalArts you learn how to be creative. You have to choreograph, you have to be used in other people's choreography and you have to learn every aspect of production. You have to learn to costume, sew, produce, and take responsibility for yourself and your own education. The era of being pampered in a company is over. You learn everything at a school like CalArts. It can make you very strong because the training shows you how to take care of yourself and be independent."

On Auditions And Getting Into A Company

Rebecca Wright
"You must always come to whatever you're doing, Broadway, modern dance, or ballet dressed in the image of that art form. You can't expect to come to class looking like a bag lady every day and assume that you're going to be chosen for the lead in a particular perfomance or go on to a major ballet company.

You have to be neat. You have to be trim. You have to be clean. The whole point of dancing is the line. You have to know how to present yourself in auditions. How are you going to look? How are you going to wear your hair? What is your face going to look like? You don't have to look like a pale, gaunt little girl who wants to get into the company. A little bit of glamour can help a lot. You have to make sure that your physical body form (weight) is in its proper place. That's your maintenance, your upkeep. You have to make sure that the shoes that you wear are clean and neat, one long line. Keep them the same color as your tights.

"If you're going to go to an audition and you've made up your mind that you want that company, the only way to go into that audition is to go center front. If you're not going to get center front, don't bother to go to the audition. You let them know you want them. If you're going to stand in the second line off to the left, they're going to know that's exactly where you want yourself placed. You have to get yourself ready to put yourself out front. You have to have an energy level and an attack. You have to know a wide range of styles and movements, classical, neo-classic, modern en pointe, modern in jazz shoes, modern in tennis shoes. A lot of these companies like Joffrey and American Ballet Theatre, do that kind of thing. You have to know how to count your music because they might not count it for you. Being able to have a rapport with your teacher or your auditioner is very important. Send out vibrations of being able to absorb. Don't be afraid of criticism, take it constructively and not negatively. Be able to communicate if there is a question that you need to ask, and don't be afraid to ask it. Always be prepared for everything. Have the shoes that you're going to need and the right tights. Always take a needle and thread, Band Aids and safety pins.

Always think of the most disastrous thing that could happen to you. The ribbon on your shoe breaks, your pointe shoe breaks. You always need two pairs of shoes in case one breaks down. Your bra strap could break. You don't want to think negatively when you walk in. You want to be prepared for anything negative that might happen. You have to be prepared for the worst, so that if it does happen, you're still optimistic and ready to go and get what you want."

Fred Strickler

"Being a dancer does take knowing people, being connected to other people in the field. The dance community is not very large. For example, you talk to people about what you're doing and they'll say they've got something coming up in six months and they need someone to do a tap dance thing and ask if you're interested. Getting work is not always done through formal auditions. I think developing a really healthy social persona is important for a dancer. The world we live in today is about networking. It's about becoming a part of and creating your own network of people. If you know somebody you're interested in working with, let them know that you're interested. Most choreographers tend to choose people they've already met. Use the *Dance Magazine Directory* to locate someone whose work you admire and call and introduce yourself. Say 'I'm doing a dance program and I'm very interested in working with your dance company at some future date and I would like very much for you to come and see my work.' Nobody ever gets offended by having you say that you want to work with them.

"You might get turned down. You have to do a lot of preparation for rejection, just as you do in any other art form. Realize that if you're a young, inexperienced dancer, it's

going to be awhile before you get those plums you're dreaming about. It's really about paying your dues. You work your way up, dance small parts, dance once in an evening. Dance in all sorts of workshops for free to get exposure, to get exposure working with choreographers because each choreographer is different. You have to learn to be psychologically flexible as well as physically capable. You'll rehearse for free and get minimal wages for performances. Sometimes you'll even have to pay money to get a certain experience. Just get lots and lots of experience. That's what paying your dues is."

Contracts, Agents and Paperwork

Fred Strickler

"If you are working with somebody with whom a letter of agreement will suffice and you don't have to spell everything out in detail, then that's fine. Because we tour a lot, Jazz Tap Ensemble has a fairly difficult, detailed Technical Rider that is 7 to 8 pages long. We go in on the day of per-formance so it has to be right and it has to be worked out in advance.

"I would recommend that you consult a lawyer if you are trying to work out a standard contract you plan to use over and over again. Have a lawyer check it out to see that it covers all the territory it needs to cover, that it's legally proper, and that you're not asking for something that is illegal such as a quick change room by a fire exit. It's very important to make fundamental decisions about what you want when you are on tour. What you want is certainly the opportunity to dance, and more than that you need to have a decent floor surface. A lot of arts presenters are not aware of your specific needs. No matter how basic and obvious you think your needs are, it's quite likely that at least one of those will be utterly missed by a sponsor. They will not understand that you need time on the

stage before the performance. Sometimes they do not tell you that you will be working around a set. You need a clear, open space of minimum dimension and you specify those dimensions. You need all the lighting facilities that will be available and you spell it out. Figure out what your needs are, what you want to do with your art and how you want to be presented." (See Chapter IV on contracts.)

Agents

Most beginning dancers and dance companies serve as their own booking agents. This is frustrating, difficult and time-consuming work and if you can find a way around it, you should. A good agent is talented, patient, persuasive and worth her weight in silver. You will rarely come across a dancer whose skills as an agent match her artistic skills and unless it's absolutely essential, don't try to play both roles. Several options to consider are:

1) Form a non-profit arts management organization with other dancers or dance companies. Depending on your level of involvement, this can either create or save you lots of headaches. CIRCUIT, an agency formed four years ago by five San Francisco choreographers, not only handles bookings but provides grantswriting, marketing and management services for the five partners. By sharing the cost of staff, information services, and an office, the choreographers have saved money and expanded the market for the kind of work they do.

2) Find a commercial agent. If you can afford one, you can benefit from the rapport and clout the agency may already have established with sponsors you don't know. In addition to finding bookings, commercial agents will often make hotel

reservations, travel arrangements and provide on-site press with up-to-date reviews and press materials. Good commercial agents are as difficult to find as clergy at Hollywood cocktail parties, so when you find them, treat them with care and respect.

3) Arts administration interns, volunteers from your Board of Directors and your company manager can also serve as agents (generally on a short-term basis) but this is not a job that everyone can do well.

If you know another dancer who is happy with his agent and if you like the kind of bookings he's getting, ask the agent to consider taking on another client. The best agents are the busiest agents. As in most professions, free time doesn't always equate with talent and an agent who can give you part of her time may be worth a lot more to you than an intern with lots of time and no contacts.

Unions

AGMA is the concert dancers' union but many dancers who work in California also belong to AFTRA and SAG. See Appendix VII for a list of union offices, addresses, initiation fees and criteria.

Ways To Make It Work

Deborah Oliver, choreographer and associate director/ producer of InterArts Visions, Inc.:

"After I graduated from CalArts, I went to New York to work with Jamie Avins, the Dance Curator at The Kitchen. I worked as a stage manager/lighting designer and I saw a lot of very good dance and some not-so-good dance. I saw dancers, choreographers and performance artists booking paid

performances and I began to get a sense of what it took to survive in the real world.

"After about two years, I came back to California and and went to work at Los Angeles Contemporary Exhibitions (LACE) as a performance coordinator. I worked there for a year and a half and during that time I began to create my own pieces. I finally realized that if I was going to be able to present my own kind of work, I'd have to create my own opportunities.

"In 1984, I decided to produce a program of my own choreography so I organized a program for myself and a few other young choreographers whose work I admired. That was my first experience with fundraising, a skill I've discovered is essential if you want to produce your own artwork. It was all very low budget. No one made any money but we covered our expenses from box office receipts and we were well-received by the local dance critics and audiences. It was very encouraging and when I was approached by Marian Scott in 1985 and she told me she had been looking for someone to help her establish an organization which would present new work, I agreed to help her. It had been a long-time dream of hers. I had learned a lot about arts management, I knew how to organize and I knew the basic rules of production. I was ready for the opportunity she offered me.

"After graduation, dancing became secondary to survival, to making money to pay the rent and buy food, but I never lost my strong desire to be a choreographer. I luckily worked with organizations that taught me about the *business* of being an artist and between graduation and now, I learned to be a producer. It all helped and now I'm not only a producer but I'm part of an organization that encourages me to do my own work. Learning to work with video, to be a stage manager and to design has all helped make my work stronger. No experience

is ever wasted on an artist."

Donna Wood

"You have to be open to a lot of ideas. You can't go into a class and say, 'I don't like this. I'm not going to do it.' You have to be able to be completely submissive in order to expand your knowledge of dance. Whatever they tell you to do, you must try to do it. You must learn everything they tell you to do, every aspect and every technique of dance in order to discover your true strengths and challenges. There's a company someplace for everybody. New York City is not for everyone. Investigate other places. A lot of those New York companies are fed from some of those other places.

"Rebecca Wright and I are good examples of that. We both came from the Dayton Ballet Company. You get a lot of the training, a little less competition, a little more concentration on the individual in some of these other, smaller places. A lot of people need a secure foundation before they can deal with the major companies. The more you live, the more you have to bring to dance. Of course you need the training, but you need life too. You have to have a balance. Dance is about people dancing, not just about technicians who dance. There are a lot of dancers out there who can do what you do. It doesn't matter if you can do ten pirouettes if you're a bore. You have to have that kind of special feeling. It can't be a series of still slides.

"I consider guest appearances the beginnning of my true growth awareness. When you guest appear, you are no longer under the protective umbrella of a company, surrounded by a family, surrounded by people who know you. When you're around people you know, you can sort of get away with things. When you go out to guest appear, you are on your own. You have to be on top of everything and be responsible for

yourself. That's the time to really take command of yourself and stretch beyond your comfort zone. Everything can be wrong and you'll want to blame the whole world. But the audience doesn't care if it's cold, they don't care if the tempo is wrong, they don't care if the other dancers are the pits. All they want to see is good dance. It doesn't matter what you have to overcome to give a good performance.

"My ultimate goal in a performance is a total sculpting of an entire ballet. You have to be able to play with the choreography without changing it. You must be able to adapt. Although you strive to make every step perfect, the artistry comes in when you fall out of a pirouette. You must cope with it as gracefully as possible, as if it were choreographed and keep on going. A half hour ballet won't fall apart because you missed one step. You can't spend the rest of the ballet knocking yourself for missing that pirouette because the entire rest of the ballet will suffer. In performance you must command your space and magnetize the audience with your energy. You can't do anything half way."

Fred Strickler

"We didn't start out planning to build Jazz Tap Ensemble. It came about almost accidently. After our first concert in January 1979, we started getting about a booking a month, regional stuff. By the end of the year, we were in New York at Dance Theatre Workshop, a very, very good place to be because it is certainly one of the most established places for new dance companies to perform. Recognition and success came quickly for us and I think it happened quickly because we combined art and entertainment. We were taking what had been primarily an entertainment form and brought it to the concert hall. We were not the first people to do that. But what

we did do was bring a modern dance choreographic sensibility into an art form that really was associated with entertainment. That particular combination and the particular chemistry of the people who were involved was wonderful. All six of us had both very similar and very different backgrounds. I had musical theatre, modern dance, classical music and tap. Lynn had acting, theatre, modern dance and tap. Camden had modern dance, visual arts and tap. So we had these diverse sensiblilities. We were all choreographers. (The musicians had the same diversities.) The one big thing that focused us was jazz music and tap dancing. We had all these things that everybody spilled into the organization and into the creation of new works.

"It was intensely creative. We made pieces that, for the most part, worked. It was popular. It came just at the right time when there was this big upsurge and interest in tap dancing and we were doing it at a pretty high level of artistry. We were a package that was organized and could be toured. We got good reviews which is very important. It has now become an international group. We were all collaborators, we all had an equal voice (although some voices were more equal than others). The dancers tended to have the strength of the decisions because we became known as a dance company rather than a music and dance company and because it has been primarily the dance press that has given us recognition.

"It's tough doing collaborative work because ultimately a decision is made by mutual agreement or through struggling until one person's idea wins out. When it's by mutual agreement, it's great. In our first two years we did more than 30 productions on practically no money. Public relations is essential and that's a lesson I learned with Jazz Tap Ensemble. It doesn't matter how good your work is. If nobody knows that

you're performing, it's not going to pay off artistically or financially. You just have to do continuous PR to compete in the market place.

"Jazz Tap Ensemble grew and started doing very good work. We found a manager and a booking agent and started writing our own press releases and getting on top of those things. We couldn't do it without the manager and booking agent. In the beginning we just did it in-house among ourselves. All of us had been around for awhile and we did have some connections. We would call around and send letters. We began to get photographs of ourselves, started sending out press packets, piecing it together, xeroxing reviews. (We did it cheaply.) A lot of the funding just came out of our own pockets. We weren't smart enough in those days to realize that we needed a non-profit corporation right away. We should have moved faster sooner.

"To succeed, a group has to make everything work, whether it's easy or not, whether it's fun or not and whether it's agreeable or not. If you want to dance, you've got to make it work. Don't expect somebody else to figure things out for you. That means you have to fight, and if you're willing to go through the artistic battles to get what you want, then do that. If you want someone else to make the decisions, then find a situation for yourself where someone is going to take over for you. Cooperation is a lot better than not cooperating. You can waste a lot of time trying to be right."

Supporting Your Act

Until you begin to generate income from your art, you will need to find other means of support. The most logical jobs are those related to your art. Arts administration jobs, teaching, and technical work such as lighting design and costuming will

offer opportunities to work in a sympathetic environment and be involved with people who understand your need to take time off for auditions or touring. Unfortunately, these kinds of jobs use up a lot of creative energy and pay less than you'd make as a waitress at a good restaurant.

Yen Lu Wong, the choreographer/director for The New Repertory Company, recommends that young beginning dancers learn another skill to support themselves over the frequent periods of unemployment:

"In California," she says, "there are many new immigrants willing to do good work for very little money. Dancers can't compete in the unskilled labor market." She also suggests looking at the jobs which pay the most money for the skills you have. "If you're going to be a waitress, don't go to Marie Callender's. Go to the most expensive restaurants and get a job as a hostess or a hat checker until a waitress job opens up. If you type, don't go to just any office and type for minimum wage. Type for studios which use teleprompters. The money is much better and your schedule will be flexible. Instead of teaching aerobics for $7.50 an hour, learn to do Shiatsu and earn four times that amount."

Fred Strickler

"Keep in mind that more than probably 90% of people who have dance careers are finished with their performing careers between ages 35 and 40, sometimes earlier than that. You have to think, even at 18, about what else you can do to support yourself. Develop something else. Perhaps a business skill. Find something else that you can do to make money. Find something which will allow you flexible hours. Find another work skill that will be both interesting and economically realistic because dancing is not an economically viable occupation for 95% of the dancers.

"There are other dance-related fields dance management, dance history if you're interested in teaching or in being a research assistant, dance notation, dance therapy. Broaden yourself in all of the arts. Familiarize yourself with art history, with contemporary arts, with visual arts, the various arts media like video and film. Learn to read music. If you're a choreographer, it will be a great advantage. Get involved. Go to the theatre. Go see films, go see all kinds of art. Dance does not exist in a vacuum. We are influenced by other artists. Familiarize yourself with the society in which you're working. Get involved with your community somehow so that you're in touch with what's going on around you. Don't isolate yourself by being an artist in a hothouse studio. There *are* distinct advantages to having your own studio and working and concentrating your own vision, but if your vision as a dancer/ choreographer is not bigger than yourself, then it's not a very big vision. You have to know what else is going on. You have to know who else is out there in your field and who is influencing them."

If you can make a major time commitment, teaching jobs offer many benefits such as rehearsal space, health and dental insurance and an occasional opportunity to perform. The American Dance Guild's Job Express Registry and the Directory of College and University Dance provide current and reliable information about teaching opportunities in the field of dance.

If you are interested in Arts Management positions, see Appendix I for resource listings.

Survival and the Price You Pay

Deborah Slater, choreographer and director of Deborah Slater and Company:

"I didn't really appreciate what it would mean to be a dancer in this country. I chose what I loved to do without being aware of the economic repercussions. In any other profession, after 10 or 12 years of hard work, I'd have a steady income, a health plan, a decent car and be able to think about putting a down payment on a house. As an artist doing nontraditional work, that's simply not possible. San Francisco prides itself on its individuality but it doesn't support its artists and its galleries. It could not even raise enough money to produce the International Theatre Festival. People are caught up in the fast food syndrome. They expect art to be synthesized as quickly as their dinner from McDonald's.

"I have never regretted being an artist. When I'm doing my work and it supports me, I'm ecstatic. There's nothing like it. I can do public relations and arts management, but it's not really satisfying. I've had a better time in my studio alone than in planning a public relations campaign. The event is much more compelling than the work that makes an event happen."

Yen Lu Wong

"Survival depends on where you live. If you live in New York where there are good support systems, it's easier to survive than it is in Los Angeles. We don't have an organization like Dance Theatre Workshop in L.A.. There's no cluster space, no organization to impact critics, to address problems with marketing, insurance and developing rosters of good, affordable designers and technicians. Survival is always difficult for artists but in some cities, it's almost impossible."

Fred Strickler

"The price a dancer pays is generally considered to be very high. You're probably never going to be rich. If you're good, you're going to be giving a lot more than you're getting. You're going to have very difficult emotional situations from time to time. The nature of creativity is very similar to emotional states. They're related and they're intense. Creating is not neutral, and it's not as private and controllable as it might be if you were doing research in a library. You have much less control over what other people are doing. You are constantly finding yourself in situations where you have to go along with something you don't really want to be part of, or you might be asked to do things that cause you to stretch in ways that make you very uncomfortable. I was asked to dance in my underwear on stage. It was a very big deal for me, but I got to the point where I realized that it wasn't about being comfortable, it was about coming through for the dance. And I'm glad I did it because now I'm not nearly afraid to do a lot of other things. There is a way to grow. Again, it's that versatility. The more you can do, the more different kinds of things you can do, the different directions in which you can go, the greater the likelihood that you will continue to work. If you narrow it down too much, you might just ace yourself right out of an opportunity."

Parting Words

Fred Strickler

"Any dancer who has ambition to be a professsional performer/choreographer absolutely has to work hard. Don't ever expect it to be easy. It's highly unlikely that it's going to be. You have to know that you're good at what you do. Be realistic and honest about that. Follow your own advice more

than anyone else's. Be sure that what you're doing is clear. Don't mess around in performance with self indulgent stuff that is really your studio work.

"When you ask an audience to sit in front of you and watch what you do for an evening or even for 10 minutes, I think it behooves you to do your absolute best. There is just too little opportunity to perform. When you go out, do your best. If you do that, then you'll be satisfied.

"I've done self-indulgent work, and it just doesn't work. What happens is that the references are so internalized that nobody can connect with it. Dancing is a language of communication and if you're going to communicate, then communicate. Don't expect your audience to work nearly as hard as you would like them to in order to understand your art. Just give. **The best dancers anywhere are always givers.**"

Chapter X.

Visionaries And Visual Artists

If I ran an art school and if I were King, I would not allow anybody to graduate with an MFA or PhD or any of those other wonderful letters without having a secondary skill with which they can earn money.

Josine Ianco-Starrels
Director, Los Angeles Municipal Gallery

When artists get together to discuss the frustrations and hazards of their work, it's difficult for eavesdropping non-artists to understand why they don't give it all up and enroll in the nearest computer training program. The ongoing struggle to pay rent, maintain a car in operating condition, buy supplies, eat regularly, and survive with any kind of dignity is so common among visual artists that family and friends frequently question their judgement and more often their sanity. Outsiders too often see only the artist's isolation, the lack of public understanding and appreciation for complex and difficult work, and the almost chronic inconvenience and poverty most artists endure in order to continue creating new work. They do not see the joy and delight an artist experiences when he goes

in a new and exciting direction. This does not minimize the inconvenience or humiliation of an eviction notice. It may, however, explain why there are not hordes of artists pounding on the doors of institutions which offer re-entry job training programs.

How much easier their lives might be if Josine Ianco-Starrels *were* King and all artists graduating from art schools were given secondary skills which would allow them to pay the rent while getting established as artists. In an arts survival workshop she gave for CalArts students in 1986, Ms. Ianco-Starrels said "If you ask me about survival, I recommend you try to earn the maximum amount of money for the minimum amount of time so that this secondary endeavour you do to pay the rent takes as little time from your art as possible."

She went on to say "Art schools which send young people out into the cold world without a secondary skill and with the cockamamie idea that they'll support themselves off their art eventually forces them into some sort of compromise. The commercial world is the commercial world and gallery owners who also have to pay rent and bills will look at the work young artists bring in and question whether or not that work will sell. So young artists, in order to be successful and receive approval, may end up producing work that helps everybody pay their bills. If you want your poetry to remain pure, you may have to make a living repairing TV sets or fixing other people's sinks and garbage disposals."

In a book entitled *Starting And Succeeding In Your Own Photography Business,* photographer/author Jeanne Thwaites tells about a family whose members, no matter how lofty their ambitions, learned a trade. Although they attained varying degrees of success in the corporate world, they always knew they could work as carpenters, mechanics and housepainters.

The knowledge that you can always support your vocation and your family with a back-up trade can do a lot to reduce the stress of contemporary life, regardless of your profession.

In addition to developing a marketable secondary skill, young artists embarking on a professional career can minimize their hardships by learning a few basic techniques of presentation. Grantswriting skills, are, of course, de rigueur for visual artists. See (Appendix XI) for a list of publications which provide resource information for visual artists. If you don't learn how to write a grant proposal before you graduate from art school, you should refuse to leave. It's as basic as learning to put your portfolio together or learning to write your resume. Since preparation of slides, cover letters, and resumes will all be part of a complete grant proposal, preparing a sample proposal is a good exercise for artists about to step out into the harsh world of galleries, museums, dealers, and art critics. If you don't believe a secondary skill is as important as Ms. Ianco-Starrels and I both think it is, at least read about grantsmanship in Chapter II, learn to write a simple, straightforward cover letter and resume, prepare your slides and portfolio, and practice a few introductory telephone calls on a patient friend before you dash out to take the art world by storm. It can't hurt.

Preparing Your Resume

The purpose of a resume is to let someone else know who you are and what you've accomplished. Place yourself in the employer/gallery director/ curator's chair and ask yourself if your resume:

1. Shows you are qualified for a particular job or show.
2. Provides a curator with a good representation of your exhibition experience.
3. Documents your qualifications for a residency or grant.

Your resume should *not* describe your art work or philosophy. If you feel the need to provide a lengthy statement, enclose it on a separate sheet of paper. Remember that most readers will give your resume less than a one-minute glance and that the physical appearance of a resume is extremely important. If your typing skills are not first-rate, you should have it prepared by a professional typist.

Your resume should include the following information:

Name
Residence/home address
Post office box
Studio address or mailing address
Phone number/s
Date of birth/age (optional)
Education and degrees
Honors
Awards/Grants
Bibliography
Group exhibitions
 Less than 3 persons
 More than 3 persons
One person shows
Collections your work is in
 (public & private - *not* relatives)
Professional appointments
 (jobs in the art field/lectures)
Professional memberships
Employment objectives (optional)
Employment history (job related only)
List of previous clients
References

In summary, remember that a good resume will contain only relevant information, with items arranged in order of importance. Resumes should be rewritten as needed, to reflect your qualifications for various positions, and should be accompanied by a cover letter that is as clear and straightforward as your resume.

Sample Resume

AMANDA BRIGGS
270 National Boulevard
San Jose, California 91173
(619) 345-6879 (home)
(619) 345-4500 (studio)

Born:	Digby, Nova Scotia; 1939

Education:	1958-1960	Honolulu Academy of Art
	1963	B.A., Summa Cum Laude,University of Hawaii
	1965	M.F.A., University of Southern California

Honors:	1968-70	California Arts Council Residencies
	1973-74	National Endowment for the Arts Fellowship
	1979-80	San Jose Art Association Award
	1983	Guggenheim Fellowship

Selected Bibliography:

Wilder, Marc. "Amanda Briggs: Performance Art in California," San Jose News, January 6, 1979, pages 12-14.

Luther, Scott. "Performance Art in Traditional Spaces: Amanda Briggs," San Francisco Chronicle, February 14, 1981, pages 22-24.

Emery, Kevin. "The Fine Fantasies of Amanda Briggs," Performance Magazine, May 12, 1985, page 7.

Selected Group Exhibitions and Performances:

1984 Printworks Gallery, Long Beach, CA. *"California Printmakers."*

1983 Gallery of Contemporary Design, San Francisco, CA. *"Serigraphs, 1970."*

1980 New York Design Center, New York, NY. *"The Next Decade."*

1979 Los Angeles Video Center, Los Angeles, CA. *"Video and Performance."*

(Continued)

One Person Shows: 1986 Long Beach Gallery, Long Beach, CA. Serigraphs.
1985 Shonell Art Center, San Jose, CA. Performance.
1984 Barcelona Contemporary Museum, Barcelona, Spain. Performance.
1982 Toronto Performance Center, Toronto, Canada. Performance.
1980 Los Angeles Video Center, Los Angeles, CA. Performance.

Selected 1983 Gannett Foundation Collection. Chicago, IL. Serigraphs.
Collections: 1980 Security Pacific Bank. Atlanta, KS. Serigraphs.
1979 Antioch University, Tucson, AZ. Serigraphs.

Professional 1984-86 Caritas Gallery and Design Center, San Jose, CA.
Experience: Visual Arts Manager.
1981-83 Children's Museum, Monterey, CA.
Design and installation of exhibitions.
1975-78 San Jose Community College, San Jose, CA.
Art Instructor, San Jose Recreation Department
1970-73 Moorpark Community College, Los Angeles, CA
Instructor in printmaking.

References upon request.

Sample Cover Letter

August 12, 1986

Ms. Lindsey Shields
Executive Director
Public Corporation for the Arts
132 Pine Avenue
Long Beach, CA 90802

Dear Ms. Shields:

On the recommendation of Mr. David Barton, Cultural Arts Supervisor for the City of Long Beach and in response to your advertisement, I am submitting my resume and application for the position of Visual Arts Coordinator.

During the past three years I have been employed as the Visual Arts Manager for CARITAS Gallery and Design Center. In this capacity, I have curated ten regional exhibitions, developed an active Artists' Registry, and coordinated an annual Art Walk involving over thirty-five galleries and artists' studios. As my resume indicates, I have had extensive experience working in multi-cultural communities and feel I could be helpful in your plans to establish a Long Beach Center for multi-cultural visual artists.

I will be coming to Southern California at the end of this month and would appreciate an opportunity to discuss my application with you. With your approval, I will call on the 24th of this month to request an appointment.

Thank you very much for your consideration. If I can provide additional information or references, please feel free to call me at my office or my home.

Yours very truly,

Amanda Briggs

Enclosure

Portfolios

A portfolio is the most important job search tool a visual artist can develop. It is therefore necessary to present your best work in your portfolio and to consciously delete any items which emphasize your limitations.

The following recommendations for preparing an effective portfolio are reprinted with the permission of the California Institute of the Arts, publishers of the *National Directory of Arts Internships:*

1. If your work is 3-D, make photographs or slides of it from more than one angle.
2. Whatever format you choose, be constant. If possible, cut mats of a several standard sizes. Avoid having a hodge-poge look to your portfolio. Your work should be easily viewed.
3. If you cannot shoot decent slides of your work, it is worth your while to find someone to shoot them for you. Remember to keep a set of original slides for yourself, in case the others are lost or damaged. It's a good idea to keep original copies for yourself because duplicating slides is very expensive and they will not have the same quality as the originals.
4. DO NOT have smudges, tears, or uncovered work, especially of pencil drawings or pastels that rub off onto other pieces.
5. DO NOT include several examples of the same problem.
6. DO NOT include too much work in your portfolio. This can be as bad as too few pieces.
7. Should your portfolio have to be mailed out be sure it is self-explanatory.

8. Generally, your portfolio will be mailed out only after a prospective employer has seen your resume and talked with you. If possible show your portfolio at the interview.

9. Prepare carefully for a short interview of about 15 minutes but be prepared with "back-up" material should the interviewer be interested in seeing more.

10. Include only your own work.

11. Include: Working drawings, design work, graphics and related artwork (paintings, ceramics, etc.)

12. The following adjectives should describe your portfolio: conveyable, durable, revisable, neat, professional, and self-explanatory.

13. It is not necessary to have all color photographs.

14. It is not necessary to have all 8" x 10" photographs.

15. DO NOT reduce working drawings to less than 11" x 14".

16. DO NOT use tracings. Instead make sepia, black line, photostats or blueprints.

17. It is usually advisable to show some original artwork as reproductions.

Tips On What To Include In Your Portfolio

A. The Commercial Portfolio

- Show work which demonstrates the diversity of your technical skills, especially those pieces which show what you can do for the company.

- Quality is more important than quantity. Limit your portfolio to no more than 15 or 20 examples which represent your very best work.

- Your fine art work is of interest only if it shows some skills that the company can use (e.g. your drawing ability.) - Get professional advice and criticism on your portfolio from people in the field whom you respect. Always ask the interviewer for criticism of your portfolio if you do not get the job.

- Always include a resume.

- Research the company before your interview. Know their clients and campaigns. Know the technical language as well as possible. Select examples of your work which you think best illustrate your problem solving ability and creativity. Try to show what commercial illustration accomplishes that photography does not.

- A good book to read in helping you prepare your advertising portfolio is *How to Get Your Book Together and Get a Job in Advertising* by Maxine Paetro. You will learn from it that you should be familiar with story boards and campaigns.

B. The Gallery Portfolio

- Galleries look for maturity and direction. Apart from quality, your portfolio should demonstrate consistency and professionalism in a body of recent work. Do not include earlier work unless you think it's necessary to show your development.

- Research the gallery to learn what kind of image it tries to project and take this into account in selecting pieces for your portfolio.

- One or two pages of slides (10 to 20) are probably sufficient. Be sure to include some good detail slides. Slides are usually the accepted format, but some artists prefer to show color photographs.

- Since galleries have different policies about looking at artist's work, check out the policies of the various galleries you'll be visiting. (Some will reserve certain hours for looking at work; others want artists to leave slides with stamped, self-addressed envelopes).

Some artists will benefit from portfolio variations:

Illustrators sometimes use 8" x 10" or 5" x 7" transparencies rather than slides. Transparencies are easier to view than slides when simply held up to the light; cumbersome equipment is not necessary.

Photographers should include both color samples and black and white samples. The recommended size for all samples is 8" x 10" or 11" x 14".

Graphic designers must often ignore the uniform size rule, since finished products will vary greatly in size and shape. If the student prefers a presentation of uniform size, she can use a slide or transparency portfolio rather than originals.

Studio artists most often use the slide format due to the cumbersome shapes of their work. In addition, they will probably need to mail a portfolio more regularly than commercial artists, and slides provide the simplest form for mailing. Studio artists dealing in three-dimensional forms should have at least two slides for each work, showing it from different angles.

Filmmakers' portfolios consist of film samples - at least three very different, brief pieces that quickly and clearly deliver a focused message.

All items in any portfolio should carry clear labels summarizing the work in two or three words. For certain types of portfolios, especially slides or transparencies, it is vital to identify the top and bottom as well as the front and back.

Whenever possible, an artist should present the portfolio in person. If asked to mail it (as is common for museum/gallery exhibitions), she can use slides but should keep duplicates. A stamped, self-addressed envelope will help ensure that slides are returned. For portfolio presentations that take place in person, the quality of the presentation holds just as much importance as the quality of the portfolio itself. The applicant must be able to discuss the artistic choices made for each entry. This requires that she articulate the development of her ideas as she was producing each piece. After his comments, the employer needs ample time to review each item in silence. The candidate should not speak again until the employer poses questions or moves on to the next portfolio item. While it is inappropriate for artists to apologize for any of their work, it is also inappropriate for them to become overly defensive. They must strive for the delicate balance between pride in their work and an openness to creative suggestion. Successful presentation of portfolio occurs only after repeated practice with faculty members or knowledgeable friends who can critique your efforts.

After the portfolio presentation, a resume is left for the organization's files. Students might also consider preparing a small package of reproduced samples to leave with the employer. The resume serves as a reminder of only experience and education, whereas actual samples allow easy reference to finished work as well.

Once you have your portfolio together and you have exhausted your friends and relatives by making them participate in mock interviews, you should be ready to take on the gallery/

museum world. Bear in mind that curators and gallery owners are in the business they're in because they love what they do. For the most part, they like artists and enjoy being part of the process that presents art work to interested viewers and collectors. Although you should treat these people with the same courtesy and respect you show your Mother, your doctor, and your mechanic, there is no need to work yourself into a frenzy prior to a viewing.

If you do have the misfortune to run into a rude, insensitive dealer or curator, make a hasty exit and remember that you will have dozens, even hundreds, of future viewings that will be more succesful. As Toby Judith Klayman points out in her *Artist's Survival Manual,* "We, too, can accept or reject. After all, galleries and museums need *us*. WIthout artists, there would be no dealers, no curators, no museums, no arts administrators or National Endowment for the Arts. It's important to remember that *we make* the goods *they're* interested in handling."

Tips for Approaching Galleries and Museums

1. Be prepared. Research the gallery or museum you're approaching. Find out about their viewing policies, the kind of work they handle, the special interests of the curatorial staff.

2. Be aware of the importance of personal appearance but also dress in a way that is comfortable for you. A viewing with a gallery owner is no time to try out a pair of four-inch heels. You'll have enough to worry about without worrying about when you're going to topple into the gallery owner's favorite potted plant.

3. Reconfirm your appointment the day before and arrive five to ten minutes early so you can relax.

4. Establish a track record before you try the gallery-museum circuit. A museum is not a jumping-off place for artists without an exhibitionhistory. Enter local juried exhibitions in your area, at schools, banks, or through art associations. Those exhibitions are frequently juried by museum staff and provide a good opportunity for you to be noticed.

5. Participate actively in the interview process. Make a checklist of the items you want defined if the gallery agrees to accept your work. If you are dealing with a museum, you should have some sort of formal written agreement outlining exhibition dates and other commitments you and they have made verbally. Discuss such issues as the size of the catalogue, the identification of the gallery space, insurance, sale of works, and your responsibility to provide photographs, research materials, etc. Formalizing all these items in writing can be tedious but the process will clarify what all participating parties are expected to do. At the same time, written agreements and contracts will protect both you and the museum.

 Although the emphasis of your relationship with a gallery will differ from that with a museum, the same kind of paperwork is necessary. Be prepared to question the gallery owner or staff about your mutual responsibilities, whether or not you will be participating in group shows or one-person exhibitions, where and how your work will be stored, promoted, and priced. Define the duration of your relationship with a gallery,

whether or not your relationship with them restricts you from exhibitions in another gallery in the same geographic areas, and how soon and how much you'll be paid after each sale. After you and the dealer have covered all the issues to your mutual satisfaction, put everything in writing. The agreement can be a simple letter which both parties will sign, date, and have witnessed or you can use one of the many sample Artist-Dealer contracts available through the sources recommended in Chapter III. (Also see Appendix IV for a model form of an Artist-Gallery Contract.) Remember that both you and the gallery owner are business professionals and clarity between you will represent a greater potential for profit as well as ensure a more satisfying business relationship.

Establish prices for your work before you sign a contract with a gallery. Any agreement you sign should stipulate the price of your work and although the gallery owner can and should advise you, the final decision on pricing is yours. It's foolish to overprice your work because this will make you inaccessible and difficult for a gallery to handle. On the other hand, if a piece means a great deal to you and if you want to be perceived as a serious professional, you won't want to begin with bargain basement prices. It's always possible to raise your prices but it's very chancy to lower them. If a collector has paid $400. for a watercolor, he's not going to want to see a similar piece on the market a year later for $250.

You must also consider your overhead and costs when you establish your prices. While it doesn't make much sense to charge by the hour or the square foot for

your work, you should consider the cost of framing a piece, materials such as handmade paper, and the commission you will be paying to the gallery. You should also guard against art patrons looking for a quick "deal" who try to buy work directly from your studio in order to avoid a gallery commission. You have a responsibility to protect the dealer or gallery by keeping your prices consistent. A gallery owner who discovers an artist underselling him has every right to drop that artist. It's very complicated and you will need to discuss pricing with your fellow artists, with your gallery, and with curators who understand your particular market. After you factor in all the advice, your attachment to the work, and finally, your own financial need, you alone must fix realistic prices and STICK TO THEM.

7. Unless the curator or dealer has been extraordinarily rude to you, send a follow-up thank you letter expressing your appreciation for their time, advice, and their interest. There are far more artists than there are curators and it can't hurt to identify yourself as an artist who is courteous, considerate, *and* professional.

Publicity

Almost everyone in the art world resents the type of artist who indulges in "hype" but no one I know in the media or in arts management positions resents artists who provide them with clear, timely information. Communicating with journalists, critics and television staff who run free public service announcements is just another chore artists have to take on if they want people outside their immediate circle of friends to know about their work.

From 1983 - 86 my company coordinated a performance art series in Los Angeles called EXPLORATIONS. Although the responsibility for publicizing the series rested with my office and with the sponsors (The Museum of Contemporary Art, Los Angeles, the California Institute of the Arts, and the Japanese American Cultural and Community Center), the responsibilty for supplying us with publicity materials rested with participating artists. Of the twenty-eight artists and groups we presented during the three-year series, no one made our publicity efforts quite as easy as choreographer/ performance artist Tim Miller. If we asked for pictures, we'd get three black and white photographs shot from different angles and a half-dozen color transparencies. If we asked for copies of recent reviews, we'd get them in the next mail, and if we asked for videotape, it would arrive the next day through Federal Express. Other artists in the series, such as Molissa Fenley, Falso Movimento and Meredith Monk, were also extremently conscientious about giving us the tools we needed to do a good job for them. However, Tim was particularly impressive because he essentially operated as his own publicist-business manager-agent-technical director, which is what a young artist starting out in the arts business has to be prepared to do.

Press releases, personal letters of invitation to critics, public service announcements, flyers, posters, post cards, and (targeted) mailing lists will all play a part in developing a market for your art. If you want to create a demand for your work, you must let people know about it. If you're lucky, you'll have a support network of family and friends who will help you and as you get to know collectors, curators, arts managers, dealers, and other artists, your support system will grow. In the beginning, however, you may have a support

system of one and it may fall on *you* to write the press releases and public service announcements, design the post cards and develop a mailing list. It's time-consuming work and it takes time and talent to do it well. It's also necessary. No one will come to your studio and drop offers in your lap and on the day you decide to become a professional artist, you should also begin the process of self-promotion.

You can begin simply by attending art events and openings where you'll meet other artists, art patrons and the arts press. By exchanging cards over the cheap white wine, you can begin assembling a mailing list. Eventually you'll build up a reliable list of people who have a genuine interest in the arts and when you add your relatives, your dentist, the neighbors, and your Mom's best friends to your new collection of art patrons, you'll find you have a pretty decent support system.

You should also, from Day One, begin assembling materials for a promotional package. Reviews, your resume, slides, photographs, press releases, and any articles written about you or your work should all be part of this package. When you have enough material to make a favorable impression, you can start sending it around to curators, gallery owners, presentors, and collectors. Whether you're seeking an exhibition, sales, or grants, you'll need to provide good, clear information. There are too many good, accessible artists around to compete for the limited time and resources curators and presenters have at their disposal. Don't make it hard for them to find you because unless you were born lucky, they're not going to make the effort when Tim Miller or Eric Bogosian's press packets are just an arm's length away.

Henry Geldzahler, Commissioner of Cultural Affairs for the City of New York, reminds us in his article, *Career and the Artist,* that no amount of self-promotion and technical business

skills will help an artist make better art. "Success is a reward," he says. "Making honest art is the goal." Publicists and promoters must always bear this in mind. It's very easy to get caught up in the style and splash of self-presentation. Self-promotion *is* necessary but if the work you're promoting is not solid, honest, and original, you're going to be found out and discarded so quickly your head will spin. Keep it all in perspective. Be a pro and learn to present yourself professionally but always stay in touch with the reason for the press releases and promotional kits. When you spend more time working as a publicist than as an artist and when your press packet outshines your art, you'd better assess who you are and what you're doing and whether or not you're confusing your goals with your rewards.

Chapter XI

In Closing....

In reading over the completed manuscript of *For The Working Artist,* I realize I've pictured arts careers as difficult, hazardous and bleak. While there is a certain amount of validity in that presentation, I do not wish to imply that arts professionals have a more difficult struggle than teachers or social workers. I also do not mean to suggest that the artist's lot is completely thankless. I quite agree with Marilyn Horne that people who can make careers in the arts are blessed. Artists enrich our world in many ways and on so many levels that parents whose children show talent as dancers or painters or writers should rejoice. Simultaneously, those same parents should teach their children to prepare budgets, keep good records and generally organize their lives so that they can always earn a living. Artists need not so often be victims and creativity should not be viewed as an excuse to botch up the simple business transactions all adults must handle. Instead, creativity should be viewed as a reason to work hard, dream big and celebrate.

Enjoy your lives. As our old friend Hippocrates said during *his* Arts Survival lecture,

Art is long;
Life is short.

Appendices

Appendix I

Organizations which provide information related to grants, employment, auditions, exhibitions, touring and legal/financial services for artists.

Affiliate Artists
37 West 65th Street
New York, NY 10023
(212) 580-2000

An organization coordinating residencies for solo performing artists including classical singers, instrumentalists, actors, dancers, chore-ographers, and mimes. To be eligible, artists must be in the early to midstages of their careers and have the potential to become major performing artists. Paid residencies are arranged in communities across the country for periods of one to six weeks.

Arts Midwest
528 Hennepin Avenue, Suite 310
Minneapolis, MN 55403
(Illinois, Indiana, Iowa, Michigan, Minnesota, North Dakota, Ohio, South Dakota, Wisconsin)
(612) 341-0755

The Affiliates State Arts Agencies of the Upper Midwest provides communities in the Upper Midwest with access to regional performing artists through its Performing Arts Touring Program, its Visual Arts Program and its regional Arts Information Management Services through which a mailing list and a computerized file of presenting organizations in the region are available.

American Council for the Arts
1285 Avenue of the Americas, 3rd Floor
New York, NY 10019
(212) 245-4510

A national membership organization for individuals and organizations interested in the arts. Its purpose is to provide professional develop-ment services to strengthen cultural activities in the United States and to develop new possibilities for arts expansion and support.

The American Federation of Arts (AFA)
41 East 65th Street, New York, NY 10021
(212) 988-7700

A national, non-profit organization aiming to cultivate a greater knowledge of art throughout the U.S.A., and of American art abroad. Organizes travelling exhibits.

Arts International Program
Institute of International Education
809 United Nations Plaza
New York, NY 10017-3580
(212) 984-5370

A program that serves artists and arts groups of all disciplines with information and research on international arts exchange worldwide. Provides counsel, technical assistance and referrals, all at no charge. Maintains a computerized data bank with listings for fellowships, grants, competitions, study programs, artist colonies, international cultural events and applicable laws and regulations. Technical assistance covers areas such as funding sources, overseas contracts, festivals, study programs and artist colonies.

Business Committee for the Arts (BCA)
1775 Broadway, Suite 510
New York, NY 10019
(212) 664-0600

The Business Committee for the Arts is a national, not-for-profit, membership organization of business leaders committed

to supporting the arts and to encouraging new and increased arts funding. BCA keeps corporations informed of existing opportunities for arts support; conducts an advertising campaign to generate public interest in the arts; and counsels firms on initiation and expansion of arts programs. Through special awards, BCA annually honors businesses for outstanding support of the arts.

Center for Arts Information
1285 Avenue of the Americas
New York, NY 10019
(212) 245-4510

The Center serves as a clearinghouse for information about the arts in New York State and the nation. The staff provides assistance by appointment in using the extensive reference library which is open to the public. Counselors offer advice on service organizations, funding agencies and arts administration. The Center also publishes directories, management aids, memos, and books for artists on such diverse topics as insurance for artists and jobs in the arts.

Center for Non-Profit Management
315 West Ninth Street, Suite 1100
Suite 500
Los Angeles, CA 90015
(213) 623-7080

The Center for Non-Profit Management provides consulting and training seminars for non-profit organizations. Seminars include fundraising, proposal writing, volunteer management, financial management, and many other topics. Fees for the seminars are $35 for the half day sessions, and $65 for full days. Also provides services for individual organizations in strategic planning, marketing, etc, with fees determined on a per hour basis.

Council On Foundations
1828 L Street, NW
Washington, DC 20036
(202) 466-6512

A national membership organization representing independent, community, and company-sponsored foundations and corporate contributions programs throughout the United States. Works to in-crease public understanding of the role of philanthropy in American life.

Ford Foundation
320 East 43rd Street
New York, NY 10017
(212) 573-5000

A private philanthropic institution chartered to serve the public welfare by giving funds for educational, developmental, and experimental efforts designed to produce significant advances on selected problems of national and international importance. Most grants are awarded to organizations working in one of the following areas: Education and Public Policy; International Affairs; and National Affairs. Details of Foundation activities are given in the Annual Report and in the pamphlet, *Current Interests*.

The Foundation Center
888 Seventh Avenue
New York, NY 10106
(212) 975-1120

The Foundation Center offers artists and organizations seeking grants an extensive library containing directories that describe particular foundations, annual reports from both foundations and corporations, and reference books on such subjects as proposal writing. The Center's own publications, available

for use in the library and for sale, include The Foundation Grants Index, which lists grant awards by foundations (organized by state); The Foundation Grants Index Bimonthly, which includes updated grant information; and Foundation Grants to Individuals. The collection is open to the public. No appointment is necessary to use the collection or to receive library assistance.

Foundation for the Creative Community, Inc. (FCC)
122 Amsterdam
New York, NY 10007
(212) 496-8861

FCC is a membership organization of artists and others in the arts community. Although FCC is largely focused on the visual arts, many of its services are valuable to performing artists. FCC offers a hospital and major medical group health insurance plan; publishes Art and Artists, a monthly newspaper covering issues that concern artists, and Artist Update, a monthly newsletter listing seminars, grants, competitions, and awards. FCC also conducts survival skill seminars and workshops on subjects such as preparing income tax returns, housing and employment. It also publishes guides to topics such as health hazards and legal issues.

Ingram Merrill Foundation
P.O. Box 202, Village Station
New York, NY 10014

Awards grants to further the advancement of the cultural and fine arts by supporting individuals engaged in creative and scholarly pursuits. Grants have been primarily for independent projects or advanced study by individual artists, musicians, theatre artists, poets, and scholars in literary criticism and art history, with some emphasis on writers rather than visual or performing artists.

Innovative Design Fund
860 United Nations Plaza
New York, NY 10017
(212) 759-8544

A public foundation organized to encourage the development of innovative design concepts in the clothing, textile, and home furnishing industries. Its goal is to discover, encourage, and open doors for gifted, innovative, creative organizations by making grants to develop prototype design concepts.

Mid-America Arts Alliance (MAAA)
912 Baltimore Avenue, Suite 700
Kansas City, MO 64105
(Arkansas, Kansas, Missouri, Nebraska, Oklahoma)
(816) 421-1388

The Mid-America Arts Alliance provides technical and managerial assistance to resident dance companies and sponsors; sells a regional mailing list of presenters; acts as an information clearing house; and manages the National Endowment for the Arts Dance Touring Initiative Program in the region. Administers tours of performing and visual arts programs, and a variety of service programs to help artists, arts institutions, administrators, and community sponsors become more skilled as arts presenters.

Mid-Atlantic States Arts Consortium
11 East Chase Street, Suite 1-A
Baltimore, MD 21202
(301) 539-6656

A regional consortium of the state arts agencies of New York, New Jersey, Pennsylvania, Delaware, Maryland, Virginia, West Virginia, and the District of Columbia that provides services including a performing arts touring program, a computerized information system about artists and arts organizations, a residency program for visual artists, and special projects.

National Assembly of State Arts Agencies
1010 Vermont Avenue, NW, Suite 920
Washington, DC 20005
(202) 347-6352

A nonprofit membership organization of the state arts agencies in the fifty states and six special jurisdictions of the Unites States. It exists to enhance the growth of the arts; to develop an informed membership; represent the collective needs and concerns of the member agencies; and provide forums for development of national arts policy.

National Association of Artists' Organizations
1007 D Street NE
Washington, DC 20002
(202) 544-0660

A service organization for non-profit organizations dedicated to the creation and presentation of contemporary visual and performing arts in all media. Promotes the awareness of artists' organizations and their contribution to contemporary American art and artists. Organizes conferences and produces publications including the National Directory of Artists' Organizations.

National Association of Local Arts Agencies
1420 K Streete, NW, Suite 204
Washington, DC 20005
(202) 371-2830

A membership organization encouraging the coordination, promotion, and development of educational, informational, and cultural activities among local arts agencies throughout the United States.

National Endowment for the Arts
1100 Pennsylvania Avenue, NW
Washington, DC 20506
(202) 682-5400 (Public Information &
 Public Affairs)
(202) 682-5410 (Office of Private
 Partnership)
(202) 682-5431 (Test Program for Support
 of Local Arts Agencies)
(202) 682-5748 (Civil Rights Division)

An independent agency of the federal government created to encourage and support American art and artists. Awards matching grants to arts organizations and nonmatching fellowships to individual artists; provides leadership; and promotes advocacy activities.

National Endowment for the Humanities
1100 Pennsylvania Avenue, NW
Washington, DC 20506
(202) 786-0438

An independent federal grantmaking agency created to support projects of research, education, and public activity in the humanities. Projects aid scholarship and research in the humanities, help improve humanities education, and foster a greater curiosity about and understanding of the humanities.

New England Foundation for the Arts
678 Massachusetts Avenue, Suite 80
Cambridge, MA 02139
(Connecticut, Maine, Massachusetts, New Hampshire,
Rhode Island, Vermont)
(617) 492-2914

The New England Foundation for the Arts administers a Regional Touring Program which offers fee support to sponsors who present performing artists from among the Foundation's

roster of 100 New England groups selected by application. The Foundation also administers smaller state touring programs within Massachusetts, New Hampshire and Rhode Island, as well as Meet The Composer grants for the region. It offers regional workshops on management and booking; and maintains and sells arts mailing, resource and presenter lists.

Publishing Center for Cultural Resources
625 Broadway
New York, NY 10012
(212) 260-2010

A nonprofit organization that helps plan, produce, and distribute publications for nonprofit groups and institutions. Their catalog includes numerous publications related to the arts.

Opportunity Resources for the Arts (OR)
500 Fifth Avenue, Suite 5416
New York, NY 10110
(212) 575-1688

OR is a national, executive search firm, which serves arts centers, arts councils, performing arts organizations, etc., and professional administrative personnel seeking employment. They specialize in executive search and management for non-profit and cultural organizations nationwide.

Southern Arts Federation
1401 Peachtree Street NE, Suite 122
Atlanta, GA 30309
(Atlanta, Florida, Georgia, Kentucky, Louisiana,
Mississippi, North Carolina, South Carolina, Tennessee)
(404) 874-7244

The Southern Arts Federation offers services to artists and arts organizations including partial fee support to sponsors through its Performance and Visual Arts Touring Progams; a mailing list of presenters in the region; audience development assistance

to minority and emerging artists; marketing support; and workshops and conferences regarding touring and development.

Western States Arts Foundation (WESTAF)
207 Shelby Street Suite 200
Santa Fe, NM 87501
(Washington, Oregon, Montana, Idaho, Wyoming, Nevada, Colorado, Arizona, New Mexico, Utah, Alaska, Hawaii)
(505) 988-1166

The Western States Arts Federation organizes the Western States Performing Arts Tour which brings performances to Western Communities. The Foundation provides partial fee support to presenters in the region who present artists from a roster of both regional and out-of-region artists. WESTAF also publishes the National arts jobbank, a bi-weekly source of arts employment information; sells a mailing list of presenters in the region; operates Artsnet, a bulletin board/electronic mail system which fosters communication among artists, presenters, and supporters; and runs WBEX, a computerized booking system which helps match performers and interested presenters.

Appendix II

The Foundation Center Network

The Foundation Center is an independent national service organization established by foundations to provide an authoritative source of information on private philanthropic giving. The Center disseminates information on private giving through public service programs, publications and through a national network of library reference collections for free private use. In all of the Center's collections, professional staff is available to assist grantseekers in identifying potential funding sources. As collections vary in their hours, materials & services, it is recommended that you call each collection in advance.

Where to go for information on foundation funding reference collections operated by the foundation center:

The Foundation Center
888 Seventh Avenue
New York, NY 10106
(212) 975-1120
(800) 424-9836

The Foundation Center
1001 Connecticut Avenue, NW
Washington, DC 20036
(202) 331-1400

The Foundation Center
Kent H. Smith Library
1442 Hanna Building
1422 Euclid Avenue
Cleveland, OH 44115
(216) 861-1933

The Foundation Center
312 Sutter Street
San Francisco, CA 94108
(415) 397-0902
(800) 424-9836

Cooperating Collections

Alabama

Birmingham Public Library
2100 Park Place
Birmingham, AL 35203
(205) 226-3600

Huntsville-Madison County Public Library
915 Monroe Street
Huntsville, AL 35801
(205) 532-5940

Auburn University at Montgomery Library
Montgomery, AL 36193-0401
(205) 271-9649

Alaska

University of Alaska, Anchorage Library
3211 Providence Drive
Anchorage, AK 99508
(907) 786-1848

Arizona

Phoenix Public Library
Business and Sciences Department
12 East McDowell Road
Phoenix, AZ 85257
(602) 262-4636

Tucson Public Library
Main Library
200 South Sixth Avenue
Tucson, AZ 85726-7470
(602) 791-4393

Arkansas

Westark Community College Library
5210 Grand Avenue
Fort Smith, AK 72913
(501) 785-7000

Little Rock Public Library
Reference Department
700 Louisiana Street
Little Rock, AR 72201
(501) 370-5950

California

Inyo County Library
Bishop Branch
210 Academy Street
Bishop, CA 93514
(619) 872-8091

California Commmunity Foundation
Funding Information Center
606 South Olive, Cuite 2400
Los Angeles, CA 90014
(213) 413-4042

California Community Foundation
1000 East Santa Ana Boulevard
Orange, CA 92668
(714) 937-9077

Community Foundation for Monterey County
420 Pacific Street
Monterey, CA 93940
(213) 375-9712

Riverside Public Library
358 7th Street
Riverside, CA 92501
(714) 782-5201

California State Library
Reference Services, Rm. 309
914 Capital Mall
Sacramento, CA 95814
(916) 322-4570

San Diego Community Foundation
525 "B" Street, Suite 410
San Diego, CA 92101
(619) 239-8815

The Foundation Center
312 Sutter Street
San Francisco, CA 94108
(415) 397-0902

**Orange County Community
 Development Council**
1695 West MacArthur Boulevard
Costa Mesa, CA 92626
(714) 540-9293

Peninsula Community Foundation
1204 Burlingame Avenue
Burlingame, CA 94011-0627
(415) 342-2505

Santa Barbara Public Library
Reference Section
40 East Anapamu
Santa Barbara, CA 93102
(805) 962-7653

Santa Monica Public Library
1343 Sixth Street
Santa Monica, CA 90401-1603
213/451-8859

Tuolomne County Library
480 Greenley Road
Sonora, CA 95370
(209) 533-5707

Colorado

Pikes Peak Library District
20 North Cascade Avenue
Colorado Springs, CO 80901
(303) 473-2080

Denver Public Library, Sociology Division
1357 Broadway
Denver, CO 80203
(303) 571-2190

Connecticut

Hartford Public Library
Reference Department
500 Main Street
Hartford, CT 06103
(203) 293-6000

D.A.T.A.
25 Science Park
Hartford, CT 06511
(203) 786-5225

Delaware

Hugh Morris Library
University of Delaware
Newark, DE 19717-5267
(302) 451-2965

Florida

Volusia County Public Library
City Island
Daytona Beach, FL 32014-4484
(904) 255-3765

Jacksonville Public Library
Business, Science, and Industry Dept.
122 North Ocean Street
Jacksonville, FL 32206
(904) 630-2665

Miami-Dade Public Library
Florida Collection
101 West Flagler Street
Miami, FL 33130
(305) 375-2665

Orlando Public Library
101 East Central Boulevard
Orlando, FL 32801
(305) 425-4694

Selby Public Library
1001 Boulevard of the Arts
Sarasota, FL 33577
(813) 951-5501

Leon County Public Library
Community Funding Resources Center
1940 North Monroe Street
Tallahassee, FL 32303
(904) 487-2665

**Palm Beach County Community
Foundation**
324 Datura Street, Suite 340
West Palm Beach, FL 33401
(407) 659-6800

Georgia

Atlanta-Fulton Public Library, Ivan
Allen Department
1 Margaret Mitchell Square
Atlanta, GA 30303-1089
(404) 730-1700

Hawaii

**Thomas Hale Hamilton Library
General Reference**
University of Hawaii
2550 The Mall
Honolulu, HI 96822
(808) 948-7214

Community Resource Center
The Hawaiian Foundation
212 Merchant Street
Honolulu, HI 96183
(808) 599-5767

Idaho

Caldwell Public Library
1010 Dearborn Street
Caldwell, ID 83605
(208) 459-3242

Illinois

Belleville Public Library
121 East Washington Strteet
Belleville, IL 62220
(618) 234-0441

DuPage Township
241 Canterbury Lane
Bolingbrook, IL 60439
(312) 759-1317

Donors Forum of Chicago
53 West Jackson Boulevard
Chicago, IL 60604
(312) 431-0265

Evanston Public Library
1703 Orrington Avenue
Evanston, IL 60201
(312) 866-0305

Sangamon State University Library
Shepherd Road
Springfield, IL 62794-9243
(217) 786-6633

Indiana

Allen County Public Library
900 Webster Street
Fort Wayne, IN 46802
(219) 424-7241

Indiana University Northwest Library
3400 Broadway
Gary, IN 46408
(219) 980-6580

Indianapolis-Marion County
Public Library
40 East St. Claire Street
Indianapolis, IN 46206
(317) 269-1733

Iowa

Public Library of Des Moines
100 Locust Street
Des Moines, IA 50308
(515) 283-4259

Kansas

Topeka Public Library
Adult Services Department
1515 West Tenth Street
Topeka, KS 66604
(913) 233-2040

Wichita Public Library
223 South Main
Wichita, KS 67202
(316) 262-0611

Kentucky

Western Kentucky University
Division of Library Services
Helm-Cravens Library
Bowling Green, KY 42101
(502) 745-6125

Louisville Free Public Library
Fourth and York Streets
Louisville, KY 40203
(502) 561-8600

Louisiana

East Baton Rouge Parish Library
Centroplex Library
120 St. Louis Street
Baton Rouge, LA 70802
(504) 389-4960

New Orleans Public Library
Business and Science Division
219 Loyola Avenue
New Orleans, LA 70140
(504) 596-2580

Shreve Memorial Library
424 Texas Street
Shreveport, LA 71120-1523
(318) 226-5894

Maine

University of Southern Maine
Center for Research and Advanced Study
246 Deering Avenue, Rm 628
Portland, ME 04103
(207) 780-4871

Maryland

Enoch Pratt Free Library
Social Science and History Department
400 Cathedral Street
Baltimore, MD 21201
301/396-5320

Massachusetts

Associated Grantmakers of Massachusetts
294 Washington Street, Suite 840
Boston, MA 02108
(617) 426-2608

Boston Public Library
666 Boylston Street
Boston, MA 02117
(617) 536-5400

Western Massachusetts Funding
Resource Center
Campaign for Human Development
Chancery Annex
73 Chestnut L Street
Springfield, MA 01103
(413) 732-3175

Grants Resource Center
Worcester Public Library
Salem Square
Worcester, MA 01608
(508) 799-1655

Michigan

Alpena County Libarary
211 North First Avenue
Alpena, MI 49707
(517) 356-6188

University of Michigan-Ann Arbor
Reference Department
209 Hatcher Graduate Libarary
Ann Arbor, MI 48109-1205
(313) 764-1149

Henry Ford Centennial Library
16301 Michigan Avenue
Dearborn, MI 48126
(313) 943-2337

Purdy Library
Wayne State University
Detroit, MI 48202
(313) 577-4040

Michigan State University Libraries
Reference Library
East Lansing, MI 48824-1048
(517) 353-8818

Farmington Community Library
32737 West 12 Mile Road
Farmington Hills, MI 48018
(313) 553-0300

University of Michigan
Flint Library
Reference Department
Flint, MI 48502-2186
(313) 762-3408

Grand Rapids Public Library
Sociology and Education Department
Library Plaza
Grand Rapids, MI 49503-30093
(616) 456-3600

Michigan Technological University
Library
Highway U.S. 41
Houghton, MI 49931
(906) 487-2507

Minnesota

Duluth Public Library
520 W. Superior Street
Duluth, MN 55802
(218) 723-3802

Southwest State University Library
Marshall, MN 56258
(507) 537-7278

Minneapolis Public Library
Sociology Department
300 Nicollet Mall
Minneapolis, MN 55401
(612) 372-6500

Rochester Public Library
11 First Street, SE
Rochester, MN 55902-3743
(507) 285-8002

Saint Paul Public Library
90 West Fourth Street
Saint Paul, MN 55102
(612) 292-6307

Mississippi

Jackson Metropolitan Library
301 North State Street
Jackson, MS 39212
(601) 968-5803

Missouri

Clearinghouse for Midcontinent
Foundations
University of Missouri, Kansas City
Law School, Suite 1-300
52nd Street and Oak
Kansas City, MO 64113-0680
(816) 276-1176

Kansas City Public Library
311 East 12th Street
Kansas City, MO 64106
(816) 221-9650

Metropolitan Association for
Philanthropy, Inc.
5585 Pershing Avenue, Suite 150
St. Louis, MO 63112
(314) 361-3900

Springfield-Greene County Library
397 East Central Street
Springfield, MO 65801
(417) 866-4636

Montana

Eastern Montana College Library
Reference Department
1500 N. 30th Street
Billings, MT 59101-0298
(406) 657-2262

Montana State Library
Reference Department
1515 E. 6th Avenue
Helena, MT 59620
(406) 444-3004

Nebraska

University of Nebraska, Lincoln
106 Love Library
Lincoln, NE 68588-0410
(402) 472-2848

W. Dale Clark Library
Social Sciences Department
215 South 15th Street
Omaha, NB 68102
(402) 444-4826

Nevada

Las Vegas-Clark County Library District
1401 East Flamingo Road
Las Vegas, NV 89119-6160
(702) 733-7810

Washoe County Library
301 South Center Street
Reno, NV 89505
(702) 785-4012

New Hampshire

The New Hampshire Charitable Fund
One South Street
Concord, NH 03301
(603) 225-6641

Littleton Public Library
109 Main Street
Littleton, NH 03561
(603) 444-5741

New Jersey

Cumberland County Library
800 E. Commmerce Street
Bridgeton, NJ 08302-2295
(609) 453-2210

The Support Center
17 Academy Street, Suite 1101
Newark, NJ 07102
(201) 643-5774

County College of Morris Masten
Learning Resource Center
Route 10 and Center Grove Road
Randolf, NJ 07869
(201) 361-5000, ext.470

New Jersey State Library
Governmental Reference
185 West State Street
Trenton, NJ 08625
(609) 292-6220

New Mexico

Albuquerque Community Foundation
6400 Uptown Blv d. N.E., Suite 500-W
Alburquerque, NM 87105
(505) 883-6240

New Mexico State Library
300 Don Gaspar Street
Santa Fe, NM 87505
(505) 827-3824

New York

New York State Library
Cultural Education Center, Humanities
Section
Empire State Plaza
Albany, NY 12230
(518) 474-5161

Bronx Reference Center
New York Public Library
2556 Bainbridge Avenue
Bronx, NY 10458
(718) 220-6575

Brooklyn in Touch
One Hanson Place, Room 2504
Brooklyn, NY 11243
(718) 230-3200

Buffalo and Erie County Public Library
Lafayette Square
Buffalo, NY 14202
(716) 858-7103

Huntington Public Library
338 Main Street
Huntington, NY 11743
(516) 427-5165

Levittown Public Library
Reference Department
One Bluegrass Lane
Levittown, NY 11756
(516) 731-5720

SUNY/College at Old Westbury Library
223 Store Hill Road
Old Westbury, NY 11568
(516) 876-3156

Plattsburgh Public Library
Reference Department
15 Oak Street
Plattsburgh, NY 12901
(518) 563-0921

Adriance Memorial Library
93 Market Street
Poughkeepsie, NY 12601
(914) 485-3445

Queens Borough Public Library
89-11 Merrick Boulevard
Jamaica, NY 11432
(718) 990-0700

Rochester Public Library
Business and Social Sciences Division
115 South Avenue
Rochester, NY 14604
(716) 428-7328

Onondaga County Public Library
447 South Salinas Street
Syracuse, NY 13202-2494
(315) 448-4636

White Plains Public Library
100 Martine Avenue
White Plains, NY 10601
(914) 682-4480

North Carolina

The Duke Endowment
200 S. Tryon Street, Ste. 1100
Charlotte, NC 28202
(704) 376-0291

Durham County Library
300 N. Roxboro Street
Durham, NC 27702
(919) 683-2626

North Carolina State Library
109 East Jones Street
Raleigh, NC 27611
(919) 733-3270

The Winston-Salem Foundation
229 Union National Bank Building
Winston-Salem, NC 27101
(919) 725-2382

North Dakota

Western Dakota Grants Resource
Center
Bismark Junior College Library
Bismark, ND 58501
(701) 224-5400

The Library
North Dakota State University
Fargo, ND 58105
(701) 237-8886

Ohio

Public Library of Cincinnati and
Hamilton County
Education Department
800 Vine Street
Cincinnati, OH 45202-2071
(513) 369-6940

The Foundation Center
1442 Hanna Building
1422 Euclid Avenue
Cleveland, OH 44115
(216) 861-1933

Columbus Public Library
96 South Grant Avenue
Columbus, OH 43215
(614) 645-2275

Toledo-Lucas County Public Library
Social Science Department
325 Michigan Street
Toledo, OH 43623
(419) 259-5245

Ohio University-Zanesville
Community Education and Development
1425 Newark Road
Zanesville, OH 43701
(614) 453-0762

Oklahoma

Okalahoma City University Library
2501 North Blackwelder
Oklahoma City, OH 73106
(405) 521-5072

Tulsa City-County Library System
400 Civic Center
Tulsa, OK 74103
(918) 596-7944

Oregon

Library Association of Portland
Government Documents Room
801 S.W. Tenth Avenue
Portland, OR 97205-2597
(503) 223-7201

Oregon State Library
State Library Building
Salem, OR 97310
(503) 378-4274

Pennnsylvania

**Northhampton County Area
Community College**
Learning Resources Center
3835 Green Pond Road
Bethlehem, PA 18017
(215) 861-5360

Erie County Public Library
3 South Perry Square
Erie, PA 16501
(814) 451-6927

Dauphin County Library System
Central Library
101 Walnut Street
Harrisburg, PA 17101
(717) 234-4961

Lancaster County Public Library
125 North Duke Street
Lancaster, PA 17602
(717) 394-2651

The Free Library of Philadelphia
Logan Square
Philadelphia, PA 19103
(215) 686-5423

Hillman Library
University of Pittsburgh
Pittsburgh, PA 15260
(412) 648-7722

Economic Development Council of
Northeastern Pennsylvania
1151 Oak Street
Pittston, PA 18640
(717) 655-5581

Rhode Island
Providence Public Library
Reference Department
150 Empire Street
Providence, RI 02903
(401) 521-7722

South Carolina
Charleston County Public Library
404 King Street
Charleston, SC 29403
(803) 723-1645

South Carolina State Library
Reader Services Department
1500 Senate Street
Columbia, SC 29211
(803) 734-8666

South Dakota

South Dakota State Library
State Library Building
800 Govenors Drive
Pierre, SD 57501-2294
(605) 773-3131

Sioux Falls Area Foundation
321 South Philips Avenue, Room 404
Sioux Falls, SD 57102-0781
(605) 336-7055

Tennessee

Knoxville-Knox County Public Library
500 West Church Avenue
Knoxville, TN 37902
(615) 544-5750

Memphis Shelby County Public Library
1850 Peabody Avenue
Memphis, TN 38104
(901) 725-8876

Public Library of Nashville and
Davidson County
8th Avenue, North and Union Street
Nashville, TN 37211
(615) 259-6256

Texas

Amarillo Area Foundation
800 South Fillmore
Amarillo, TX 79101
(806) 376-4521

The Hogg Foundation for Mental Health
The University of Texas
Austin, TX 78713
(512) 471-5041

Corpus Christi State University Library
6300 Ocean Drive
Corpus Christi, TX 78412
(512) 994-2608

Dallas Public Library
Grants Information Service
1515 Young Street
Dallas, TX 75201
(214) 670-1487

Pan American University
Learning Resource Center
1201 W. University Drive
Edinburg, TX 78539
(512) 381-3304

El Paso Community Foundation
201 East Main
El Paso, TX 79901
(915) 533-4020

Funding Information Center
Texas Christian University Library
Ft. Worth, TX 76129
(817) 921-7664

Houston Public Library
Bibliographic & Information Center
500 McKinney Avenue
Houston, TX 77002
(713) 236-1313

Funding Information Library
507 Brooklyn
San Antonio, TX 78215
(512) 227-4333

Utah

Salt Lake City Public Library
Business and Science Department
209 East Fifth South
Salt Lake City, UT 84111
(801) 363-5733

Vermont

State of Vermont Department of Libraries
Reference Service Unit
109 State Street
Montpelier, VT 05602
(802) 828-3268

Virginia

Grants Resources Library
4207 Victoria Boulevard
Hampton, VA 23669
(804) 727-1154

Richmond Public Library
Business, Science & Technology
Department
101 East Franklin Street
Richmond, VA 23219
(804) 780-8223

Washington

Seattle Public Library
1000 Fourth Avenue
Seattle, WA 98104
(206) 386-4620

Spokane Public Library
Funding Information Center
West 906 Main Avenue
Spokane, WA 92201-0976
(509) 838-3364

West Virginia

Kanawha County Public Library
123 Capitol Street
Charleston, WV 25304
(304) 343-4646

Wisconsin

Marquette University Memorial Library
1415 West Wisconsin Avenue
Milwaukee, WI 53233
(414) 288-1515

**University of Wisconsin-Madison
Memorial Library**
728 State Street
Madison, WI 53706
(608) 262-3242

Wyoming

Laramie County Community College
Library
1400 East College Drive
Cheyenne, WY 82007-3299
(307) 778-1205

Canada

Canadian Center for Philanthropy
74 Victoria Street
Toronto, Ontario M5C 2A5
(416) 368-1138

England

Charities Aid Foundation
18 Doughty Street
London WCIN - 2PL
(01) 831-7798

Mexico

Biblioteca Benjamin Franklin
Londres 16
Mexico City 6, D.F. 06600
(905) 211-0042

Puerto Rico

Universidad Del Sagarado Corazon
M.M.T. Gurevarra Library
Correro Calle Loiza
Santurce 00914
(809) 844-4150

Virgin Islands

College of the Virgin Islands Library
Saint Thomas
U.S. Virgin Islands 00802
(809) 776-9200 ext. 1487

Appendix III

Offices of Volunteer Lawyers For the Arts (VLA)

California:

California Lawyers for the Arts
315 West Ninth Street, 11th Floor
Los Angeles, CA 90015
　　(213) 623-8311

California Lawyers for the Arts
Fort Mason Center, Bldg. C, Room 225
San Francisco, CA 94123
　　(415) 775-7200
　　Alma Robinson, Esq., Exec. Director

Canada:

**Canadian Artists' Representation
Ontario (CARO)**
183 Bathurst Street
Toronto, Ontario M5T 2R7
CANADA
　　(416) 360-0780
　　Garry Conway, Executive Director

Colorado:

Colorado Lawyers for the Arts (COLA)
770 Pennsylvania
Denver, CO 80203
　　(303) 894-2617
　　Holly Bennett, Esq., Exec. Director

Connecticut:

Connecticut Volunteer Lawyers for the Arts (CTVLA)
Connecticut Commission on the Arts
227 Lawrence Street
Hartford, CT 06106
(203) 566-4770
Alex Giesinger, Coordinator

District of Columbia:

Lawyers Committee for the Arts (LCA)
Volunteer Lawyers for the Arts
918 16th Street, NW, Suite 503
Washington, DC 20006
(202) 429-0229
Joshua Kaufman, Esq., Exec. Director

Washington Area Lawyers for the Arts (WALA)
2025 Eye Street, NW, Suite 1114
Washington, DC 20006
(202) 861-0055
Ruth Cogen, Director

Florida:

Volunteer Lawyers for the Arts program
Pinellas County Arts Council
400 Pierce Blvd.
Clearwater, FL 34616
(813) 462-3327
Judith Powers Jones, Exec. Director

Office of cultural Affairs-Main Library
100 South Andrews Avenue
Fort Lauderdale, FL 33301
(305) 357-7457
Mary A. Becht, Director

Business Volunteers for the Arts/Miami
c/o Greater Miami Chamber of Commerce
1601 Biscayne Blvd.
Miami, FL 33132
(305) 350-7700
Rhodele Holzberg, Senior Vice Pres.

Georgia:
Georgia Volunteer Lawyers for the Arts (GVLA)
34 Peachtree Street, Suite 2330
Atlanta, GA 30303
(404) 525-6046
Gail Centini, Exec. Director

Illinois:
Lawyers for the Creative Arts (LCA)
213 West Institute Place
Chicago, IL 60610
(312) 944-2787
Dan Mayer, Director

Iowa:
Volunteer Lawyers for the Arts
Committee
Cedar Rapids/Marion Arts Council
424 First Avenue NE - PO Drawer 760
Cedar Rapids, IA 52407
(319) 398-5322
Ann Bergren, Exec. Director

Kentucky:
Community Arts Council
623 West Main Street
Louisville, KY 40202
(502) 582-0100
Baylor Landrum III, Vice President

Louisiana:
Louisiana Volunteer Lawyers for the Arts (LVLA)
c/o Arts Council of New Orleans
821 Gravier, Suite 600
New Orleans, LA 70112
(504) 523-1465

Maine:

Maine Volunteer Lawyers for the Arts Project
Main State Commission on the Arts and
the Humanities
55 Capitol Street
State House Station 25
Augusta, ME 04333
 (207) 289-2724
 Dick Dyer, Public Information Assoc.

Maryland:

Maryland Lawyers for the Arts
c/o Hotel Belvedere
1 East Chase Street, Suite 1118
Baltimore, MD 21202-2526
 (301) 752-1633
 Rita Edwards, Exec. Director

Massachusetts:

The Arts Extension Service (AES)
Division of Continuing Education
University of Massachusetts
604 Goodell Boulevard
Amherst, MA 01003
 (413) 545-2360
 Craig Dreeszen, Director
 Brenda D'Addamio, Office Manager

Volunteer Lawyers for the Artists, Inc.
The Artists Foundation, Inc.
8 Park Plaza, room 2240
Boston, MA 02116
 (617) 523-1764
 Carolyn Rosenthal, Director
 Lauren Morin, Director

Minnesota:
Resources and Counseling Center
United Arts
429 Landmark Center
75 West Fifth Street
St. Paul, MN 55102
 (612) 292-3206
 Chris Osgood, Manager/Arts

Missouri:
St. Louis Volunteer Lawyers and Accountants for the Arts (SLVLAA)
3540 Washington
St. Louis, MO 63103
 (314) 652-2410
 Sue Greenberg, Exec. Director

Montana:
Montana Volunteer Lawyers for the Arts
c/o Joan Jonkel, Esq.
P.O. Box 8687
Missoula, MT 59807
 (406) 721-1835

New Jersey:
Volunteer Lawyers for the Arts of New Jersey
c/o Center for Non-profit Corporations
36 West Lafayette Street
Trenton, NJ 08608
 (609) 695-6422
 Judith Trachtenberg, Esq.

New York:
Volunteer Lawyers for the Arts (VLA)
1285 Avenue of the Americas, 3rd floor
New York, NY 10019
 (212) 977-9270
 Jennifer Moyer, Exec. Director

Volunteer Lawyers for the Arts Program
Albany League of Arts (ALA)
19 Clinton Avenue
Albany, NY 12207
 (518) 449-5380
 Jacqueline Cavalier, Exec. Director

Arts Council in Buffalo and Erie County
700 Main Street
Buffalo, NY 14202
 (716) 856-7520
 Karen Cosman, Admin. Coordinator

Huntington Arts Council, Inc.
213 Main Street
Huntington, NY 11743
 (516) 271-8423
 Cindy Kiebitz, Exec. Director

North Carolina:
North Carolina Volunteer Lawyers for the Arts (NCVLA)
PO Box 26484
Raleigh, NC 27611-6484
 (919) 741-7508
 Guy M. Glenn, Secretary-Treasurer

Ohio:
Cleveland Volunteer Lawyers for the Arts
c/o Cleveland Bar Association
Mall Building
113 St. Clair Avenue
Cleveland, OH 44114-1253
 (216) 696-3525
 Dorothea J. Kingsbury, Esq., Chairman

Toledo Volunteer Lawyers for Arts
421-A North Michigan
Toledo, OH 43624
 (419) 243-3125
 Arnold Gott

Pennsylvania:
Philadelphia Volunteer Lawyers for the Arts (PVLA)
251 South 18th Street
Philadelphia, PA 19103
 (215) 545-3385
 Dorothy R. B. Manou, Exec. Director

Rhode Island:
Ocean State Lawyers for the Arts (OSLA)
P.O. Box 19
Saunderstown, RI 02874
 (401) 789-5686
 David M. Spatt, Esq., Director

South Carolina:
South Carolina Lawyers for the Arts (SCLA)
PO Box 8672
Greenville, SC 29604
 (803) 232-3874
 C. Diane Smock, Esq., Legal Director

Texas:
Austin Lawyers and Accountants for the Arts (ALAA)
PO Box 2577
Austin, TX 78768
 (512) 476-7573
 Robert M. Sweeney, Exec. Director

Volunteer Lawyers and Accountants for the Arts (VLAA)
1540 Sul Ross
Houston, TX 77006
 (713) 526-4876
 Sarah Roady, Exec. Director

Utah:
Utah Lawyers for the Arts (ULA)
50 South Main, Suite 1600
Salt Lake City, UT 84144
(801) 532-3333
Phyllis Vetter, President

Washington:
Washington Volunteer Lawyers for the Arts (WVLA)
1331 Third Avenue, Suite 512
Seattle, WA 98101
(206) 223-0502
Judith Nebot, Exec. Director

Sample Contracts

Sample I. Artist - Gallery Agreement

This Sample Artist - Gallery Agreement is a sample agreement. Since it is impossible to cover every contingency that might occur, this sample agreement should be adapted to suit your own individual needs. Keep in mind that state laws vary and change, and that before entering any contractual relationship, you should consult a knowledgeable lawyer. Always make two copies of any contract (one for you, the other for the second party), and have the relevant parties sign both copies. Your copy of the contract should never have photcopied signatures.

[This contract has been adapted form the following sources: Norman J. Stone, An Introduction to Contracts for the Visual Artist (San Francisco: Bay Area Lawyers for the Arts); Tad Crawford, Contracts for Artists (American Artist Business Letter); and Lawyers for the Arts committee of the Philadelphia Bar Association, "Model Form of Artist-Gallery Agreement with Explanatory Annotations;" The Artist-Gallery Partnership (American Council For The Arts).]

Agreement made this _____ day of _____ , 19___ , between_____(hereinafter called "the Artist"), residing at_____and (hereinafter called "the Gallery"), located at_____ .

WHEREAS, the Artist is a recognized professional artist, WHEREAS, the Artist wishes to have certain of his/her artworks represented by the Gallery, and;

WHEREAS, the Gallery wishes to represent the Artist under the terms and conditions of this Agreement;

NOW, THEREFORE, in consideration of the mutual covenants hereinafter contained, the parties hereto agree as follows:

1. SCOPE OF AGENCY. The Artist appoints the Gallery his/her_____[enter "nonexclusive or "exclusive] agent for the purpose of exhibition and sale of the consigned works of art in the following geographical area: _____.

2. CONSIGNMENT. The Artist shall consign to the Gallery and the Gallery shall accept consignment of the following works of art during the term of this Agreement:

 Check whichever apply
 The works described in the Consignment Sheet (Schedule A of this Agreement) and such additional works as shall be mutually agreed upon and described in a similar Consignment Sheet.

 All new works created by the Artist, excluding works reserved by the Artist for his/her private collection, in the following media _____.

 All new works created by the Artist, excluding works reserved by the Artist for his/her private collection, in the following media:_____.

 All new works created by the Artist, excluding works reserved by the Artist for his/her private collection, and excluding works reserved by the Artist for studio sales made directly by the Artist, in the following media:
 _____.

 All works which the Gallery shall select, excluding works reserved by the Artist for his/her private collection, and excluding works reserved by the Artist for studio sales made directly by the Artist, in the following media:
 _____ .

Not less than _____ mutually agreed upon works per year, in the following media: _____.
The Artist shall be free to exhibit and sell any work not consigned to the gallery under this Agreement. Upon Gallery's request, Artist will inform Gallery of other agents representing Artist's work.

3. TITLE AND RECEIPT. The Artist warrants that he/she created and possesses unencumbered title to all works of art consigned to the Gallery under this Agreement. Title to the consigned work shall remain in the Artist until he/she is paid in full. The Gallery acknowledges receipt of the works in the Consignment Sheet (Schedule A of this Agreement) and shall give the Artist a similar Consignment Sheet to acknowledge receipt of all additional works consigned to the Gallery under this Agreement.

4. CONTINUOUS SALES REPRESENTATION AND PROMOTION. The Gallery shall use its best efforts to promote the sale of the Artist's consigned works, to support a market for the Artist's work, and to provide continuous sales representation in the following manner: _____.*
 [Here you should list, in as clear but detailed a manner as possible, everything the Gallery will do to best represent you: whether the Gallery will visit your studio regularly to get a better idea of the full range of your work; where the Gallery will exhibit your work—on the walls, in bins, drawers, sliding panels, etc.; whether you will be included in the Gallery's regular advertising throughout the year, etc.]

5. SALES PRICE. The Gallery shall sell the consigned works at the retail price specified in writing in the Consignment Sheet.

a. The Gallery, however, may give a customary trade discount [which shall not exceed_____% of sales price without the Artist's written consent] of sales to museums, other galleries, decorators, and architects. In the case of such discount sales, the amount of the discount shall be deducted from the Gallery's sales commission.

b. Sales price specified in writing in the Consignment Sheet does not include any applicable sales tax. Any such applicable tax will be collected by the Gallery on works sold by the Gallery. The Gallery will supply the Artist with its signed resale certificate and its resale number, for the Artist's records.

c. Sales price specified in writing in the consignment Sheet does not include costs of delivering said work to customer. Delivery costs (including packing, transportation, and insurance) will be paid by the Gallery.

d. Artist will support the efforts of the Gallery and will maintain the fair market value of the work in any studio sales.

6. REMOVAL FROM GALLERY, RENTALS, APPROVAL AND INSTALLMENT SALES. The gallery shall not lend out, remove from its premises, rent, or sell on approval or installment any of the consigned works, without the written consent of the Artist.

a. The Gallery shall not permit any consigned work to remain in the possesson of a customer for the purpose of sale on approval for a period exceeding seven (7) days.

b. No rental period may exceed_____ weeks unless a longer period is approved by the Artist in writing.

c. If after renting one of Artist's consigned works, a customer desires to purchase said work, the rental fees paid_____ [enter "shall" or "shall not"] be deducted from the sales price.

d. Although the Gallery may arrange for representation of the Artist by another agency with the Artist's written consent, the Gallery shall pay such agency by splitting its own commission.

e. When, with the Artist's written approval, the Gallery lends out or removes from its premises one of the Artist's works for the purposes of rental, approval sales, installment sales, or representation by another agency, then the costs of delivery from and if necessary to the Gallery (including packing, transportation, and insurance) shall be paid by the Gallery.

7. SALES COMMISSION. The Gallery shall receive the following sales commission:

a. _____% of the agreed retail price on sales made by the Gallery.

b. _____% of any rental fees on rentals arranged by the gallery.

c. _____% of the price of any commissions given to Artist to create works of art when such commissions are obtained for him/her by the Gallery.

d. _____% of the amount received for prizes and awards granted to the Artist when such prizes and awards are obtained for the Artist by the Gallery.

e. _____% of lecture fees for lectures arranged for the Artist by the gallery.

f. _____% of the amount paid for studio sales of referrals by the Gallery

g. _____% of the amount paid for studio sales made directly by the Artist.

h. _____% of any rental fees on rentals arranged directly by the Artist.

i. _____% of the price of any commissions given to Artist to create works of art when such commissions are obtained directly by the Artist.

The remainder shall be paid to the Artist. Pursuant to Paragraph 5a, in the case of discount sales, the amount of the discount shall be deducted from the Gallery's sales commission. Pursuant to Paragraph 6d, in the case of the Gallery's arranging for representation of the Artist by another agency, the gallery shall pay such agency by splitting its own commission*

[The Paragraph delineating the commission arrangement is, of course, one of the most important provisions in your Agreement, and it should be tailored to your particular situation. If, for example, the costs of the materials for your work is quite high, you might stipulate that the costs of materials, installation, and foundry fees, etc. shall be deducted before the Gallery's commission is calculated. If much of your work is framed, this Paragraph could include a provision that the Gallery's commission will be on the retail price of the work minus the cost of the frame. In another situation, you might arrange for a sliding commission scale. The Gallery could take a 50% commission on works under $3,000, a 40% commission on works in the $3,000 to $8,000 range, and a 30% commission on works over $8,000. On those sales arranged directly by you (Paragraph 7g,h,i,j) the commission should be lower than on those sales arranged by the Gallery (Paragraph 7a,b,c,d,e,f). In fact, in some cases, you might want to stipulate that the Gallery receives no commission on sales made directly by the Artist. Or you might arrange that in such Artist-arranged sales, the Gallery receives no commission unless it generates annual sales for you in excess of a certain amount. This Paragrpaph of your Agreement could also cover any cash advances the Gallery might provide you.]

8. PAYMENT ON GALLERY'S SALES. With respect to sales made under Paragraph 7a,b,c,d,e:

a. On outright sales, the Gallery shall pay the Artist's share within thirty (30) days of purchaser's payment to the gallery.*

[You might want to include a provision that for sales in excess of a certain amount, the Gallery will pay you as soon as the Purchaser's check clears. That way you won't have to wait thirty days for your share.]

b. On installment sales the Gallery shall first apply the proceeds from sale of the work to pay the Artist's share. Payment shall be made within thirty (30) days after the Gallery's receipt of each installment.

The Gallery shall hold the proceeds from sale of the consigned works in trust for the benefit of the Artist. The Gallery agrees to guarantee the credit of its customers, and to bear all losses due to the failure of the customer's credit.

9. PAYMENT ON ARTIST'S SALES. With respect to sales made under Paragraph 7f,g,h,i,j:

a. On outright sales, the Artist shall pay the Gallery its sales commission within thirty (30) days of purchaser's payment to Artist.

b. If purchaser pays in installments, the Artist shall first apply the proceeds from sale of work to pay his/her own share. Payment to gallery shall then be made within thirty (30) days after the Artist's receipt of each installment.

10. STATEMENTS OF ACCOUNT. The Gallery shall give the Artist a Statement of Account within fifteen (15) days after the end of each calendar quarter beginning with_____. 19_____. The Statement shall include the following information:

1) the works sold or rented

2) the date, price, and terms of sale or rental (that is, whether by cash, barter, exchange, credit, partial payment or other)

3) the commission due to the Gallery

4) the name and address of each purchaser or renter

5) the amount due to the Artist

6) the location of all unsold works, if not on the Gallery's premises, and if on the Gallery's premises, whether at time of said Account, the work is on display or not.

The Gallery warrants that the Statement shall be accurate and complete in all respects. The Artist shall have the right to inspect the financial records of the Gallery pertaining to any transactions involving the Artist's work. (The Gallery shall also have the right to inspect the financial records of the Artist pertaining to any transaction involving the Gallery.)

11. EXHIBITIONS. During the term of this Agreement, in addition to continuous sales representation, the Gallery shall arrange, install, and publicize at least one solo exhibition of the Artist's work of not less than _____ weeks duration each, every _____ months, and shall use its best efforts to arrange other solo exhibitions for Artist and for the inclusion of the Artist's work in group exhibitions in other galleries or museums, provided, however, that the Artist's work may not be included in any group or solo exhibition without the Artist's written consent.

 a. The Gallery shall give the Artist at least _____ months notice of said solo exhibition.

 b. The Gallery will give the Artist reasonable notice of any deadlines for said solo exhibition, including but not limited to: when work is due at the Gallery, date of reception, hours of Gallery during exhibition, deadlines for resumes or press photographs that may be required, when unsold work will be returned after the exhibition. The Gallery will also give the Artist all information

concerning all physical restrictions in advance, including but not limited to: what weight the Gallery's floors can support, what size works can fit throught the Gallery's doors.

c. The Artist will give the Gallery reasonable notice of any special requirements of his/her solo exhibition.

d. Prior to any exhibition of the Artist's work, the Gallery and Artist shall agree on the extent of, and division of, artistic control of and financial responsibility for the costs of exhibitions and other promotional efforts to be undertaken in connection with such exhibition, including but not limited to, installation, advertising, printing, postage, reception, framing. Neither the Gallery nor the Artist shall be entitled to reimbursement from the other for any expense incurred by him/her or it without the prior written approval of the other.*

[You might want your Agreement to specify exactly what your gallery will do for you during your solo exhibitions]

e. If the Artist gives the Gallery his/her mailing list to use for any exhibition, the gallery shall respect confidentiality of same.

f. After the exhibition, the frames, photographs, negatives, and any other tangible property created in the course of the exhibition shall be the property of the Artist.

g. After the exhibition, the Gallery will provide the Artist with copies of all reviews Gallery has received concerning said exhibition.

12. DELIVERY OF WORKS. _____ shall be responsible for delivery of the consigned works to the Gallery. All costs of delivery (including packing,

transportation, and insurance) shall be paid as follows: _____% by the Artist, _____% by the Gallery.

13. RETURN OF WORKS. _____ shall be responsible for return of works from the Gallery to the Artist. All costs of return (including packing, transportation, and insurance) shall be paid as follows: _____% by the Artist, _____% by the Gallery.

 a. The Gallery may return any consigned work on thirty (30) days written notice.

 b. The Artist may withdraw his/her consigned work on thirty days written notice.

 c. If the Artist fails to accept return of the works within _____ days after written request by the Gallery, the Artist shall pay reasonable storage costs.

 d. The Gallery agrees to return consigned works in the same good condition as received, subject to the provisions of Paragraph 14.

14. LOSS OR DAMAGE. The Artist and Gallery hereby agree as follows:

 a. The Gallery shall not intentionally commit or authorize any physical defacement, mutilation, alteration, or destruction of any of the consigned works. The Gallery shall be responsible for the proper cleaning, maintenance, and protection of consigned work, and shall also be responsible for the loss or damage to the consigned work, whether the work be on the Gallery's premises, on loan, on approval, or otherwise removed from its premises pursuant to Paragraph 6.

 b. Upon Gallery's request, the Artist will supply Gallery with a Statement of Maintenance (similar

to Schedule Bl of this Agreement) for the consigned works.

c. If restoration is undertaken for any consigned work, all repairs and restoration shall have the Artist's written permission, The Artist shall be consulted as to his/her recommendations with regard to all such repairs and restoration, and will be given first opportunity to accomplish said repairs and restorations for a reasonable fee.

d. In the event of loss or damage that cannot be restored, the Artist shall receive the same amount as if the work had been sold at the retail price listed in the Consignment Sheet. The Gallery shall not deduct a commission from this payment. The damaged work will be returned to Artist upon his/ her request.

e. For the benefit of the Artist, the Gallery will provide at its expense all risk insurance on all of the Artist's works of art shown in the Consignment Sheet for _____% of the retail price.*

 [If possible, try to be named on the insurance policy as the beneficiary in case of a a claim. Most galleries, however, will not permit this.]

15. COPYRIGHT. The Artist and the Gallery hereby agree as follows:

 a. The Artist hereby reserves for himself/herself the common law copyright, including all reproduction rights and the right to claim statutory copyright in all works consigned to the Gallery.

 b. The Gallery will not permit any of the works of art to be copied, photographed, or reproduced without the written approval of the Artist.

c. All approved reproductions in catalogues, brochures, advertisements, and other promotional literature shall carry the following notice: © by _____, 19___ .

d. The Gallery will have printed on each bill of sale in a prominent place the following notice: "The right to copy, photograph, or reproduce the work(s) of art identified herein is reserved by the Artist, _____."

e. The Gallery will display in a prominent place in its Gallery a sign advising its customers that Artist's work may not be copied, photographed, or reproduced and that it will use its best efforts to prevent violations thereof.

f. Notwithstanding the foregoing, reproduction rights may be specifically sold by Gallery with the Artist's prior written consent. Gallery shall not receive any commissions on royalties or sales of reproduction rights unless sold or arranged by Gallery, in which case Gallery's sale commission shall be _____%. In such case, the Gallery will pay the Artist his/her share within thirty (30) days of purchaser's payment to Gallery.

16. MORAL RIGHT. The Gallery will not permit any use or misuses of the Artist's name or misuses of the consigned works which would reflect discredit on his/her reputation as an artist or which would violate the spirit of the work.

17. SECURITY. The consigned works shall be held in trust for the benefit of the Artist, and shall not be subject to claim by a creditor of the Gallery. In the event of any default by the Gallery, the Artist shall have all the rights of a secured party under the Uniform Commercial code.

18. CONTRACT FOR SALE. The Gallery shall use the Artist's own Contract for Sale in any sale of the Consigned works.*

[Append a copy of the Artist's transfer Agreement and Record (Resale Contract) if you use such an agreement. You may want to draft your own version of a sales contract to be appended here.]

19. DURATION AND TERMINATION OF AGREE-MENT. This Agreement shall commence upon the date of signing and shall continue in effect until the _____ day of _____,19___.

 a. Either party may terminate this Agreement by giving sixty (60) days prior written notice, except that the Agreement may not be terminated ninety (90) days prior to the opening of the Artist's solo exhibition, or ninety (90) days following the close of the Artist's solo exhibition.

 b. The Agreement shall automatically be terminated with the death of the Artist; the death or termination of employment of _____ with the Gallery; if the Gallery moves outside of the area of _____; or if the Gallery becomes bankrupt or insolvent.*

 [When you first join a gallery, you may do so because of your personal relationship with and confidence in a particular employee of the Gallery. This provision of your Agreement gives you the option to terminate your Agreement should that particular employee be dismissed or die.]

 c. Upon termination of this Agreement, the Gallery shall return within thirty (30) days all Artist's works which are held by it on consignment and all accounts shall be settled.

20. ARBITRATION. Any dispute hereunder between the parties shall be resolved by resort to binding arbitration by a mutually agreed upon party in accordance with the standards and procedures of the American Arbitration Association, and the arbitration award may be entered for judgement in any court having jurisdiction thereof.

 a. Notwithstanding the foregoing, either party may refuse to arbitrate when the dispute is for a sum of less than $_____ (dollars), or more than $_____ (dollars).

 [In the space provided "for less than _____," you may want to insert the jurisdictional amount of the local small claims court. This usually provides an even easier forum than arbitration for settling disputes.]

21. NO ASSIGNMENT OR TRANSFER. Neither party hereto shall have the right to assign or transfer this agreement without the prior written consent of the other party. The Artist, however, shall retain the right to assign any payments provided for by this Agreement. The Gallery shall notify the Artist in advance of any change in personnel in charge of the Gallery or any change in ownership of the Gallery.

22. ASSIGNS. This Agreement shall be binding upon the parties hereto, their successors, assigns, and personal representatives, and references to the Artist and the gallery shall include their successors, assigns, and personal representatives, notwithstanding anything to the contrary herein.

23. NO WAIVER. No waiver of full performance by either party shall be construed or operate as a waiver of any subsequent default of any of the terms, covenants, and conditions of this Agreement.

24. SEVERABILITY. If any part of this Agreement is held to be illegal, void, or unenforceable for any reason, such

holding shall not affect the validity and enforceabiltiy of any other part.

25. ENTIRE AGREEMENT. This Agreement contains all of the covenants, promises, agreements, and conditions, either oral or written, between the parties, and may not be changed or modified ecxcept in writing signed by both parties.

26. ADDRESS NOTICE. All notices to the artist shall be delivered to _____, and all notices to the Gallery to _____. Each party shall notify the other party in case of change of address prior to to such change.

27. GOVERNING LAWS. The validity of this Agreement and of any of its terms, as well as the rights and duties of the parties under this Agreement, shall be governed by the laws of the State of _____.

IN WITNESS WHEREOF the parties hereto have executed this Agreement on the day and year first above written.

BY_____ BY_____
 (The Artist) (The Gallery)

Sample II. Art Consignment Agreement

The Artist (name, address, and telephone number):_____and the Gallery (name, address, and telephone number):_____heareby enter into the following Agreement:

1. Agency: Purposes. The Artist appoints the Gallery as agent for the works of art ("the Artworks") consigned under this Agreement, for the purposes of exhibition and sale. The Gallery shall not permit the Artworks to be used for any other purposes without the written consent of the Artist.

2. Consignment. The Artist hearby consigns to the Gallery, and the Gallery accepts on consignment, those Artworks listed on the attached Inventory Sheet which is a part of this Agreement. Additional Inventory Sheets may be incorporated into this Agreement at such time as both parties agree to the consignment of other works of art. All Inventory Sheets shall be assigned by Artist and Gallery.

3. Warranty. The Artist hereby warrants that he/she created and possesses unencumbered title to the Artworks, and that their descriptions are true and accurate.

4. Duration of Consignment. The Artist and the Gallery agree that the initial term of consignment for the Artworks is to be_____(months), and that the Artist does not intend to request their return before the end of this term. Thereafter, consignment shall continue until the Artist requests the return of any or all of the Artworks or the Gallery requests that the Artist take back any of all of the

Artworks with which request the other party shall comply promptly.

5. Transportation Responsiblities. Packing and shipping charges, insurance costs, other handling expenses, and risk of loss or damage incurred in the delivery of Artworks for the Artist to the Gallery, and in their return to the Artist, shall be the responsibility of the _____ (specify Gallery or Artist).

6. Responsiblity for Loss or damage; Insurance Coverage. The Gallery shall be responsible for the safekeeping of all consigned Artworks while they are in its custody. The Gallery shall be strictly liable to the Artist for their loss or damage (except for damage resulting from flaws inherent in the Artworks), to the full amount the Artist would have received from the Gallery if the Artworks had been sold. The Gallery shall provide the Artist with all relevant information about its insurance coverage for the Artworks if the Artist requests this information.

7. Fiduciary Responsibilities. Title to each of the Artworks remains with the Artist until the Artist has been paid the full amount owing him or her for the Artworks; title then passes directly to the purchaser. All proceeds from the sale of the Artworks shall be held in trust for the Artist. The Gallery shall pay all amounts due the Artist before any proceeds of sales can be made available to creditors of the Gallery.

8. Notice of Consignment. The Gallery shall give notice, by means of a clear and conspicuous sign in full public view, that certain works of art are being sold subject to a contract of consignment.

9. Removal from Gallery. The Gallery shall not lend out, remove from the premises, or sell on approval any of the Artworks without first obtaining written permission from the Artist.

10. Pricing; Gallery's Commission; Terms of Payment. The Gallery shall sell the Artworks only at the Retail Price specified on the Inventory Sheet. The Gallery and the Artist agree that the Gallery's commission is to be _____% of the Retail Price of the Artwork. Any change in the Retail Price, or in the Gallery's commission, must be agreed to in advance by the Artist and the Gallery. Payment to the Artist shall be made by the Gallery within _____ days after the date of any sale of any of the Artworks. The Gallery assumes full risk for the failure to pay on the part of any purchaser to whom it has sold an Artwork.

11. Promotion. The Gallery shall use its best efforts to promote the sale of the Artworks. The Gallery agrees to provide adequate display of the Artworks, and to undertake other promotional activities on the Artist's behalf, as follows:_____.
The Gallery and the Artist shall agree in advance on the division of artistic control and of financial responsibility for expenses incurred in the Gallery's exhibitions and other promotional activities undertaken on the Artist's behalf. The Gallery shall identify clearly all Artworks with the Artist's name, and the Artist's name shall be included on the bill of sale of each of the Artworks.

12. Reproduction. The Artist reserves all rights to the reproduction of the Artworks except as noted in writing to the contrary. The Gallery may arrange to have the Artworks photographed to publicize and promote the Artworks through means to be agreed to by both parties. In every instance of such use, the Artist shall be acknowledged as the creator and copyright owner of the Artwork. The Gallery shall include on each bill of sale of any Artwork the following legend: "All rights to reproduction of the work(s) of art identified herein are retained by the Artist."

13. Accounting. A statement of accounts for all sales of the Artworks shall be furnished by the Gallery to the Artist on a regular basis, in a form agreed to by both parties, as follows:_____(specify frequency and manner of accounting). The Artist shall have the right to inventory his or her Artworks in the Gallery and to inspect any books and records pertaining to sales of the Artworks.

14. Additional Provisions.

15. Termination of Agreement. Notwithstanding any other provision of this Agreement, this Agreement may be terminated at any time by either the Gallery or the Artist, by means of written notification of termination from either party to the other. In the event of the Artist's death, the estate of the Artist shall have the right to terminate the Agreement. Within thirty days of the notification of termination, all accounts shall be settled and all unsold Artworks shall be returned by the Gallery.

16. Procedures for Modification. Amendments to this Agreement must be signed by both Artist and Gallery and attached to this agreement. Both parties must initial any deletions made on this form and any additional provisions written onto it.

17. Miscellany. This Agreement represents the entire agreement between the Artist and the Gallery. If any part of this

Appendix V

Tax Forms

Business Tax Form

SCHEDULE C (Form 1040) Department of the Treasury Internal Revenue Service (5)	**Profit or Loss From Business** (Sole Proprietorship) Partnerships, Joint Ventures, Etc., Must File Form 1065. ▶ Attach to Form 1040 or Form 1041. ▶ See Instructions for Schedule C (Form 1040).	OMB No 1545-0074 **1990** Attachment Sequence No. 09

Name of proprietor | Social security number (SSN)

A Principal business or profession, including product or service (see Instructions) | **B** Enter principal business code (from page 2) ▶

C Business name and address ▶ (include suite or room no.) ... | **D** Employer ID number (Not SSN)

E Accounting method: (1) ☐ Cash (2) ☐ Accrual (3) ☐ Other (specify) ▶..........................

F Method(s) used to value closing inventory: (1) ☐ Cost (2) ☐ Lower of cost or market (3) ☐ Other (attach explanation) (4) ☐ Does not apply (if checked, go to line H) **Yes No**

G Was there any change in determining quantities, costs, or valuations between opening and closing inventory? (If "Yes," attach explanation.) ____

H Are you deducting expenses for business use of your home? (If "Yes," see Instructions for limitations.) . . . ____

I Did you "materially participate" in the operation of this business during 1990? (If "No," see Instructions for limitations on losses.) ____

J If this is the first Schedule C filed for this business, check here . ▶ ☐

Part I Income

1	Gross receipts or sales. *Caution: If this income was reported to you on Form W-2 and the "Statutory employee" box on that form was checked. see the Instructions and check here* ▶ ☐	1
2	Returns and allowances	2
3	Subtract line 2 from line 1. Enter the result here	3
4	Cost of goods sold (from line 38 on page 2)	4
5	Subtract line 4 from line 3 and enter the **gross profit** here	5
6	Other income, including Federal and state gasoline or fuel tax credit or refund (see Instructions)	6
7	Add lines 5 and 6. This is your **gross income** ▶	7

Part II Expenses

8	Advertising	8	21 Repairs and maintenance . .	21	
9	Bad debts from sales or services (see Instructions)	9	22 Supplies (not included in Part III) .	22	
			23 Taxes and licenses	23	
10	Car and truck expenses (attach Form 4562)	10	24 Travel, meals, and entertainment:		
11	Commissions and fees . .	11	a Travel	24a	
12	Depletion	12	b Meals and entertainment .		
13	Depreciation and section 179 expense deduction (not included in Part III) (see Instructions). .	13	c Enter 20% of line 24b subject to limitations (see Instructions) .		
14	Employee benefit programs (other than on line 19)	14	d Subtract line 24c from line 24b	24d	
15	Insurance (other than health) .	15	25 Utilities	25	
16	Interest:		26 Wages (less jobs credit) . .	26	
a	Mortgage (paid to banks, etc.) .	16a	27a Other expenses (list type and amount):		
b	Other	16b		
17	Legal and professional services .	17		
18	Office expense.	18		
19	Pension and profit-sharing plans .	19		
20	Rent or lease (see Instructions):			
a	Vehicles, machinery, and equip. .	20a			
b	Other business property . .	20b	27b Total other expenses . . .	27b	

28	Add amounts in columns for lines 8 through 27b. These are your **total expenses** ▶	28
29	**Net profit or (loss).** Subtract line 28 from line 7. If a profit, enter here and on Form 1040, line 12. Also enter the net profit on Schedule SE, line 2 (statutory employees, see instructions). If a loss, you MUST go on to line 30 (fiduciaries, see instructions) .	29

30 If you have a loss, you MUST check the box that describes your investment in this activity (see Instructions).	30a ☐ All investment is at risk.
If you checked 30a, enter the loss on Form 1040, line 12, and Schedule SE, line 2 (statutory employees, see Instructions). If you checked 30b, you MUST attach Form 6198.	30b ☐ Some investment is not at risk.

For Paperwork Reduction Act Notice, see Form 1040 Instructions.

Business Tax Form (Continued)

Part III Cost of Goods Sold (See Instructions.)

31	Inventory at beginning of year. (If different from last year's closing inventory, attach explanation.)	31	
32	Purchases less cost of items withdrawn for personal use	32	
33	Cost of labor. (Do not include salary paid to yourself.)	33	
34	Materials and supplies	34	
35	Other costs	35	
36	Add lines 31 through 35	36	
37	Inventory at end of year	37	
38	Cost of goods sold. Subtract line 37 from line 36. Enter the result here and on page 1, line 4	38	

Part IV Principal Business or Professional Activity Codes

Locate the major category that best describes your activity. Within the major category, select the activity code that most closely identifies the business or profession that is the principal source of your sales or receipts. **Enter this 4-digit code on page 1, line B.** *For example, a grocery store is under the major category of "Retail Trade," and the code is "3210." (Note: If your principal source of income is from farming activities, you should file Schedule F (Form 1040), Farm Income and Expenses.)*

Construction

Code
0018 Operative builders (for own account)

General contractors
0034 Residential building
0059 Nonresidential building
0075 Highway and street construction
3889 Other heavy construction (pipe laying, bridge construction, etc.)

Building trade contractors, including repairs
0232 Plumbing, heating, air conditioning
0257 Painting and paper hanging
0273 Electrical work
0299 Masonry, dry wall, stone, tile
0414 Carpentering and flooring
0430 Roofing, siding, and sheet metal
0455 Concrete work
0885 Other building trade contractors (excavation, glazing, etc.)

Manufacturing, Including Printing and Publishing
0638 Food products and beverages
0653 Textile mill products
0679 Apparel and other textile products
0695 Leather, footware, handbags, etc.
0810 Furniture and fixtures
0836 Lumber and other wood products
0851 Printing and publishing
0877 Paper and allied products
1032 Stone, clay, and glass products
1057 Primary metal industries
1073 Fabricated metal products
1099 Machinery and machine shops
1115 Electric and electronic equipment
1883 Other manufacturing industries

Mining and Mineral Extraction
1511 Metal mining
1537 Coal mining
1552 Oil and gas
1719 Quarrying and nonmetallic mining

Agricultural Services, Forestry, Fishing
1933 Crop services
1958 Veterinary services, including pets
1974 Livestock breeding
1990 Other animal services
2113 Farm labor and management services
2212 Horticulture and landscaping
2238 Forestry, except logging
0836 Logging
2246 Commercial fishing
2469 Hunting and trapping

Wholesale Trade—Selling Goods to Other Businesses, Etc.

Durable goods, including machinery, equipment, wood, metals, etc.
2618 Selling for your own account
2634 Agent or broker for your own firm— more than 50% of gross sales on commission

Nondurable goods, including food, fiber, chemicals, etc.
2659 Selling for your own account

2675 Agent or broker for other firms— more than 50% of gross sales on commission

Retail Trade—Selling Goods to Individuals and Households
3012 Selling door-to-door, by telephone or party plan, or from mobile unit
3038 Catalog or mail order
3053 Vending machine selling

Selling From Showroom, Store, or Other Fixed Location

Food, beverages, and drugs
3079 Eating places (meals or snacks)
3086 Catering services
3095 Drinking places (alcoholic beverages)
3210 Grocery stores (general line)
0612 Bakeries selling at retail
3236 Other food stores (meat, produce, candy, etc.)
3251 Liquor stores
3277 Drug stores

Automotive and service stations
3319 New car dealers (franchised)
3335 Used car dealers
3517 Other automotive dealers (motorcycles, recreational vehicles, etc.)
3533 Tires, accessories, and parts
3558 Gasoline service stations

General merchandise, apparel, and furniture
3715 Variety stores
3731 Other general merchandise stores
3756 Shoe stores
3772 Men's and boys' clothing stores
3913 Women's ready-to-wear stores
3921 Women's accessory and specialty stores and furriers
3939 Family clothing stores
3954 Other apparel and accessory stores
3970 Furniture stores
3996 TV, audio, and electronics
3988 Computer and software stores
4119 Household appliance stores
4317 Other home furnishing stores (china, floor coverings, etc.)
4333 Music and record stores

Building, hardware, and garden supply
4416 Building materials dealers
4432 Paint, glass, and wallpaper stores
4457 Hardware stores
4473 Nurseries and garden supply stores

Other retail stores
4614 Used merchandise and antique stores (except motor vehicle parts)
4630 Gift, novelty, and souvenir shops
4655 Florists
4671 Jewelry stores
4697 Sporting goods and bicycle shops
4812 Boat dealers
4838 Hobby, toy, and game shops
4853 Camera and photo supply stores
4879 Optical goods stores
4895 Luggage and leather goods stores
5017 Book stores, excluding newsstands
5033 Stationery stores
5058 Fabric and needlework stores
5074 Mobile home dealers
5090 Fuel dealers (except gasoline)
5884 Other retail stores

Finance, Insurance, Real Estate, and Related Services
5520 Real estate agents or brokers
5579 Real estate property managers
5710 Subdividers and developers, except cemeteries
5538 Operators and lessors of buildings, including residential
5553 Operators and lessors of other real property
5702 Insurance agents or brokers
5744 Other insurance services
6064 Security brokers and dealers
6080 Commodity contracts brokers and dealers, and security and commodity exchanges
6130 Investment advisors and services
6148 Credit institutions and mortgage bankers
6155 Title abstract offices
5777 Other finance and real estate

Transportation, Communications, Public Utilities, and Related Services
6114 Taxicabs
6312 Bus and limousine transportation
6361 Other highway passenger transportation
6338 Trucking (except trash collection)
6395 Courier or package delivery services
6510 Trash collection without own dump
6536 Public warehousing
6551 Water transportation
6619 Air transportation
6635 Travel agents and tour operators
6650 Other transportation services
6676 Communication services
6692 Utilities, including dumps, snowplowing, road cleaning, etc.

Services (Personal, Professional, and Business Services)

Hotels and other lodging places
7096 Hotels, motels, and tourist homes
7211 Rooming and boarding houses
7237 Camps and camping parks

Laundry and cleaning services
7419 Coin-operated laundries and dry cleaning
7435 Other laundry, dry cleaning, and garment services
7450 Carpet and upholstery cleaning
7476 Janitorial and related services (building, house, and window cleaning)

Business and/or personal services
7617 Legal services (or lawyer)
7633 Income tax preparation
7658 Accounting and bookkeeping
7518 Engineering services
7682 Architectural services
7708 Surveying services
7245 Management services
7260 Public relations
7286 Consulting services
7716 Advertising, except direct mail
7732 Employment agencies and personnel supply
7799 Consumer credit reporting and collection services

7856 Mailing, reproduction, commercial art and photography, and stenographic services
7872 Computer programming, processing, data preparation, and related services
7922 Computer repair, maintenance, and leasing
7773 Equipment rental and leasing (except computer or automotive)
7914 Investigative and protective services
7880 Other business services

Personal services
8110 Beauty shops (or beautician)
8318 Barber shop (or barber)
8334 Photographic portrait studios
8532 Funeral services and crematories
8714 Child day care
8730 Teaching or tutoring
8755 Counseling (except health practitioners)
8771 Ministers and chaplains
6882 Other personal services

Automotive services
8813 Automotive rental or leasing, without driver
8839 Parking, except valet
8953 Automotive repairs, general and specialized
8896 Other automotive services (wash, towing, etc.)

Miscellaneous repair, except computers
9019 TV and audio equipment repair
9035 Other electrical equipment repair
9050 Reupholstery and furniture repair
2881 Other equipment repair

Medical and health services
9217 Offices and clinics of medical doctors (MDs)
9233 Offices and clinics of dentists
9258 Osteopathic physicians and surgeons
9241 Podiatrists
9274 Chiropractors
9290 Optometrists
9415 Registered and practical nurses
9431 Other health practitioners
9456 Medical and dental laboratories
9472 Nursing and personal care facilities
9886 Other health services

Amusement and recreational services
8557 Physical fitness facilities
9597 Motion picture and video production
9688 Motion picture and tape distribution and allied services
9613 Videotape rental
9639 Motion picture theaters
9670 Bowling centers
9696 Professional sports and racing, including promoters and managers
9811 Theatrical performers, musicians, agents, producers, and related services
9837 Other amusement and recreational services

Social Security Tax Form

Name of person with **self-employment** income (as shown on Form 1040)	Social security number of person with **self-employment** income ▶

Who Must File Schedule SE

You must file Schedule SE if:

- Your net earnings from self-employment were $400 or more; **OR**
- You were an employee of an electing church or church-controlled organization that paid you wages (church employee income) of $100 or more;

 AND

- Your wages (subject to social security or railroad retirement tax) were less than $51,300.

Exception: If your only self-employment income was from earnings as a minister, member of a religious order, or Christian Science practitioner, AND you filed **Form 4361** and received IRS approval not to be taxed on those earnings, DO NOT file Schedule SE. Instead, write "Exempt–Form 4361" on Form 1040, line 48.

For more information about Schedule SE, see the Instructions.

Note: *Most people can use the short Schedule SE on this page. But, you may have to use the longer Schedule SE on the back.*

Who MUST Use the Long Schedule SE (Section B)

You must use Section B if ANY of the following apply:

- You elect the "optional method" to figure your self-employment tax (see Section B, Part II, and the Instructions);
- You are a minister, member of a religious order, or Christian Science practitioner and you received IRS approval (from **Form 4361**) not to be taxed on your earnings from these sources, but you owe self-employment tax on other earnings;
- You had church employee income of $100 or more that was reported to you on Form W-2;
- You had tip income that is subject to social security tax, but you did not report those tips to your employer; OR
- You were a government employee with wages subject ONLY to the 1.45% Medicare part of the social security tax (Medicare qualified government wages) AND the total of **all** of your wages (subject to social security, railroad retirement, or the 1.45% Medicare tax) plus **all** your earnings subject to self-employment tax is **more** than $51,300.

Section A—Short Schedule SE (Read above to see if you must use the long Schedule SE on the back (Section B).)

1	Net farm profit or (loss) from Schedule F (Form 1040), line 36, and farm partnerships, Schedule K-1 (Form 1065), line 15a	**1**		
2	Net profit or (loss) from Schedule C (Form 1040), line 29, and Schedule K-1 (Form 1065), line 15a (other than farming). See Instructions for other income to report.	**2**		
3	Combine lines 1 and 2. Enter the result	**3**		
4	Multiply line 3 by .9235. Enter the result. If the result is less than $400, **do not** file this schedule; you **do not** owe self-employment tax ▶	**4**		
5	Maximum amount of combined wages and self-employment earnings subject to social security or railroad retirement (tier 1) tax for 1990	**5**	$51,300	00
6	Total social security wages and tips (from Form(s) W-2) and railroad retirement compensation (tier 1). **Do not** include Medicare qualified government wages on this line	**6**		
7	Subtract line 6 from line 5. Enter the result. If the result is zero or less, **do not** file this schedule; you **do not** owe self-employment tax ▶	**7**		
8	Enter the **smaller** of line 4 or line 7	**8**		
9	Rate of tax .	**9**	×.153	
10	**Self-employment tax.** If line 8 is $51,300, enter $7,848.90. Otherwise, multiply the amount on line 8 by the decimal amount on line 9 and enter the result. Also enter this amount on Form 1040, line 48 . **Note:** *Also enter one-half of this amount on Form 1040, line 25.*	**10**		

For Paperwork Reduction Act Notice, see Form 1040 Instructions.　　　　　　　　　　　　　　　　**Schedule SE (Form 1040) 1990**

Social Security Tax Form (Continued)

Schedule SE (Form 1040) 1990	Attachment Sequence No. **17**		Page **2**
Name of person with **self-employment** income (as shown on Form 1040)	Social security number of person with **self-employment income** ▶		

Section B—Long Schedule SE (Before completing, see if you can use the short Schedule SE on the other side (Section A).)

A If you are a minister, member of a religious order, or Christian Science practitioner, AND you filed **Form 4361,** but you had $400 or more of **other** earnings subject to self-employment tax, continue with Part I and check here ▶ ☐

B If your only income subject to self-employment tax is church employee income and you are not a minister or a member of a religious order, skip lines 1 through 4b. Enter -0- on line 4c and go to line 6a. But **do not** include your church employee income on line 6a.

Part I Social Security Self-Employment Tax

1	Net farm profit or (loss) from Schedule F (Form 1040), line 36, and farm partnerships, Schedule K-1 (Form 1065), line 15a. (**Note:** Skip this line if you elect the farm optional method. See requirements in Part II below and in the Instructions.)	**1**		
2	Net profit or (loss) from Schedule C (Form 1040), line 29, and Schedule K-1 (Form 1065), line 15a (other than farming). See Instructions for other income to report. **Do not** include church employee income from Form W-2 on this line. (**Note:** Skip this line if you elect the nonfarm optional method. See requirements in Part II below and in the Instructions.)	**2**		
3	Combine lines 1 and 2. Enter the result	**3**		
4a	If line 3 is more than zero, multiply line 3 by .9235. Otherwise, enter the amount from line 3 here .	**4a**		
b	If you elected one or both of the optional methods, enter the total of lines 12 and 14 here	**4b**		
c	Combine lines 4a and 4b. If less than $400, **do not** file this schedule; you **do not** owe self-employment tax. (**Exception:** If less than $400 and you had church employee income, enter -0- and continue.) . ▶	**4c**		
5	Maximum amount of combined wages and self-employment earnings subject to social security or railroad retirement (tier 1) tax for 1990	**5**	$51,300 00	
6a	Total social security wages and tips (from Form(s) W-2) and railroad retirement compensation (tier 1). **Do not** include Medicare qualified government wages or church employee income on this line **6a**			
b	Unreported tips subject to social security tax (from Form 4137, line 9) or railroad retirement tax (tier 1) **6b**			
c	Add lines 6a and 6b. Enter the total.	**6c**		
7a	Subtract line 6c from line 5. If zero or less, **do not** file this schedule; you **do not** owe self-employment tax . ▶	**7a**		
b	Enter your church employee income from Form W-2 of $100 or more . . . **7b**			
c	Multiply line 7b by .9235 (if the result is less than $100, enter -0-) . . . **7c**			
d	Add lines 4c and 7c. Enter the total ▶	**7d**		
8	Enter the **smaller** of line 7a or line 7d	**8**		
9	Enter your Medicare qualified government wages. See Instructions to see if you must use the worksheet in the Instructions to figure your self-employment tax . **9**			
10	Self-employment tax. If line 8 is $51,300, enter $7,848.90 Otherwise, multiply line 8 by .153 and enter the result. Also enter this amount on Form 1040, line 48 **Note:** Also enter one-half of this amount on Form 1040, line 25.	**10**		

Part II Optional Method To Figure Net Earnings (See "Who Can File Schedule SE" in the Instructions.)

See Instructions for limitations. Generally, you may use this part only if:

A Your **gross farm income**[1] was not more than $2,400; **or**
B Your **gross farm income**[1] was more than $2,400 and your **net farm profits**[2] were **less** than $1,733; **or**
C Your **net nonfarm profits**[3] were less than $1,733 and also **less** than two-thirds (⅔) of your **gross nonfarm income.**[4]

11	Maximum income for optional methods	**11**	$1,600 00
12	**Farm Optional Method**—If you meet test A or B above, enter the **smaller** of: two-thirds (⅔) of gross farm income[1] or $1,600. Also include this amount on line 4b above	**12**	
13	Subtract line 12 from line 11. Enter the result	**13**	
14	**Nonfarm Optional Method**—If you meet test C above, enter the **smallest** of: two-thirds (⅔) of gross nonfarm income[4] or $1,600; **or,** if you elected the farm optional method, the amount on line 13. Also include this amount on line 4b above	**14**	

[1]From Schedule F (Form 1040), line 11, and Schedule K-1 (Form 1065), line 15b. [3]From Schedule C (Form 1040), line 29, and Schedule K-1 (Form 1065), line 15a.
[2]From Schedule F (Form 1040), line 36, and Schedule K-1 (Form 1065), line 15a. [4]From Schedule C (Form 1040), line 7, and Schedule K-1 (Form 1065), line 15c.

For Paperwork Reduction Act Notice, see Form 1040 Instructions. Schedule SE (Form 1040) 1990

Appendix VI

Equity Franchise Agents

Affiliate Artists Inc.
37W. 65th Street
New York, NY 10023
 (212) 580-2000
 Carol Wolff, Dir.

Agency For The Performing Arts
888 Seventh Av.
New York, NY 10106
 (212) 582-1500
 Harvey Litwin

Alexander Artists Management
13906 Ventura Bl, Ste 184
Sherman Oaks, CA 91423
 (818) 785-1185

Alkahest Agency
P.O. Box 12403, Northside Stn.
Atlanta, GA 30355
 (404) 237-1540
 Scott Bridges, Pres.

Allegheny Artists
7520 Kensington St.
Pittsburgh, PA 15221
 (412) 242-6699
 Eva Tumiel-Kozak, Dir.

Allied Artists Bureau
170 W. 74th Street
New York, NY 10023
 (212) 874-3990
 Michael Leavitt, Man. Dir.

American Artists Management, Inc.
801 West End Avenue, Ste 12A
New York, NY 10025
 (212) 222-3770
 Sophy Haynes, Pres.

American International Artists
515 E. 89th St., Ste 6B
New York, NY 10128
 (212) 996-6131
 Cynthia B. Herbst, Dir

Ancel Artists
15 W. 44th Street, Ste 303
Paramus, NJ 07653-1753
 (201) 447-5764

Artist Management Services
305 Hamilton Avenue
Silver Springs, MD 20901
 (301) 565-8011
 Lois E. Groner

Berkeley Agency
2490 Channing Way, Ste 406
Berkeley, CA 94704
 (415) 843-4902

Blade Agency
P.O.Box 1556
Gainesville, FL 32602
 Charles Steadman, Owner

Blues Management Group
2613 S. 51st Street
Milwaukee, WI 53219
 (414) 321-0188
 Tom Radai

Bravo Artist Management, Inc.
333 Taylor Av., N, Ste 202
Seattle, WA 98109
 (206) 728-2787

Broadway Artists Management
99 64th Avenue
Rego Park, NY 11374
 (718) 897-6471
 Sioma Glaser, Coord.

California Artists Management
1182 Market St., Suite 418
San Francisco, CA 94102
 (415) 861-2787

CCS International
2531 S. Westgate Av.
Los Angeles, CA 90064
 (213) 313-1318
 Carol Cunning, Mgr.

Chicago Concert Artists
431 S. Dearborn St., Suite 906
Chicago, IL 60605
 (312) 663-6434

Classical Artists International
1995 Broadway, Suite 901
New York, NY 10023
 (212) 769-0099

Columbia Artists Management
4605 Lankershim Bl, Suite 421
North Hollywood, CA 91602
 (818) 766-7177

Colwell Arts Management
R.R. #1
New Hamburg, Ontario N0B 2G0
Canada
 Jane Colwell, Dir.

Concert Artists Guild
850 7th Av., Suite 1003
New York, NY 10019
 (212) 333-5200

Dance Connection
P.O. Box 8021
W. Bloomfield, MI 48304
 (313) 682-0151

Douglass Associates
26 Russ Street
Hartford, CT 06106
 (203) 527-4980
 Phillip A. Douglass

DSI Theatrical Productions
660 NE 139th Street
North Miami, FL 33161
 (305) 891-4449

Eckstein Management Co.
7356 Malvern Av.
Philadelphia, PA 19151
 (215) 463-4840

Feuchtenberger Management
P.O. Box 22456
Baltimore, MD 21203
 (703) 326-1491

Florid a Artists Management
8769 Como Lake Drive
Jacksonville, FL 32216-8431
 (904) 353-3264
 Karen Armel

Folklore Productions, Inc.
1671 Appian Way
Santa Monica, CA 90401
 (213) 451-0767
 Manny Greenhill, Pres.

For The Arts
33 E. 60th Street
New York, NY 10022
 (212) 752-7812
 Steven Keith

FREE STREET THEATER
441 W. North Avenue
Chicago, IL 60610
 (312) 642-1234

Frothingham Management
40 Grove Street, 4th Flr.
Wellesley, MA 02181
 (617) 237-6141
 Gelsey T. Frothingham

General Arts Management, Inc.
651 Queen Street East
Toronto, ON M4M 1G4 CANADA
 (416) 461-0301

Gershunoff Attractions, Inc.
502 Park Avenue
New York, NY 10022
 (212) 548-1776
 Maxim Gershunoff

Global Artists
18 W. State Street
Savannah, GA 31401
 (912) 233-8819

Golden Pen Artist Management
355 Waterford Street
Pacifica, CA 94044
 (415) 355-0282

Goldston Mime Foundation
P.O. Box 02189
Columbus, OH 43202
 (614) 263-6096
 Greg Goldston, Art. Dir.

Gowanus Arts Exchange
295 Douglass Street
Brooklyn, NY 11217
 (718) 596-5250

Great Lakes Performing
Artists Associates
505 E. Huron, Suite 301
Ann Arbor, MI 48104
 (313) 665-4029
 Constance Barron, Exec. Dir.

Harlequin Enterprises
366 Avon Drive
Pittsburgh, PA 15228
 (412) 563-0468

Hart Associates
105 Shady Lane
Randolph, NJ 07869
 (201) 895-3356

Hartstein Personal Management
8822 Evanview Drive
Los Angeles, CA 90069
 (213) 855-0640

Heartland Artservices
6641 Linden Road
Kansas City, MO 64113
 (816) 361-3437
 Madelyn Voigts, Pres.

Hot Foot Agency
73 Academy Road
Bala-Cynwyd, PA 19004
 (215) 564-0820
 Lis Braun, Dir.

Ibbs & Tillett, LTD.
18B Pindock Mews
London, W9 2PY
United Kingdom
 (01) 266-2687

ICM Artists, Ltd.
40 W. 57th Street
New York, NY 10019
 (212) 556-5677

International Artist Management
105 72 Jason Lane
Columbia, MD 21044
 (301) 997-5080
Adrienne Newberg

International Artist Alliance
P.O. Box 131
Springfield, VA 22150
 (703) 451-1662

International Artists Productions
Thielallee 21 E
1000 Berlin, 33
Federal Republic Of Germany
(49) 30-8327701
Eva F. Maze, Dir.

International Booking Agency
3 Avenue Florimont
CH 1820 Montreux
Switzerland
(41) 21-9638895

International Concert Management
Vorosmarty ter 1
H-1368, P.O. Box 239
Budapest, 1051
Hungary
176-222

International Production Associates
853 Broadway, Rm 2120
New York, NY 10003
(212) 505-1688
Jebediah Wheeler, Dir.

Jensen Artists Management
716 Joseph Vance Bldg.
Seattle, WA 98101
(206) 622-7896
Helen Jensen, Mgr.

Howard Agency
P.O. Box 1210
Hamilton, OH 45012
(513) 829-6790

Jon Associates
18662 Fairfield Avenue
Detroit, MI 48221
(313) 861-6930

Joyce Agency, Inc.
370 Harrison Avenue
Harrison, NY 10528
(914) 835-5643
Van Joyce, Pres.

Kaplan, Inc.
115 College Street
Burlington, VT 05401
(802) 658-2592
Melvin Kaplan, Pres.

Karlsrud Concerts, Inc.
948 The Parkway
Mamaroneck, NY 10543
(914) 698-3535
Edmond Karlsrud, Pres.

Keller Management
P.O. Box 19328 A
Los Angeles, CA 90019
(213) 737-4564
David Keller, Mgr.

William Knight
Grant House
309 Wood Street
Burlington, NJ 08016-4407
(609) 386-3933

Komar Management
1122 West Street
Oceanside, CA 92054
(619) 722-1181
Marilyn Lambson, Dir.

Kunstlersekretariat
Rudolf Buchmann
Schachnerstrasse 27
A-1220 Vienna, 1220
Austria
(0222) 236357

Kurland Associates
173 Brighton Avenue
Boston, MA 02134
 (617) 254-0007

Kyra Artists Management
104 Magazine Street
Cambridge, MA 02139
 (617) 868-0440
 Nancy J.Barker

Matthew Lafer Artists
Management
410 W. 24th St., Suite 21
New York, NY 10011
 (212) 929-7429

Lampl Management
16 Cherry Lane Drive
Englewood, CO 80110
 (303) 758-0253
 Rosalie Lampl, Mgr.

Latitude 45 Artists Promotion
109 Boul. St. Joseph West
Montreal, PQ H2T 2P7
Canada
 (514) 276-2696
 Barbara Scales, Dir.

LDP Artists Management
P.O. Box 3253
Boulder, CO 80303
 (303) 494-8934

Leiser Artists Management
Dorchester Towers
155 W. 68th Street
New York, NY 10023
 (212) 595-6414
 Jacques Leiser, Pres.

Lew Artists Representative
204 W. 10th Street
New York, NY 10014
 (212) 243-4191

Lieberman Agency
2333 Pontius Avenue
Los Angeles, CA 90064
 (213) 312-1648
 David Lieberman

Liegner Management
P.O. Box 884
New York, NY 10023
 (212) 496-1515
 Judith Leigner

Lindsey Artist Services
943 Quintara Street
San Francisco, CA 94116
 (415) 759-6410
 Gary Lindsey, Dir.

Living Art- Impresariat
9 Boulevard Montmartre
75002 Paris, FRANCE
 (42) 36.36.32
 Angelika Belamaric

Living Arts, Inc.
250 W. 57th Street
New York, NY 10019
 (212) 765-7777

Lombardo Associates
One Harkness Plaza
61 W. 62nd St., Suite 6F
New York, NY 10023
 Robert Lombardo

Lordly & Dame
51 Church Street
Boston, MA 02116
 (617) 482-3593

Lorraine Productions
2269 Ocean Avenue
Brooklyn, NY 11229
 (718) 336-9032

Maikin Agency
651 Colonial Bl., Westward P.O.
Washington Township, NJ 07675
 (201) 666-4400
 Seymour Maikin

Mainstage Management International
7150 Princeton
St. Louis, MO 63136
 (314) 725-5051

Malama Arts, Inc.
P.O. Box 1761
Honolulu, HI 96806
 (808) 329-5828

Management Support Associates
P.O. Box 92222
Milwaukee, WI 53202
 (414) 374-5599
 Marc Haupert, Pres.

Maple Hill Productions
P.O. Box 16
Hillsboro, NH 03244
 (603) 464-3776

Marimba Productions, Inc
P.O. Box 467
Asbury Park, NJ 07712
 (201) 774-0088

Marotta Associates
9 Fairview Avenue
Watertown, MA 02172
(617) 924-3336
Paul Marotta, Dir.

Martin Personal Management
Pinehurst, NC 28374
(919) 295-3303
Lindy S. Martin, Pres.

Masterwork Music & Art Foundation
Morristown, NJ 07962-1436
(201) 543-3212
Shirley S. May

Metropolitan Artists Management
140 West End Avenue, Suite 3K
New York, NY 10023
(212) 799-5989

William Morris Agency
1350 Avenue of the Americas
New York, NY 10019
(212) 586-5100
 or:
151 El Camino Drive
Beverly Hills, CA 90212
(213) 274-7451
 or:
2325 Crestmore Road
Nashville, TN 37215
(615) 385-0310

Munro Artists Management
858 Rock O'Dundee Road
South Darmouth, MA 02748
(508) 997-4282
Martha Munro, Pres.

Murtagh/Mc Farlane Artists, Inc.
3269 W. 30th Street
Cleveland, OH 44109
(216) 398-3990

Music International
13 Ardilaun Road
Highbury
London, N5 2QR
United Kingdom
(01) 226-9792

Musical Arrangements, Ltd.
16115 Onaway Road
Cleveland, OH 44120
(216) 561-6842

National Artists Management
165 W. 46th Street, Suite 1202
New York, NY 10036
(212) 575-1044
Susan Weaving

Andres Neumann International
Casella Postale 714
Rome, Italy
(39 6) 6547760

New Aspect Promotions
5F, 200 Hsin-yi Road
Taipei, Taiwan
(02) 735-7371
Hsu Po-Yun, Pres.

NY Artists Bureau, Inc.
170 West End Avenue, 3N
New York, NY 10023
 (212) 799-4445
 Clyde Kreutzer, Pres.

O'Donnell Management
2677 Datura Street
Sarasota, FL 34239
 (813) 365-2484

O'Malley & Associates
P.O. Box 9188
Colorado Springs, CO 80932
 (303) 635-7776

Optimum Promotions, Ltd
12 Natalie Street
Nelson, New Zealand
 (054) 82-934

Overture Concerts
207-5740 Cambie Street
Vancouver, BC V5Z 3A6
Canada
 (604) 325-0202

Adrienne Pardo De Zela
622 Esplanade
New Orleans, LA 70116
 (504) 581-5262

Parsons Artists Management
P.O. Box 160
Highland Park, IL 60035
 (312) 831-5020

Peel And Smith Management
155 W. 72nd Street, Suite 605
New York, NY 10023
(212) 496-9121

Pentacle
104 Franklin Street
New York, NY 10013
 (212) 226-2000
 Ivan Sygoda & Mara Greenberg, Dirs.

Perfect Pitch Artist Management
2614 Madeline Street
Oakland, CA 94602
 (415) 482-1299
 Willa Rabinovitch, Dir.

Performing Artist Associates
10 Puritan Park
Swampscott, MA 01907-2423
 (617) 783-2060

Performing Arts Consultants
295 Huntington Av, Suite 208
Boston, MA 02115
 Robin Wheeler, Pres.

Performing Arts Foundation
International House
500 Riverside Drive
New York, NY 10027
 (212) 316-8430
 Herman Rottenberg, Pres.

Perper Services
200 E. Royal Palm Road
Boca Raton, FL 33432
 (407) 338-5185
 Kay Perper, Dir.

Polara
P.O. Box 23951
Pleasant Hill, CA 94523
 (415) 676-3355

Pragokoncert
Maltezske nam. 1
118 13 Prague 1
Czecho-slovakia

Primo Artist Management
127 Jefferson Road
St. Louis, MO 63119
 (314) 968-9027

Propinquity Management
P.O. Box 9036
Denver, CO 80209
 (303) 722-6812

Ragsdale & Associates
2800 Euclid Av, #500
Cleveland, OH 44115
 (216) 781-7624
 Oliver Ragsdale

Rile Artists Management
100 Old York Road
Benson East, Suite 1206
Jenkintown, PA 19046-3613
 (215) 885-6400
 Joanne Rile, Pres.

Roettger & Associates
3809 De Longpre Ave.
Los Angeles, CA 90027
 (213) 665-6444

Rohr Artists' Management
775 Pleasant Street
Boulder, CO 80302
 (303) 443-0710
 Joyce Rohr, Dir.

Rosebud Agency
P.O. Box 210103
San Francisco, CA 94121
 (415) 386-3456

Royce Carlton, Inc.
866 United Nations Plaza
New York, NY 10017
 (800) 532-8873
 Carlton Sedgeley, Pres.

Safimm Corp.
250 W. 57th St., Suite 1018
New York, NY 10107
 (212) 333-2600
 Peter H. Hauser

Salomon Artists Management
8301 Penobscot Road
Richmond, VA 23227
 (804) 264-0123
 Leon I. Salomon

SF International Arts Mgmt
231 Franklin St., Suite 6
San Francisco, CA 94102
 (415) 861-0315

Sanfield Management
31550 Stonewood Court
Farmington Hills, MI 48018
 (313) 626-0948

Seearts Management
P.O. Box 206
Port Jefferson, NY 11777
 (516) 821-9462

Ruth Shahar Concert Mgmt.
62 Ben Gurion Blvd
Tel Aviv, 64589 Israel
(03) 224922

Shaw Concerts, Inc.
1 Lincoln Plaza, 2nd Flr
1900 Broadway
New York, NY 10023
(212) 595-1909
Harold Shaw, Pres.

Showcase Associates, Inc.
911 Cypress Avenue
Philadelphia, PA 19117
(215) 884-6205

Siegel Artist Management
3003 Van Ness St., NW, Ste W205
Washington DC 20008
(202) 966-0003
Ethel Siegel, Dir.

Simmons Artist Management
3285 Enderby Road
Cleveland, OH 44120
(216) 283-4648
Beverly Simmons, Pres.

Simonds Management
30 Hewlett Street
Waterbury, CT 06710
(203) 574-3349

Sky's The Limit, Unlimited
22 Lois Avenue
Demarest, NJ 07627
(201) 767-8704
James J. Seiler, Pres.

Soho Booking
625 Broadway, 8th Flr
New York, NY 10012
(212) 473-5666

SRO Artists
P.O. Box 9532
Madison, WI 53715
(608) 256-9000
Jeffrey C. Laramie

SRO Productions, Inc.
821 Marquette Av., #1815
Minneapolis, MN 55402
(612) 341-4110
Larry Berle, Pres.

Tandem Arts Management
115 Chelmsford Road
Rochester, NY 14618
(716) 266-6374
D.C. Kennedy, Dir.

Theatour
P.O. Box 408
Ginger Road
High Falls, NY 12440
(914) 687-7522
Howard Crampton-Smith

Theta Production Associates
P.O. Box 4187
Portland, OR 97208
(503) 231-9407

Treen Artists Management
1221 Scott Road
Burbank, CA 91504
(818) 846-6869

Triad Artists, Inc.
10100 Santa Monica Bl, 16th Flr
Los Angeles, CA 90067
 (213) 556-2727

TRM Management, Inc.
825 S. Lazelle Street
Columbus, OH 43206
 (614) 444-0033

Truckenbrod Concert Artists
P.O. Box 69
West Hartford, CT 06107
 (203) 233-5858
 Phillip Truckenbrod, Co-Dir.

United Arts
3906 Sunbeam Drive
Los Angeles, CA 90065
 (213) 256-7828
 Linda Chiavaroli, Pres.

Universal Artists Management
401 5th Avenue
New York, NY 10016
 (212) 889-3044
 Caroline Betancourt

Venture West
1364 Dahlia
Denver, CO 80220
 (303) 399-1905
 James Schwartzkopff, Rep.

Vermont Recital Associates
35 Proctor Avenue
South Burlington, VT 05403
 (802) 862-6344

Villa-Roiz Management
Ave. Coyoacon 627
Mexico City, Mexico
 (5) 23-0385/ 15-1952

W.S.A. Artist Management
9103 Summer Glen Lane
Dallas, TX 75243
 (214) 341-1911

Weinstein Arts Management
347 Varick St., Suite 418A
Jersey City, NJ 07302
 (201) 860-9552

Wentworth Associates, Ltd.
Lincoln Bldg, Suite 503
100 Stevens Avenue
Mount Vernon, NY 10550
 (914) 667-0784

Western & Southern Arts Assocs.
P.O. Box 50120
Austin, TX 78763
 (512) 477-1859

Willens Entertainment
31 E. 20th Street, 2F
New York, NY 10003
 (212) 674-7544

Winthrop International
1995 Broadway
New York, NY 10023
 (212) 496-9450
 Paul Bongiorno, Div. Dir.

Young Concert Artists, Inc.
250 W. 57th St., Suite 921
New York, NY 10019
 (212) 307-6655
 Susan Wadsworth, Dir.

Zajonc Management
P.O. Box 7023
Ann Arbor, MI 48107
 (313) 662-9137

Appendix VII

Offices Of American Federation Of Television And Radio Artists

California
P.O. Box 11961
Fresno, CA 93776

6922 Hollywood Boulevard, Suite 811
Hollywood, CA 90028

2413 Capitol Avenue
Sacramento, CA 95816

7827 Convoy Court, Suite 400
San Diego, CA 92111

100 Bush Street
San Francisco, CA 94104

Colorado
950 South Cherry, Suite 502
Denver, CO 80222

Connecticut
117 Prospect Street
Stamford, CO 06901

Florida
20401 N.W. Second Avenue, Suite 102
Miami, FL 33169

Georgia
1627 Peachtree Street, N.W., Suite 210
Atlanta, GA 30309

Hawaii
> 1127 Eleventh Avenue, Suite 205
> Honolulu, HI 96816

Illinois
> 307 North Michigan Avenue
> Chicago, IL 60601
>
> 2907 Springfield Road
> East Peoria, IL 61611

Kentucky
> 410 South Third Street
> Louisville, KY 40202

Louisiana
> 2475 Canal Street, Suite 108
> New Orleans, LA 70119

Massachusetts
> 11 Beacon Street
> Boston, MA 02108

Michigan
> 28690 Southfield Road
> Latrup Village, MI 48076

Minnesota
> 15 South Ninth Street, Suite 400
> Minneapolis, MN 55402

Missouri
> 406 West 34th Street, Suite 206
> Kansas City, MO 64111
>
> 906 Olive Street, Suite 1006
> St. Louis, MO 63101

Nebraska
> P.O. BOx 31103
> Omaha, NE 68131

New York

341 Northern Boulevard
Albany, NY 12204

c/o W.I.V.B. Television
2077 Elmwood
Buffalo, NY 14207

260 Madison Avenue
New York, NY 10016

Chamberlain, D-Amanda
1600 Crossroads Building
Rochester, NY 14614

170 Ray Avenue
Schenectady, NY 12304

Ohio

1367 East 6th Street, Suite 229
Cleveland, OH 44114

Oregon

516 S.E. Morrison, M-3
Portland, OR 97214

Pennsylvania

230 South Broad Street, 10th Floor
Philadelphia, PA 10192

625 Stanwix Street, Penthouse
Pittsburgh, PA 15222

Tennessee

1108 Seventeenth Avenu, South
Nashville, TN 37212

Texas

6060 N. Central Expressway, Suite 302
Dallas, TX 75206

Washington
P.O. Box 9688
601 Valley Street, Suite 200
Seattle, WA 98109

Washington, D.C.
Highland House
5840 Wisconsin Avenue, SUite 201
Chevy Chase, MD 20815

Wisconsin
929 52nd Street
Kenosha, WI 53140

American Guild of Musical Artists (AFL—CIO)

National office:
1727 Broadway
New York, NY 10019-5284
 (212) 265-3687
 Sanford I. Wolff, Exec. Secretary

Regional offices:
Chicago:
343 S. Dearborn, Thirteenth Floor
Chicago, IL 60604
 (312) 922-2800
 Barbara J. Hillman

New Orleans:
619 N. Hennesey Street
Jefferson, LA 70119
 (504) 486-9410
 Rosemary Le Boeuf

Los Angeles:
15060 Ventura Boulevard
Sherman Oaks, CA 91403
 (818) 907-8986
 Dennis Moss

Northwest:
6228 Lake View Drive
Kirkland, WA 98033
 (206) 889-0330
 Carolyn Carpp

New England:
ll Beacon Street
Boston, MA 02108
 (617) 742-0206
 Robert M. Segal

Philadelphia:
Lafayette Building, 8th floor
5th and Chestnut Streets
Philadelphia, PA 19106
 (215) 925-8400
 Mark P. Muller

San Francisco:
235 Pine Street
San Francisco, CA 94104
 (415) 986-4060
 Ann Sebastian
 Donald Tayer

Texas:
3915 Fairlakes Drive
Dallas, TX
 (214) 328-2033
 Benny Hopper

Washington, D.C.:
913 Sixteenth Street, N.W., Suite 503
Washington, DC 20006
 (202) 429-0221
 Joshua J. Kaufman

Offices of Screen Actors Guild (SAG)

Arizona
1616 East Indian School Road, Suite 380
Phoenix, AZ 85016

California
7065 Hollywood Boulevard
Hollywood, CA 90028-6065

7827 Convoy Court, Suite 400
San Diego, CA 92111

100 Bush Street, 16th Floor
San Francisco, CA 94104

Colorado/Nevada/New Mexico/Utah
950 South Cherry Street
Denver, CO 80222

Florida
2299 Douglas Road, Suite 200
Miami, FL 33145

3393 West Vine Street, Suite 302
Kissimmee, FL 34741

Georgia
1627 Peachtree Street, N.E.
Atlanta, GA 30309

Hawaii
949 Kapiolani Boulevard, Suite 105
Honolulu, HI 96814

Illinois
307 North Michigan Avenue, Suite 312
Chicago, IL 60601

Maryland
5480 Wisconsin Avenue, Suite 201
Chevy Chase, MD 20815

Massacusetts
11 Beacon Street, Suite 512
Boston, MA 02108

Michigan
28690 Southfield Road, Suite 290A
Lathrup Village, MI 48076

Minnesota
15 South Ninta Street, Suite 400
Minnestota, MN 55402

Missouri
906 Olive Street, Suite 1006
St. Louis, MO 63101

New York
551 Fifth Avenue
New York, NY 87501

Ohio
1367 East Sixth Street
Cleveland, OH 44114

Pennsylvania
230 South Broad Street, Tenth Floor
Philadelphia, PA 19102

Tennessee
1108 Seventeenth Avenue, South
Nasthville, TN 37212

Texas
6309 North O'Connor Road
Irving, TX 75039

Washington
601 Valley Street, Suite 200
Seattle, WA 98109

Appendix VIII

Selected Theatre Publications

Academy Players Directory
89459 Wilshire Boulevard, 6th floor
Beverly Hills, CA 90211-1972
(213) 247-3058

Published three times annually, Academy Players Directory contains headshots of actors and actresses who are union members, as well as information regarding their agents, management, etc. The Directories are distributed without charge to casting directors and producers and are a vital source of information for potential employers. In New York, request the Players Guide, 165 W. 46th Street, New York, New York.

Audition News
6114 W. North Avenue
Chicago, IL 60639
(312) 637-4695

Published 10 times yearly, *Audition News* lists employment oppor-tunities for theatre, dance, music, Equity and non-Equity theatre designers and administrators. Geared primarily for the mid-West.

Back Stage Magazine
205 W. Randolph
Chicago, IL 60606
(312) 236-9102

Weekly trade paper with excellent coverage of local and current casting for TV, legitimate theatre, movie, commercials, etc. Published weekly in New York, Chicago, and Los Angeles.

Back Stage Publications
330 W. 42nd Street
New York, NY 10036
Prints weekly updates on theater in New York.

Business Committee for the Arts
1775 Broadway, Suite 510
New York, NY 10019
Prints business news journal on arts and funding.

Call Board
2940 16th Street #102
San Francisco, CA
Theatre Bay Area publication offers audition notices and pertinent information to members in it's newsletter.

Daily Variety
3700 Wilshire Boulevard
Hollywood, CA 90028
(213) 857-6600
Carries casting notices and publishes financial information on the entertainment industry. Published weekly in New York, daily in Los Angeles.

Drama-Logue
P.O. Box 38771
Hollywood, CA 90038
An excellent resource covering legitimate theatre and film, T.V. and commercial casting. Interesting articles and interviews.

Dramatists Sourcebook
Foreward by David Henry Hwang
Assistant Editor by Amlin Gray
An annual guide to professional theatre opportunities for the playwright, translator, composer, librettist or lyricist. The 1989-90 edition has over 800 listings.

High Performance
Edited By Steven Durland
240 South Broadway, Fifth Floor
Los Angeles, CA 90012
Monthly Magazine that features articles on new experimental works in theatre.

Hollywood Reporter (HR Industries)
6715 Sunset Boulevard
Hollywood, CA 90028
Daily trade publications dealing with all aspects of the industry,
primarily Business news.

League Of Chicago Theatres Bulletin
67 E. Madison
Chicago, IL 60606
(312) 977-1730

Pacific Coast Studio Directory
6331 Yucca Street
Hollywood, CA 90028
(213) 467-2920
Published quarterly, the Studio Directory lists advertising
agencies, casting directors, producers, services, unions,
organizations, labor offices, etc. Available through subscription
or at news stands.

The Ross Report
40 - 29 27th Street
Long Island, NY
(718) 937-3990
A much recommended booklet containing names of casting
directors, advertising agencies, etc.

Show Business
1501 Broadway
New York, NY 10036
New York trade published weekly with casting notices,
information. Available on newstands or by subscription.

Variety
154 West 46th Street
New York, NY 10036
(212) 869-5700
Carries casting notices and publishes financial information on
the entertainment industry. Published weekly in New York,
daily in Los Angeles.

Appendix IX

List of Support Organizations For Composers

American Composers Alliance & Edition
170 W. 74th Street
New York, NY 10023

American Federation of Musicians
1501 Broadway, Suite 600
New York, NY 10036

American Music Center, Inc.
250 W. 54th Street, Room 300
New York, NY 10019

American Musicians Union
8 Tobin Court
Dumont, NJ 07628

American Musicological Society
201 South 34th Treet
Philadelphia, PA 19104

American Opera Projects
463 Broome Street
New York, NY 10013

ASCAP
One Lincoln Plaza
New York, NY 10023

American Women Composers, Inc.
1690 36th Street, N.W., Suite 409
Washington, DC 20007

The Arts Exhcange
Box 160575
Austin, TX 78746

Arts Midwest
528 Hennepin Avenue, Suite 310
Minneapolis, MN 55403

BMI-Broadcast Music, Inc.
320 W. 57th Street
New York, NY 10019

College Music Society, Inc.
4860 Riverbend Road, Suite 2
University of Colorado
Boulder, CO 80301

Composers & Lyricists Guild of America
13542 Ventura Boulevard
Sherman Oaks, CA 91423

Composers Forum, Inc.
596 Broadway, Suite 602-A
New York, NY 10012

Composers Guild
Box 586
Farmington, UT 84025

Composers' Resources, Inc.
P.O. Box 19935
Atlanta, GA 30325

Computer Music Association
P.O. Box 1634
San Francisco, CA 94101-1634

Conductor's Guild, Inc.
P.O. Box 3361
Westchester, PA 19381

**Creative Audio & Mus. Elec. Org.
(CAMEO)**
Route 2, Box 408
Meridian, MS 39305
Independent Composers Association
Box 2126
Los Angeles, CA 90078

International League of Women Composers
Southshore Road, Box 670, Pt. Peninsula
Three Mile Bay, NY 13693

League of Composers, ISCM
250 West 54th Street, Suite 300
New York, NY 10019

Masterwork Music + Art Foundation, Inc.
P. O. Box 1436
Morristown, NJ 07631

Meet The Composer Organization
849 S. Broadway, Suite 419
Los Angeles, CA 90014

Mid-America Arts Alliance
912 Baltimore Avenue, Suite 700
Kansas City, MO 64105

Music Alliance
130 West 56th Street
New York, NY 10019

Music Associates of America
224 King Street
Englewood, NJ 07631

Music Library Association
P.O. Box 487
Canton, MA 02021

Music Publishers' Assoc. of the USA
130 West 57th Street
New York, NY 10019

National Association of Composers, USA
P.O. Box 49652, Barrington Station
Los Angeles, CA 90049

National Association of Schools of Music
11250 Roger Bacon Drive
Restin, VA 22090

National Music Council
40 West 37th Street, Fifth Floor
New York, NY 10018

New England Presenters
203 Hasbrouck
University of Massachusetts
Amherst, MA 01003

New Music Alliance
849 South Broadway, Suite 419
Los Angeles, CA 90014

New Music Distribution
500 Broadway, Fourth Floor
New York, NY 10012

New York Consortium For New Music
170 West 74th Street
New York, Ny 10023

New York Music Association
P.O. Box 311
Brooklyn, NY 11226

Opera America
777 14th Street. N.W., Suite 520
Washington, DC. 20005

Pennsylvania Pro Musica
225 - A South 42nd Steet
Philadelphia, PA 19104

People-to-People Music, Inc.
712 Auburn Avenue
Takoma Park, MD 20912

Recording Industry Association of USA
1020 19th Street, N.W., Suite 200
Washington, DC 20036

SESAC, Inc.
55 Music Square East
Nashville, TN 37203

SESAC, Inc.
156 West 56th Street
New York, NY 10019

Society of Composers, Inc.
P.O. Box 296 / Old Chelsea Station
New York, NY 10011-9998

Society of University Composers
New York, NY
(718) 899-2605

Songwriters Guild of America
276 Fifth Avenue, Suite 306
New York, NY 10001

Southern Arts Federation
1293 Peachtree Street, N.E., Suite 500
Atlanta, GA 30309

Violin Society of America
85 Abingdon Road
Kew Gardens, NY 11226

Youth in Music, USA
34 William Street
New York, NY 10038

Dance Publications

Arabesque
1 Sherman Square, Suite 22-F
New York, NY
Bi-monthly national journal on dance.

Attitude: The Dancer's Magazine
1040 Park Place
Brooklyn, NY 11213
Quarterly dance publication.

CCT Newsletter
Choreographers theatre
225 Lafayette Street, #713
New York, NY 10012
Publication that includes contemporary dance news.

Dance Chronicle
270 Madison Avenue
New York, NY 10016
Quarterly dance news publication.

Dance Magazine
33 West 60th Street
New York, NY l0023
Monthly subscription includes an annual issue that gives
information on grants.

Dance Pages
P.O. Box 916
Ansonia Station
New York, NY 10023

Includes a section on grants.

In Dance
SanFrancisco Bay Area Dance Coalition
2141 Mission Street, Suite 303
San Francisco, CA 94110

Monthly dance publication with feature articles and dance news.

Regional/State/Local Dance Support Organizations

American Dance Guild (ADG)
31 West 21rst Street, Third Floor
New York, NY 10010

ADG is a national membership organization of dance professionals including educators, writers and performers. ADG's Job Express Registry contains monthly listings of employment opportunities in teaching, administration and performance. Its newsletter contains reviews, conference reports and other news about the dance world. ADG also holds national conferences, maintains a library of comtemporary dance publications, and markets relevant publications to its members.

Beyond Dance
4649 Sunnyside Avenue, N,
Seattle, WA 98103

Organization has programs designed to assist dancers in making transition to professional dance and to other creative arts careers.

Carlisle Project
9 South Pitt Street
Carlisle, PA 17013

This organization offers choreography workshops, fellowships, and showcase performances to assist the transition from student to professional work in the dance world.

Chicago Dance Coalition
67 East Madison Avenue, Suite 2112
Chicago, IL 60603

The Coalition is a membership service organization which provides support services for the dance community of the greater Chicago area.

Dance Collection
Performing Arts Research Center of the
New York Public Library at Lincoln Center
111 Amsterdam Avenue
New York, NY 10023

This library houses an in-depth multimedia collection of resource material relevant to the dance field. The Dance Collection contains books, periodicals, dance notation scores, photographs, reviews, oral history interviews and a comprehensive archive of films and videotapes with viewing facilities available.

Dance in Canada Association
322 King Street, W., Suite 403
Toronto, ON M5V 1J2
Canada

A national non-profit that is open to all persons and groups within the dance community. They publish a quarterly magazine and a monthly newsletter. They present dance consulting services, annual conferences, festivals and workshops.

Dance Network
14118 Archwood Street
Van Nuys, CA 91405

Specializes in casting choreographers and dancers for commercials, industrials, television, film, and the stage.

Dance St. Louis
149 Edgar roadt
St. Louis, MO 63119

Organization provides regional dance activities and support to dance groups.

Dance Theatre Workshop, Inc. (DTW)
219 West l9th Street
New York, NY 10011

DTW provides artist sponsorship and related administrative, promotional and technical services to performing artists, companies, and organizations throughout the country.

Dance Umbrella, Boston, Inc.
380 Green Street
Cambridge, MA 02139

Dance Umbrella is a presenting organization.

Dance/USA
777 14th Street, N.W., Suite 540
Washington, DC 20005-3270

Dance/USA, a national membership organization of dance professionals, represents interests of professional dance companies, assists local and regional not-for-profit dance service organizations, and advocates the concerns of the dance field to funding agencies, legislative bodies and the press.

Florida Dance Association
927 Lincoln Road, Suite 120
Miami, FL 33139

The State Dance Association of Florida provides services to its members including a statewide newsletter; a dance calendar; an annual conference; and an information referral service.

Golden State DanceTeachers Association
10804 Woodruff
Downey, CA 90241-3910

Organization maintains an information bureau to inform the public, teachers, employers, and students on dance.

Institute for Social Dance Studies
60 West 57th Street, Suite 18A
New York, NY 10019

Institute provides grants and scholarships for teacher training in the art of dance.

International Dance-Exercise Association
6190 Cornerstone Court East. Suite 204
San Diego, CA 92121

"IDEA" provides educational, instructional, and informational assistance to the professional dance instructor. It distributes dance news and coordinates 28 seminars and conventions. They publish a bi-monthly magazine and an annual directory.

Los Angeles Area Dance Alliance (LAADA)
Ford Theatre
2580 Cahuenga Blvd, East
Los Angeles, CA 90068-2752

LAADA membership benefits include a subscription to the Dance Flash Calendar, notices of master classes, and technical and management workshops offered by the Alliance. The LAADA Dance Video Center will tape members performances for a minimal fee and the LAADA Dance Exchange provides members with showcase opportunities.

Mid-America Dance Network
912 Baltimore Avenue, Suite 700
Kansas City, MO 64105

Mid-America Dance Network is a regional information resource center.

Minnesota Dance Alliance
Hennepin Center for the Arts
528 Hennepin Avenue
Minneapolis, MN 55403

Provides Minnesota choreographers with a support system and promotes the creation and performance of dance by Minnesota choreographers.

National Association for Regional Ballet (NARB)
1860 Broadway
New York, NY 10023

NARB coordinates five annual regional ballet festivals, sponsors two Craft of Choreography conferences each summer, conducts a placement service for artistic personnel and a set and costume referral service and publishes newsletters, bulletins and newsletters.

The National Corporate Fund for Dance (NCFD
250 West 57th Street, Suite 314
New York, NY 10107

The NCFD is a national organization that seeks general operating support for major American dance companies, and provides special service programs for professional and semi-professional companies and dance related organizations. Staff and board members offer consultation to dance organizations on fundraising, particularly within the corporate sector; marketing; long-range financial planning; and administrative structure.

Ohio Dance
695 Bryden Road
Columbus, OH 43205

Ohio Dance provides ongoing workshops, performances and community dance news.

Omaha Modern Dance Collective
P.O. Box 1084
Omaha, NE 68101-1084

Organization provides an information resource on regional dance news and activities.

Philadelphia Dance Alliance
1315 Walnut Street, Suite 1505
Philadelphia, PA 19107-4719

The Philadelphia Dance Alliance provides professional services to its membership in the areas of promotion, marketing, and management; publishes a dance calendar; works to develop a

local dance audience; and serves as a resource for dance information to the public.

San Francisco Bay Area Dance Coalition
2141 Mission Street, Suite 303
Fort Mason, San Francisco, CA 94110
The San Francisco Bay Area Dance Coalition is a membership service organization which publishes a monthly Bay Area performance calendar/newsletter; maintains an information center; offers performance opportunities; provides an insurance plan; and acts as an advocate for dance with funders, sponsors, and the media.

Southern Oregon Dance Association, Inc.
P.O. Box 4
Oakland, OR 97462
The Association is a informations resource center.

Publications for Visual Artists

Afterimage
Visual Studies Workshop
31 Prince St.
New York, NY 14607

Reports on film, broadcasting and photography. Includes grant and award announcements.

AIVF
Association of Independent Video and Filmmakers
625 Broadway
New York, NY 10016

Contains information on screenings, courses, conferences, festivals and other events, and lists grant opportunities as well as production and studio resources.

American Art Directory
R.R. Bowker Co.
245 West 17th Street
New York, NY 10011

Contains information about American arts magazines, art schools, arts organizations, scholarships and fellowships in the visual arts. This directory is a standard in the field.

American Crafts
American Crafts Council
40 West 53rd Street
New York, NY 10019

Contains information on grants, exhibitions, and other practical matters.

*American Film: The Magazine of the
Film and Telvision Arts*
American Film Institute (AFI)
3 East 54th Street
New York, NY 10022

Includes information about AFI grants and other sources of
funds.

*The Art in America Annual Guide to
Galleries, Museums and Artists. Art in
America*
980 Madison Avenue
New York, NY 10021

Artletter
Art in America, Inc.
575 Broadway
New York, NY 10006

Gives grant deadline dates and information on government
and foundation programs and announces competitions.

*The Artist in the Marketplace: Making
Your Living in Fine Arts*
Patricia Frischer and James Adams. 1980 by M. Evans and
Company, Inc.

The Business of Art
Lee Evan Caplin, editor. 1989 by Prentice-Hall, Inc.

CAA Newsletter
College Art Association of America (CAA)
16 East 52nd Street
New York, NY 10022

CPB Report
Corporation for Public Broadcasting
1111 16th Street
Washington, DC 20036

Gives funding information in the public broadcasting field
and lists grants and contracts made by CPB.

Film and Video Makers Travel Sheet
Carnegie Institute - Film Section
Museum of Art
4400 Forbes Avenue
Pittsburgh, PA 15213
Lists exhibitions and lecture tours by film and video makers.
Gives current information on funding sources, competitions,
and other notes of interest.

Film Comment
The Film Society of Lincoln Center
1865 Broadway
New York, NY 10023
Covers a broad range of topics and news related to cinema and
includes funding information.

Filmmakers Newsletter
P.O. Box 115
Ward Hill, MA 01830
Information on grants and scholarships is included in this
publication for both professionals and semi-professionals
working in film and videotape.

Grant Proposals That Succeed
Virginia P. White, editor. 1983, by Plenum Publishers.

How to Open Your Own Shop or Gallery
Leta W. Clark. 1983 by Penguin, New York, NY.

Museums and the Law
Marilyn Phelan, editor. 1982, AASLH printers.

Museum News
American Association of Museums
1225 I Street N.W., Suite 200
NW, Washington, DC 20005
Contains articles, reports, book reviews and other information
of interest to museum professionals. Bi-monthly periodical.

News from the Film Fund
The Film Fund
80 East 11th Street
New York, NY 10003
Contains information on grants made by the Fund and on other grant programs and sources.

Televisions
Washington Community Video Center, Inc.
P.O. Box 21068
Washington, DC 20009
Provides funding information for independent producers.

The Visual Artist's Manual: A Practical Guide to Your Career
Susan A. Grode and David Paul Steiner. 1981 by Gore Graphics.

The Washington International Arts Letter
Box 9005
Washington, DC 20003

Women Artists News
Box 3304
Grand Central Station
New York, NY 10017
Contains funding information for women, minority and other artists.

Bibliography

Acting In Television Commercials For Fun And Profit
Squire Fridell. Harmony Books, 1980.

American Art Directory
Jaques Cattel Press, Editor. R.R. Bowker Co., New York, NY, 1986 (Biennial).

Artculture: Essays On The Post Modern
Douglas Davis. Harper and Row, Inc., 1977.

Artist Colonies
Center for Arts Information, New York, NY, 1986.

The Artist-Gallery Partnership:
A Practical Guide To Consignment
Susan Mellon and Tad Crawford. American Council for the Arts, 1981.

The Artist's Guide to the Art Market
Betty Chamberlain. Watson-Guptill Publications, New York, NY, 1983.

Artists' Housing Manual: A Guide to Living in New York City
Nancy Biberman and Roger Evans. Volunteer Lawyers for the Arts, New York, NY, 1987.

Artists in Space: A Handbook for Developing Artists' Space
Jero Nesson. Fort Point Arts Community, Inc., Boston, MA, 1987.

Artists Live/Work Spaces: Changing Public Policy
Artists Equity Association, San Francisco, 1981.

The Artists' Survival Manual
A Complete Guide To Marketing Your Work
Toby and Judith Klayman with Cobbett Steinberg.
Charles Scribner's Sons, 1984.

The Art of Deduction: Income Taxation for Performing, Visual , and Literary Artists
Bay Area Lawyers for the Arts. San Francisco, CA, 1983.

The Art Resource Directory for Blind and Visually Impaired People
Museum of American Folk Art and American Foundation for the Blind. Museum of American Folk Art, New York, NY, 1988.

Arts and the States
Larry Briskin. National Conference of State Legislatures, Denver, CO, (second edition) 1984.

Auditions Are Just The Beginning
The Business Of Art
Lee Evan Caplin. Prentice-Hall, Inc., 1982.

A Career Guide To Orchestras.
Wendy Reid and Christopher Weait.
Association of Canadian Orchestras, 1981.

Careers In Music
Edited by Betty Stearns and Clara Degen.
American Music Conference, 1980.

Catalog Of Literary Magazines
Coordinating Council of Literary Magazines
2 Park Ave., NY, NY 10016
Includes descriptive entries for over 340 literary magazines.

Coordinating Council Of Literary Magazines Newsletter
666 Broadway, Eleventh Floor, NY, NY 10012
Reports on funding, manuscript requests and information on work-shops, conferences, grants and prizes.

The Copyright Book: A Practical Guide
William Strong. MIT Press, Cambridge, MA, 1986

Dance Auditions; Preparations, Presentation, Career Planning
Eric Brandy Nielson. Princeton Book Company

A Directory Of American Poets And Fiction Writers, 1984
Poets & Writers Inc., 72 Spring Street, New York, NY 1984

Directory of Grants in the Humanities
Oryx Press, Phoenix, AZ, 1987.

Dramatists Sourcebook
1989-90 edition.

Film, Tape & TV - Where Do I Fit In?
Barbara Berger Keller. Keller International Publishing Company, 1985.

Grants and Awards Available to American Writers
Fifteenth edition 1988-89. Published by P.E.N. American Center, New York, NY.

Grants For The Arts
Virgina P. White. Plenum Press, 1980.

A Guide to Corporate Giving in the Arts
American Council for the Arts, New York, NY 1987.

Guide to Grantsmanship
Lionel E. Mayrand, editor. 1977, Systems Planning Publishers.

A Guide To Theatre In America.
Compiled and Edited by Lawrence S. Epstein. Broadcasting Publications, 1985

Guide to the National Endowment for the Arts
NEA, Office of Public Affairs, Washington, DC, 1987

How To Act And Eat At The Same Time The Business Of Landing A Professional Acting Job
Tom Logan. Communication Press, Inc., 1988, second edition.

How To Audition
Gordon Hunt. Harper and Row, 1979.

How to Enter and Win Contests
Alan Gadney. Facts on File, New York, 1984.

The Individual's Guide to Grants
Judith Margolin. Plenum Press, New York, NY, 1983.

Jobsearch Techniques For Fine Artists
A Career Counselor's Handbook
Katherine Lammon. University of Connecticut, 1983.

Law & The Writer
Edited By Kirk Polking and Leonard S. Meranus. Writer's Digest Books, 1989.

Literary Agents - A Writer's Guide
Debby Mayer. Poets & Writers, Inc., 1984.

National Directory of Arts Internships
Warren Christensen, editor, 1991, second edition. NNAP, 935 Avenue 37, Los Angeles, CA 90067.

National Directory of Artists Organizations
National Association of Artists' Organizations,
Washington, DC, 1987.

Negotiating a Book Contract
Mark Levine. Mover Bell, Ltd., 1988.

The Platinum Rainbow
Bob Monaco and James Riordan. Swordsman
Press, 1980.

Poor Dancers Almanac
A Survival Manual For Choreographers,
Managers And Dancers
Executive Editors David R. White & Mindy N.
LeVine. Dance Theatre Workshop Publications,
1984.

A Quick Guide to Loans and Emergency Funds
Center for Arts Information, New York, NY, 1986.

The Rights of Authors and Artists
Kenneth P. Norwick, et. al. An American Civil
Liberties Union Handbook. Illinois University
Press, 1984.

Sponsors List: 641 Organizations In The U.S.
that Sponsor Programs Involving Fiction
Writers And Poets
Poets and Writers, Inc., 1982.

Starting And Succeeding In Your Own
Photography Business
Jeanne C. Thwaites. Writer's Digest Books, 1984.

Supporting Yourself As An Artist
A Practical Guide
Deborah A. Hoover. Oxford University Press, 2nd
Edition, 1989.

Theatre Directory Of The San Francisco Bay Area: A Professional Resource Guide
Jean Schiffman. Theatre Communications Center of the Bay Area, Inc., 1987-88.

This Business Of Music
Sidney Shemel and M. William Krasilovsky. Watson-Guptil, 1985.

The Working Actor
A Guide to the Profession
Katinka Matson. Penguin Books, 1978.

A Writer's Guide To Copyright
Poets & Writers, Inc., 1990.

Your Film Acting Career
How To Break Into The Movies And TV And Survive In Hollywood
M.K. Lewis and Rosemary Lewis. Crown Publishers, Inc., 1983.

COMPLETELY REVISED AND UPDATED

Theatre In Progress, a non-profit organization dba the National Network for Artist Placement N.N.A.P. presents an invitation to subscribe to our <u>newly expanded fourth edition</u>. When have you wanted to find a resource for an artist and have simply not known where to look.

NATIONAL DIRECTORY OF ART INTERNSHIPS 1991/1992

4th EDITION

EXAMPLE:

Kalamazoo Civic Players
329 S. Park Street
Kalamazoo, MI 49007
(616) 343-2280 Contact: David Grapes

Description: Increase your experience in all phases of theatre while joining the staff of one of the top community theatres in the country. Internships available in scene design, technical direction, directing and management. A $6,000.00 stipend is paid to each for the 40 week season from Sept. to May.

Eligibility Requirements: College graduates who have completed study and individuals who have theatrical backgrounds.

Application Procedures: Write by March 15th for the following year.

One of the most comprehensive guides of its kind, the **National Directory** begins the 1990's with an expanded listing of entry opportunities for artists seeking experience in every art form produced in the U.S.A. Whether you're interested in Art/Design, Theatre Production, Music, Dance, Film, or Arts Management, this Directory cites nearly one thousand businesses and institution across the country who offer a wide variety of internship options for you to choose from in pursuing your arts vocations. Use this publication as a resource guide to make that bridge from emergence to paid professionalism.

> *"One of the BEST in career and education print publications"*
> National Education and
> Information Centers

Art & Design
Graphic Arts
Arts Administration
Museum/Gallery Operation
Videographer
Photographer
Darkroom Technician
Artist's Apprentice
Festival Coordinator
Art Teacher

Dance
Administration
Tech Production

Theatre
Acting
Directing
Tech Production
Costume
Administrative

Film & Video
Cinematography
Videography
Film/TV Directing
Production Assistant
Gofer
Art Direction
Film Editing
Sound Editing
Video Post Production
Video Tape
Talent Booking
Editorial & Screen Writing
Documentary
Commercials
News
Sports Film Festival
Coordination

Music
Performance
Opera
Administration
Radio

MAKE CHECKS PAYABLE TO:

National Network for Artist Placement

N.N.A.P.
935 W. Ave. 37
Los Angeles, CA 90065
(213) 222-4035

THIS 1991/1992 EDITION IS
AVAILABLE NOW

Please send ___ copy/copies of the completely revised and updated 4th Edition of the <u>National Directory of Art Internships</u> 1991/1992:

Name _____

Organization _____

Address _____ City _____ State/Zip _____

Telephone () _____

Per-copy cost: $35.00 with pre-payment. Sales tax, postage and handling included in price. Add $5 per-copy with purchase order (if we have to bill). If you purchase 5 or more copies, your discount is 40%. <u>No orders will be honored without pre-payment or purchase order!</u> Orders are mailed parcel-post book rate (4-6 weeks). If you would like a 1st class mailing, please add $3.00.

COMPLETELY REVISED AND UPDATED

Theatre In Progress, a non-profit organization dba the National Network for Artist Placement N.N.A.P. presents an invitation to subscribe to our **newly expanded second edition**. When have you wanted to find a resource for an artist and have simply not known where to look.

ARTLINES 1991-1992:

2 nd EDITION

An Annotated Guide To Organizations and Publications Essential to Artists.

This latest edition of our annotated artist bibliography presents a comprehensive introduction to hundreds of arts organizations lending support to artists and concise descriptions of trade publications essential to practitioners of every art form.

Artlines extends the network of arts services to the reader from across the nation.

Where to

seek job

opportunities

and

funding

sources

for

your work.

Listings include these resources to the artist:

- Where to find jobs and sources of funding.

- Where to find artist job banks.

- Organizations and individuals to contact: Where to find space, equipment, referrals.

- Where to find legal information.

- "How to" Information useful to the artist for basic activities such as drawing up a contract, filing taxes, copyright, writing and artist resume and more.

- What are the trades most beneficial to the artist in a particular field?

- What associations should the artist belong to and what resources do they offer?

MAKE CHECKS PAYABLE TO:

National Network for Artist Placement

N.N.A.P.
935 W. Ave. 37
Los Angeles, CA 90065
(213) 222-4035

THIS 1991/1992 EDITION IS

AVAILABLE NOW

Please send ___ copy/copies of the completely revised and updated 2nd edition of **Artlines 1991/1992 to:**

Name			
Organization			
Address	City	State/Zip	
Telephone ()			

Per-copy cost: $35.00 with pre-payment. Sales tax, postage and handling included in price. Add $5 per-copy with purchase order (if we have to bill). If you purchase 5 or more copies, your discount is 40%. **No orders will be honored without pre-payment or purchase order!** Orders are mailed parcel-post book rate (4-6 weeks). If you would like a 1st class mailing, please add $3.00.

Theatre In Progress, A Non Profit Organization dba
The National Network for Artist Placement N.N.A.P. Presents

YOUR FILM ACTING CAREER

How to Break into the Movies & TV and Survive in Hollywood

By M.K. Lewis & Rosemary R. Lewis

This is the classic book actors call ''The Bible''—in a new, revised edition. It provides answers to hundreds of questions asked about the Hollywood scene:

- **Finding work in TV, movies, and commercials**
- **Getting into the unions**
- **Choosing photos that sell**
- **Finding an agent**
- **Handling interviews and cold readings**
- **Residuals, overtime, contracts ...and more**

When it comes to the business of acting, there is no better book.

"This is undoubtedly the best handbook for actors new to Los Angeles that has been published for some time, and even performers who have been here for years may find answers to their questions about the business of being an actor."
—**Drama-Logue**

"Even successful actors and actresses should read this enlightening book.
—**June Allyson**

"If only M.K. Lewis' marvelously informative handbook had been around a few years ago when I first came to Hollywood from San Diego, maybe it wouldn't have taken me 20 years to hit my stride." —**Marion Ross, ''Happy Days''**

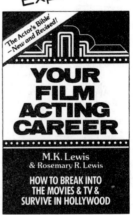

M.K. Lewis is a prominent Los Angeles acting teacher whose career spans 25 years in the theatre, TV and film. He is a former member of the SAG Conservatory Committee, and the California Institute of the Arts faculty. Writer/cartoonist Rosemary Lewis worked in TV, film and print media.

CAREERS IN THEATRE ARTS

DIRECTORY OF THEATRE TRAINING PROGRAMS, II (2nd Ed.)

The only resource of its kind, listing Theatre programs (Undergraduate and Graduate) at 250 Colleges, Universities and Conservatories. Detailed information on Admissions, Scholarships, Faculty, Curriculum, Facilities, Productions and Philosophy of Training. *Ed. Jill Charles; 164 pp., paper, $17.50*

"Recommended for all libraries that serve performing arts programs."
— CHOICE, Jan. '88., American Library Association

"The prefatory matter is useful, consisting of previously published articles on choosing a career in theater, and what degree (or nondegree situation) is best. This is a very useful book..."
— Reference Books Bulletin/Booklist, Jan. 1990., ALA

"More comprehensive and up-to-date than the theater education sections of such general works as Lawrence Epstein's Guide to Theatre in America, this would be a highly useful addition to theater and career education collections."
— Library Journal, Feb. 1990, Cahners Publishing Co.

REGIONAL THEATRE DIRECTORY, 1990-91

Detailed profiles of 435 professional Regional & Dinner Theatres, with information on hiring and audition proceedures and **Internship** opportunities. Appendix includes a nationwide listing of Drama specialty bookstores; reviews of 30+ books on careers in the performing arts; listing of theatre-related service organizations and periodicals. *Ed. Jill Charles; 180 pp., paper, $12.95.*

"This publication is a bargain, ideal for academic and public libraries serving people who want to work in the theater."
— CHOICE, Nov. 1986, ALA

"A valuable assist to professional job hunting...offers specific guidance to performers, directors, designers, technicans and staff. Meticulously edited..."
— Back Stage, Aug. 31, 1990, BPI Communications, Inc.

SUMMER THEATRE DIRECTORY, 1991

Opportunities at 475 Professional Summer Theatres and intensive Summer Training Programs, with information on hiring, auditioning, salaries, **Apprenticeships, Internships,** etc. Also information on all major regional spring auditions. Appendix includes articles on preparing for auditions, union information, useful periodicals and trade papers, etc. *Ed. Jill Charles; 180pp., paper, $12.95.*

"...an indispensable employment guide for students and professionals in all areas of theatrical summer work."
— Back Stage, April 6, 1989, BPI Communications, Inc.

MAKE CHECKS PAYABLE TO:
National Network for Artist Placement

> N.N.A.P.
> 935 W. Ave. 37
> Los Angeles, California 90065
> (213) 222 4035

THESE 1991 EDITIONS ARE
AVAILABLE NOW

Please send ___ copy/copies of the completely revised and updated 2nd edition of <u>Directory of the Theatre Training Programs, II</u>, 1991, and ___ copy/copies of <u>Regional Theatre Directory</u>, 1990/1991 and ___ copy/copies of **Summer Theatre Directory**, 1991 to:

Name _____

Organization _____

Address _____
city state zip

Telephone _____

"Directory of Theatre Training Programs, II" $17.50 per copy with pre-payment. "Regional Theatre Directory" and " Summer Theatre Directory" $12.95 per copy with pre-payment. Sales tax included. **Add $5 per book for parcel-post book rate postage and handling.** (Add $8 for FIRST CLASS POSTAGE) Add $5 with purchase order (if we have to bill). If you purchase 5 or more copies, your discount is 40%. No orders will be honored without pre-payment or purchase order! Orders are mailed parcel-post book rate (4-6 weeks).